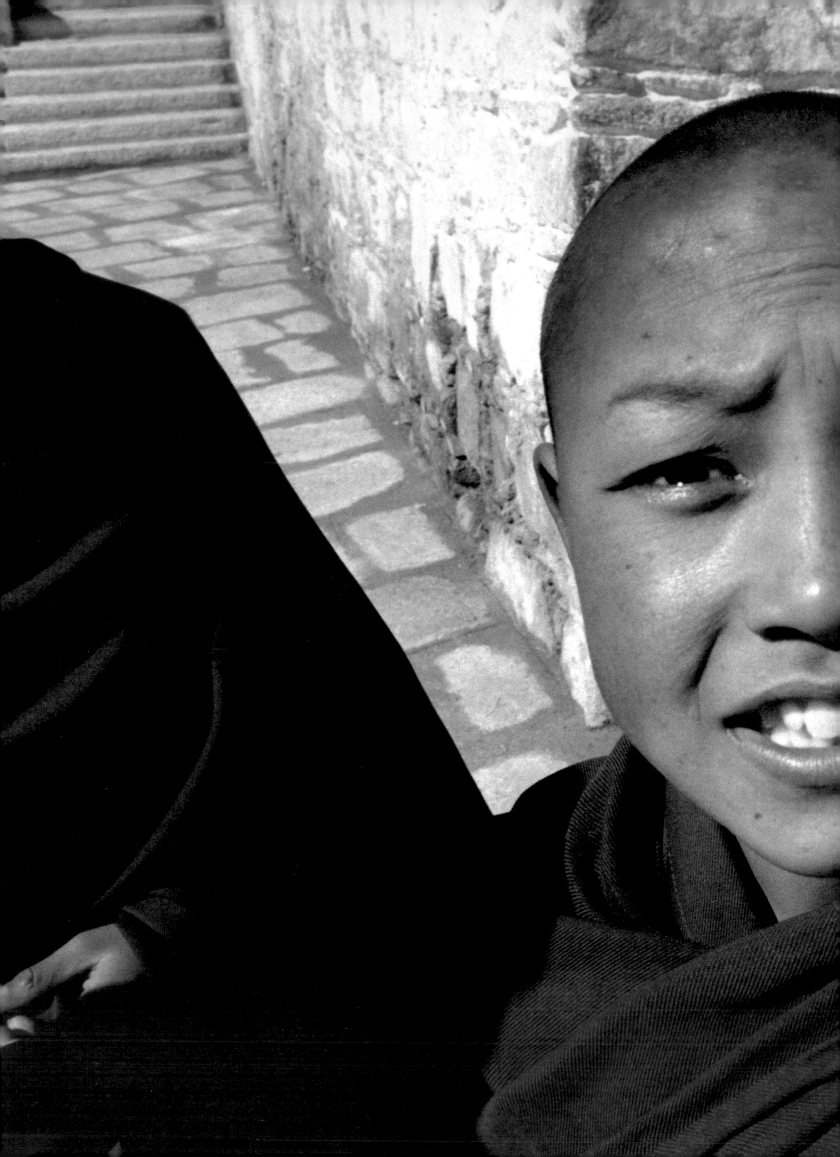

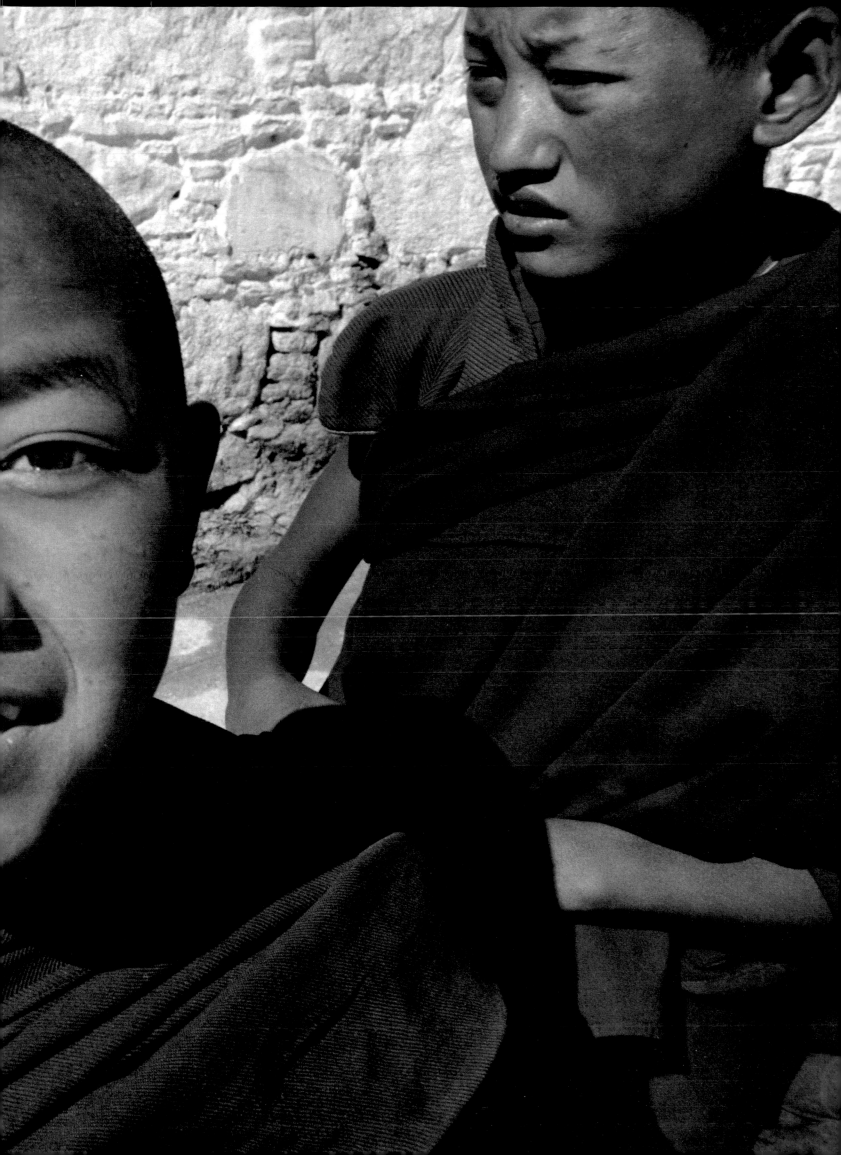

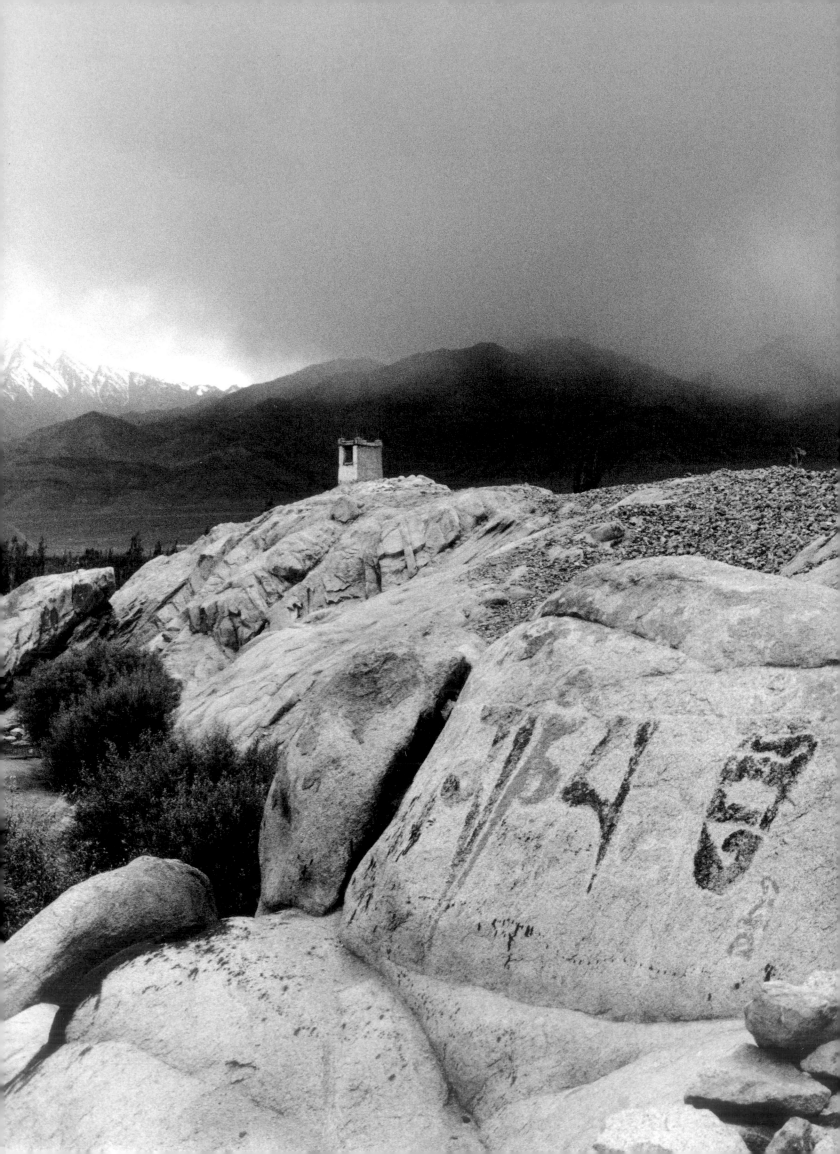

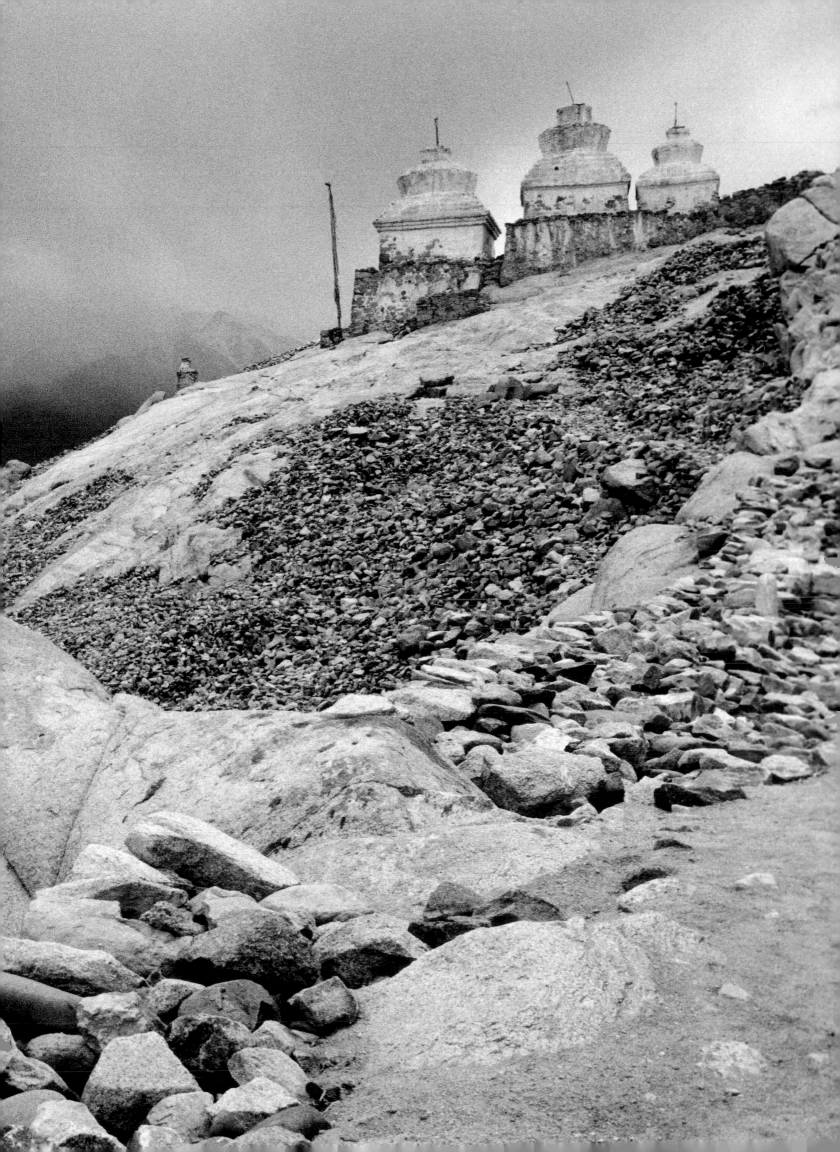

the

tibetans

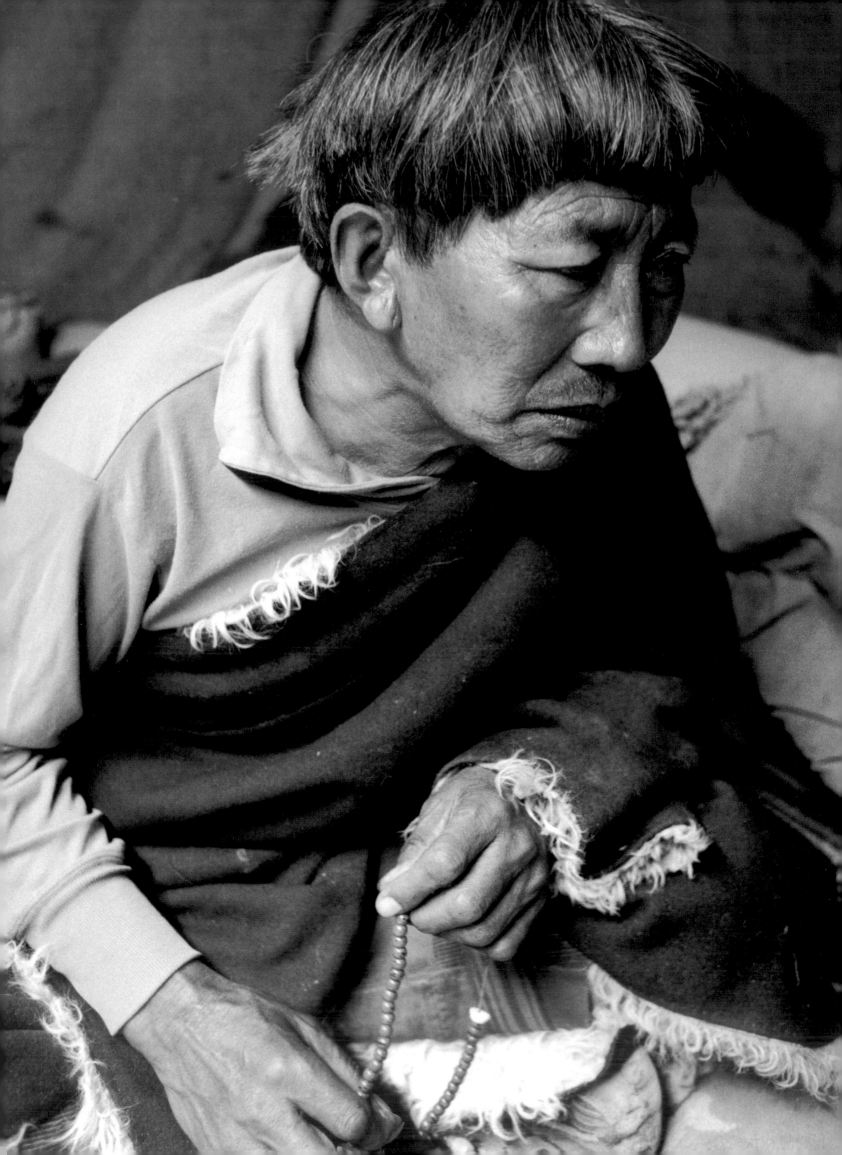

the

tibetans

photographs

Art Perry

Introduction by Robert A. F. Thurman

VIKING STUDIO
Published by the Penguin Group

{

Penguin Putnam Inc.,
375 Hudson Street,
New York, New York 10014, U.S.A.
Penguin Books Ltd,
27 Wrights Lane,
London W8 5TZ, England
Penguin Books Australia Ltd,
Ringwood, Victoria, Australia
Penguin Books Canada Ltd,
10 Alcorn Avenue,
Toronto, Ontario, Canada M4V 3B2
Penguin Books (N.Z.) Ltd,
182-190 Wairau Road,
Auckland 10, New Zealand

Penguin Books Ltd, Registered Offices:
Harmondsworth, Middlesex, England

First published in 1999 by Viking Studio,
a member of Penguin Putnam Inc.

1 3 5 7 9 10 8 6 4 2

CIP data available
ISBN 0-670-88645-9

Printed in Japan
Set in New Century Schoolbook
and Clarendon

Designer:
Tom Brown/BSM GROUP LLC.
Assistant Designer:
Rob Hewitt

To the people of
Tibet

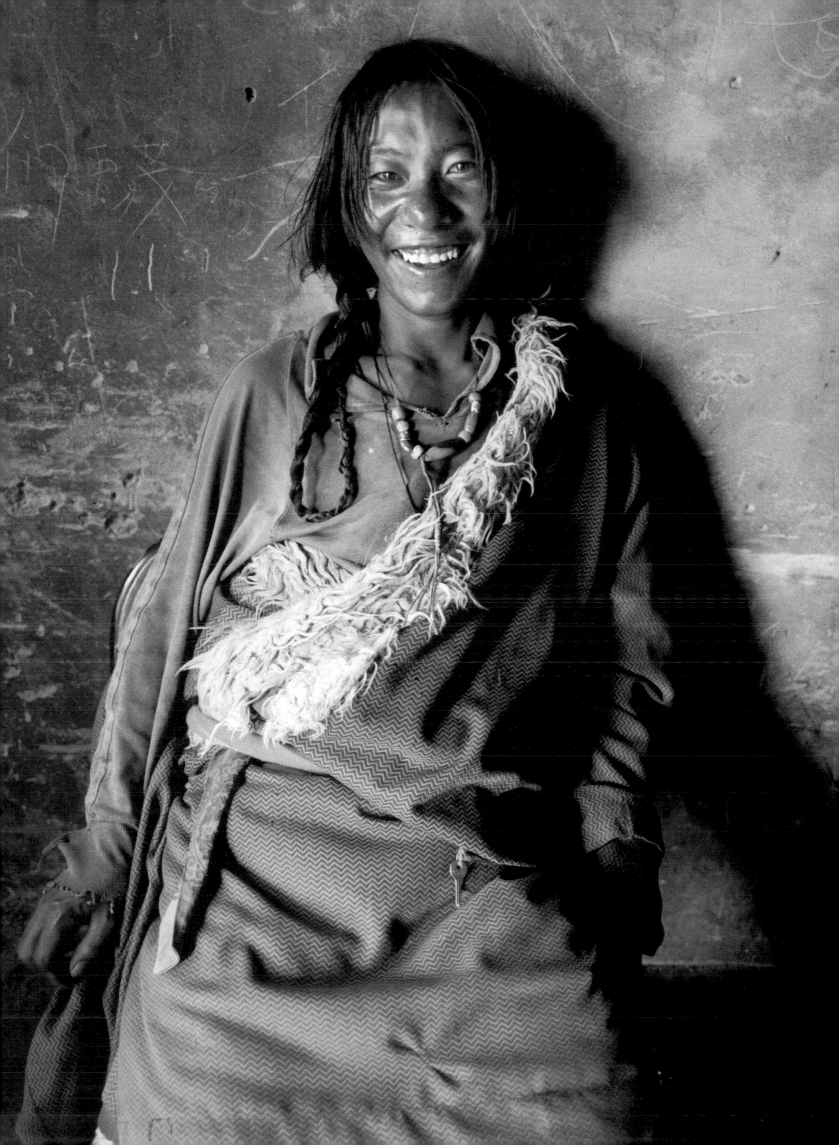

Introduction

THESE BEAUTIFUL PHOTOGRAPHS OF TIBET AND TIBETANS COULD ONLY HAVE emerged from the eye and hand and heart of a man who made every effort to share the life and feelings of the extraordinary individuals who live on the highest plateau on earth.

The Tibetan people have had more than their fair share of suffering over the last fifty years. When the Chinese Red Army invaded Amdo Province of northeast Tibet in 1949, the Tibetan Buddhist lifestyle of townspeople and nomads began to come to a violent end as property was confiscated and communities were first shattered and then collectivized.

The invading soldiers, hardened by the horrors of civil wars in China, alienated from Tibetans by racist identifications, and charged up with ideological fanaticism, crushed all physical and mental resistance using the "barrel-of-a-gun" Maoist techniques of Communist class struggle and materialist thought reform. People who tried to defend themselves, their families, and their temples were tortured and killed.

This well-planned invasion, occupation, and colonization spread next to the southeastern province of Kham beginning in 1950 and moved into central Tibet in 1951. Over the next decades an extensive system of military roads, military camps, and concentration camps was created using forced labor. Once the occupation was stabilized, new Chinese colonists were settled on the best farmland, and the nomads were subjected to collective herding practices and state confiscation policies that destroyed their traditional prosperity. Chinese soldiers and settlers raped the land, commandeering whatever goods they wanted, destroying the plentiful forests of the southeast and central regions, mining with no regard for poisoning or polluting, and slaughtering the previously abundant wildlife. The only things arresting the total, rapid, mass Chinese colonization of Tibet were the difficulty of adapting to the high altitude and fragile ecosystem. Since it does not permit the intensive Chinese agriculture needed to sustain the influx of a large Chinese population, Mao was unable to fulfill his vow to fill up Tibet with sixty million Chinese within the first ten years. This was how he and all Chinese rulers since have wished to end the "Tibet problem"; i.e., the problem that Tibet has always been a country separate from China, populated by Tibetans whom, face-to-face, nobody considers to be Chinese, who have adapted to their high-altitude ecosystem by thousands of generations of lived experience.

The first fifteen years of China's blatantly genocidal activity in Tibet were ignored by the world, partly due to lack of information and partly due to a diplomatic and commercial realpolitik that considered China of paramount importance and Tibet something to be sacrificed.

During Korean War times and until the Nixon-Kissinger visit to Beijing, the American government did support a low-intensity resistance by Tibetan freedom fighters and a low-profile, unaccredited mission to the United Nations by Tibetan government-in-exile diplomats. However, on the whole, the world community followed the Indian and British policy of equivocation that never chal-

lenged either Taiwan or Beijing in its flimsy pretensions to legal ownership of Tibet. During the second wave of atrocities in Tibet inspired by the great cultural revolution of the sixties and seventies, the diplomatic community persisted in turning its back on Tibet. With 1.2 million people killed, six thousand monasteries destroyed, billions of dollars of old-growth trees clear-cut and whole ecosystems polluted, and massive colonization systematically pursued, no one spoke up to protest. After 1989, when the Tiananmen Square massacre plainly showed the fangs of the Chinese dictatorship bared and bloodied on the bodies of its own youth, the Norwegians took heart and awarded

His Holiness the Dalai Lama the Nobel Prize for Peace. The Berlin Wall came down and the velvet revolution liberated Eastern Europe from the Soviets—and still the world made only symbolic efforts to see justice done in Tibet. The Chinese government persists today in its laughable denial of the well-documented facts of the case, and Western journalists and governments continue to cover for them, wittingly or unwittingly, as the case may be.

As we approach the new century and millennium, the Dalai Lama has become a figure of international prominence, both as a spiritual teacher and as the leader of his long-suffering people. He travels widely giving Buddhist teachings, sharing his wisdom in ecumenical settings, and speaking on behalf of his people both publicly and privately. His major concern over the past decade has been to engage in a constructive dialogue with the new rulers of the Peoples' Republic of China. They rebuff his every effort, stubbornly keeping their heads buried in the sand. Tragically, they treat their potential best friend as if he were their worst enemy. He does not give up and makes a good case for an eventual turn to the positive, expected as reality prevails in the near future.

TIBETANS HAVE SURVIVED THE HELLISH HOLOCAUST OF THE LAST FIFTY YEARS as best they could, keeping their deep and powerful spirituality secretly burning in their hearts. They patiently endure. They pray for the day when freedom, justice, economic recovery, and spiritual opportunity will return. The few Tibetans in exile struggle to live and preserve the seeds of their precious traditions in greenhouse enclaves in foreign countries. They appeal to the conscience of the world though their cries are muffled by the censorship of journalism by commercial interests. A few brave heroes and heroines broke with their Buddhist heritage of gentleness and pursued a guerrilla campaign against great odds, during the sixties supported half-heartedly by the United States and grudgingly tolerated by Nepal and India. This campaign was betrayed to China by Kissinger in 1971, and those freedom fighters who would not heed the Dalai Lama's appeal to lay down their arms were eventually crushed by Nepali troops.

In the early eighties, the post-Mao PRC rulers had a moment of misgiving about the destruction they had wreaked on Tibet and slightly relaxed their control of day-to-day activities. Tibetans at once returned to their cherished spiritual pursuits, digging out hidden rosaries and prayer wheels, rebuilding monasteries as volunteers, ordaining monks and becoming nuns with boundless relief and enthusiasm.

Decollectivization allowed the nomads to rebuild their ruined herds, and

some farmers were again permitted to manage their lands with appropriate crops. Western tourists were allowed in and soon developed friendly relationships with Tibetans, also learning in detail of the long night of suffering they had experienced. However, the slight recovery did not last, and soon all gains were lost under the pressure of the endless influx of Chinese settlers and carpetbaggers, taking away ever more money, space, and resources. Tibetans were allowed out occasionally on pilgrimage to India, and some exiles were permitted to return to visit remnants of families. A new flood of refugees ensued, all without any government assistance, since India and other countries were too afraid of China to admit they were receiving them. At the end of the eighties, Deng Xiaoping followed his Tiananmen repression with a new crackdown on Tibet and a return to the genocidal policies of the past. This was conducted in secrecy, under a cloak of official denial, until 1994, when Clinton's delinking of human rights and trade emboldened the politburo to bring its "strike hard" campaign out in the open. The authorities arrested the rightful Panchen Lama and returned to a fierce "anti-Dalai" rhetoric, confiscating shrine photographs of the leader and proclaiming Tibetan Buddhism itself to be intrinsically seditious against the "motherland."

Today, Tibetans expect America to live up to its fabled reputation as defender of the oppressed, champion of freedom, justice, equality, and human rights. All Tibetan accounts of life as a prisoner in the numerous concentration camps China continues to operate in Tibet tell of the daily presence of America in the dialogue between prisoners and guards. When the United States does something positive, like a president having a meeting with the Dalai Lama, Tibetans feel hope and their morale rises. When China gains some commercial advantage, when a premier snows the American media, when Hong Kong is returned, when anything happens that shows America in a bad light and China as triumphant, the guards crow with glee, openly challenge the prisoners' misplacing their hopes, and heap abuse on America and the attitude of self-respect it symbolizes.

Thus, the faces looking out at us from the pages of this book are looking to us for help, quietly praying that we will be moved with compassion. Spiritually, they recite their *om mani padme hum* and hope for the intervention of their protective archangel, Chenrayzee, the bodhisattva Avalokiteshvara, who incarnates as the Dalai Lama (also as the Karmapa and numerous other persons and beings) to help Tibet. And politically, they talk of the United Nations and above all of America, and hope that they will finally be saved from being utterly consumed by China. These faces move our hearts. They see us as their long-lost kinfolk. They call out to us for help. Yet they are also proud and self-contained, enduring no matter what. They give us hope and make the impossible seem possible.

ROBERT A. F. THURMAN
Jey Tsong Khapa Professor
of Indo-Tibetan Buddhist Studies,
Columbia University

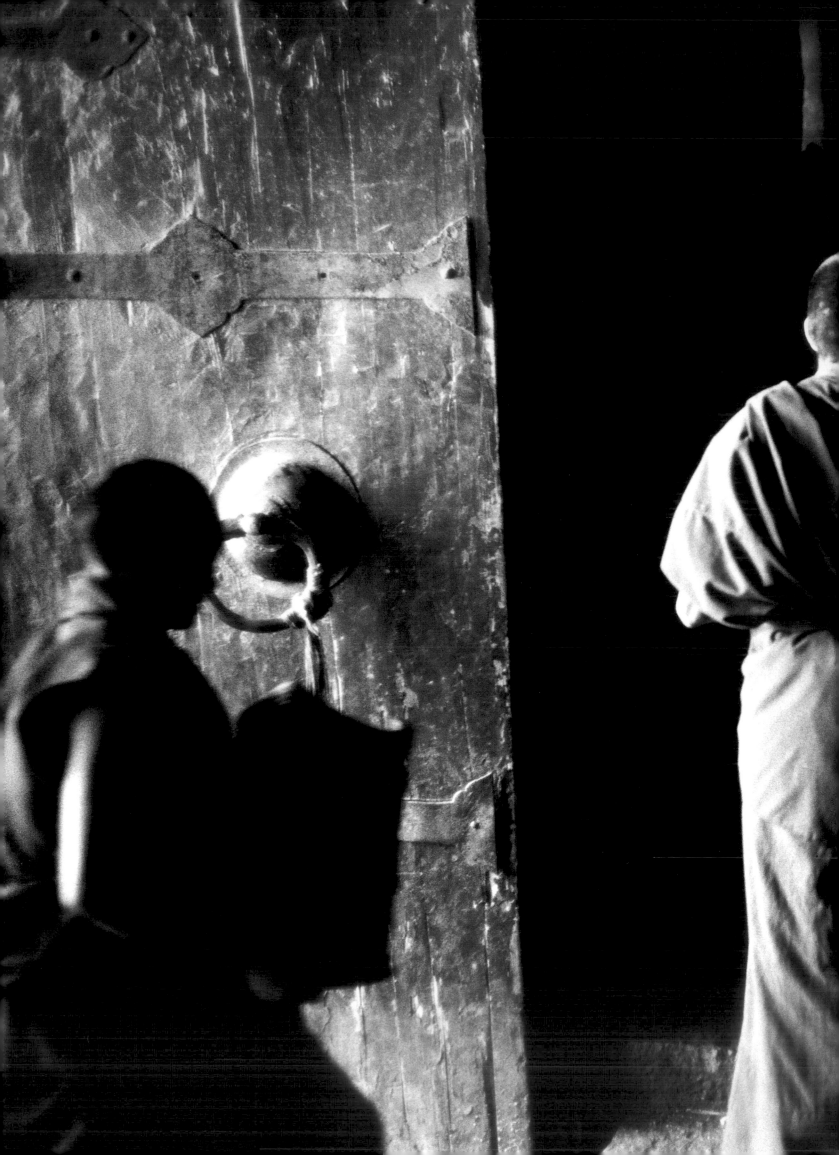

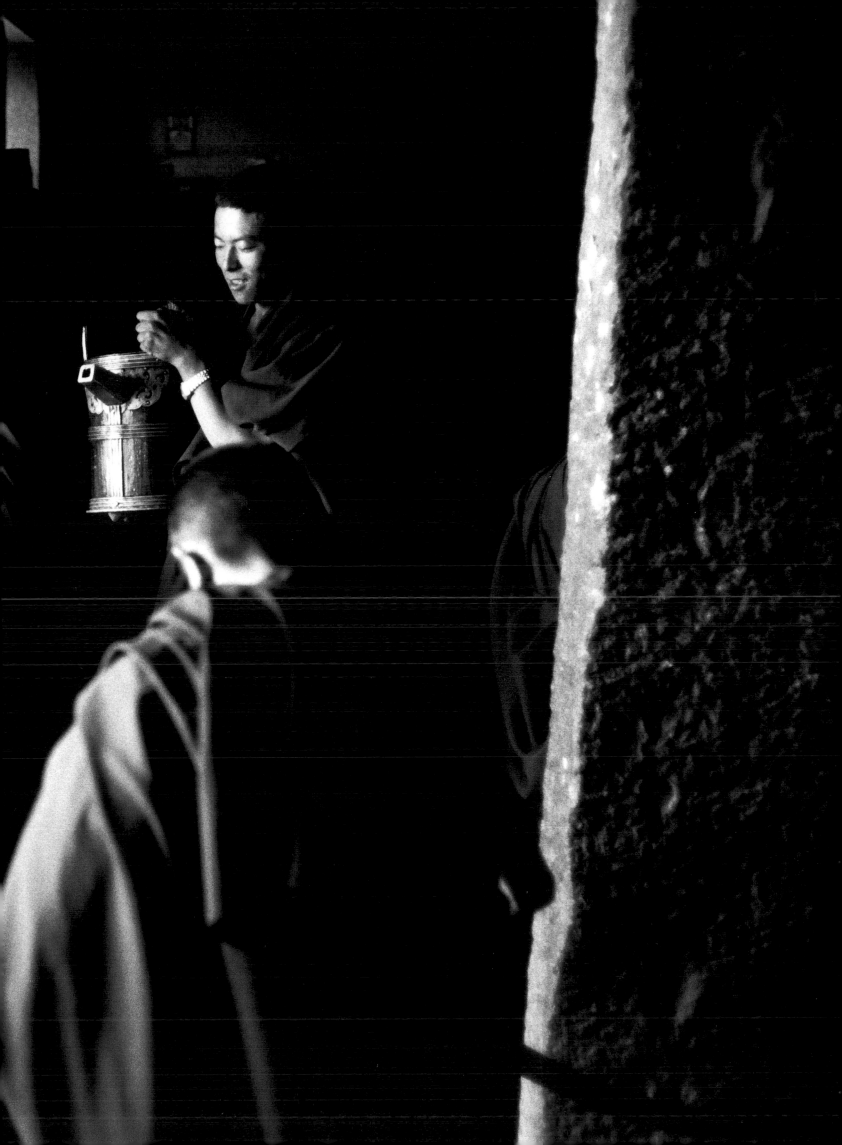

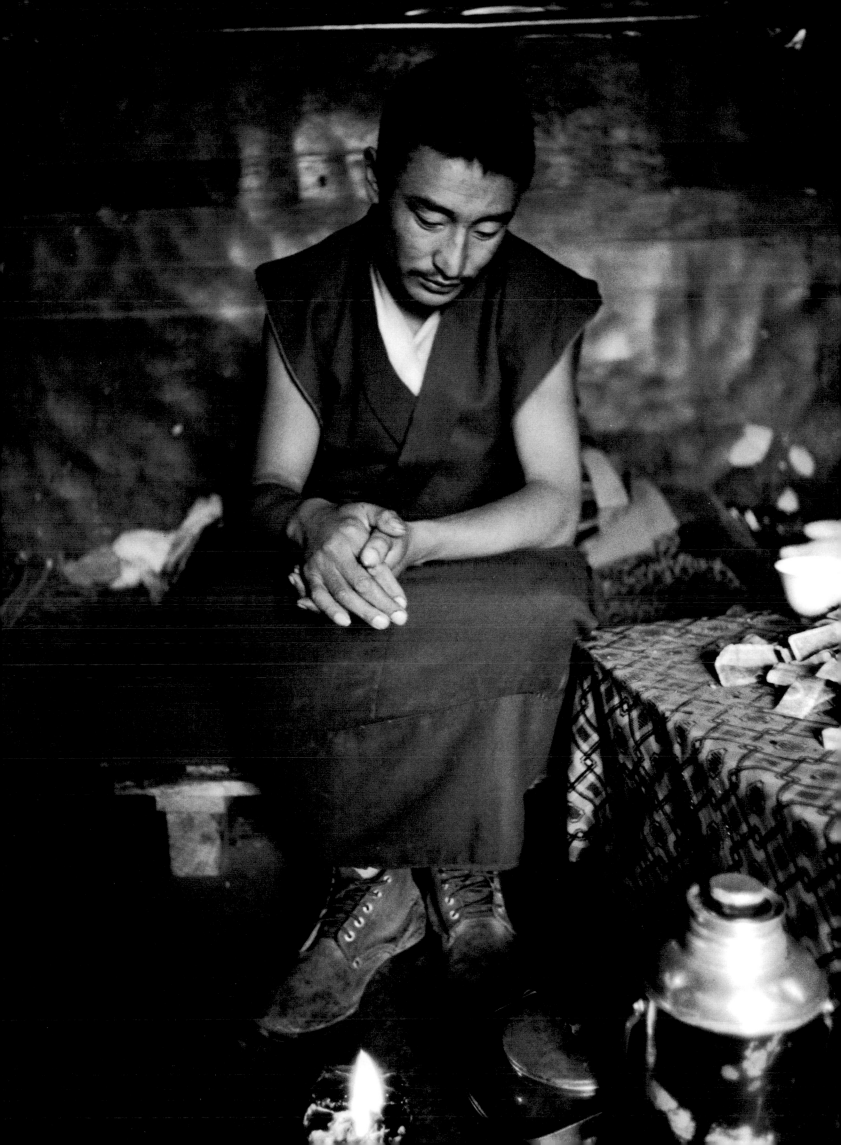

Before the Chinese invaded in 1959,
the kings of Tibet created laws for the country based
on the Buddhist concept of morality. People throughout the world
say that the Tibetan people are exceptionally
gentle and benevolent. I do not see any other reason to explain
this unique feature of our culture
than by the fact it has been based on the
Buddhist teaching of nonviolence for so many centuries.[1]
— HIS HOLINESS THE DALAI LAMA

Power grows out of the barrel of a gun.[2] — MAO ZEDONG

If a single pain
Can abolish many pains,
A loving person would feel compelled
To undergo that pain for the self and other[3]
— SHANTIDEVA (eighth century)
Teachings of Great Compassion, Tolerance,
Remedy for Anger

The holocaust that happened in
Tibet revealed Communist China
as a cruel
and inhumane executioner—more brutal
and inhumane than any other Communist
regime in the world.[4]
— ALEXANDER SOLZHENITSYN

Compassion, loving kindness,
altruism, and a sense of brotherhood
and sisterhood are the keys to human development,
not only in the future
but in the present as well.[5]
— HIS HOLINESS THE DALAI LAMA

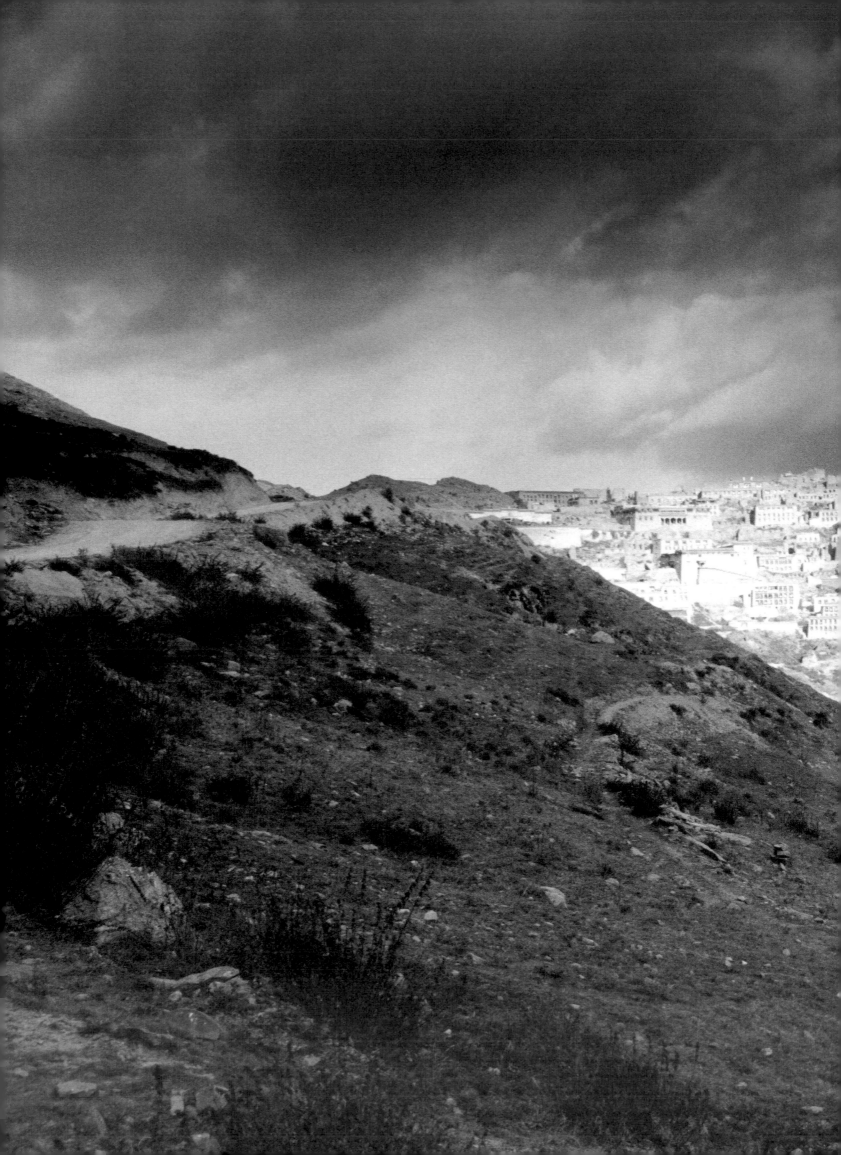

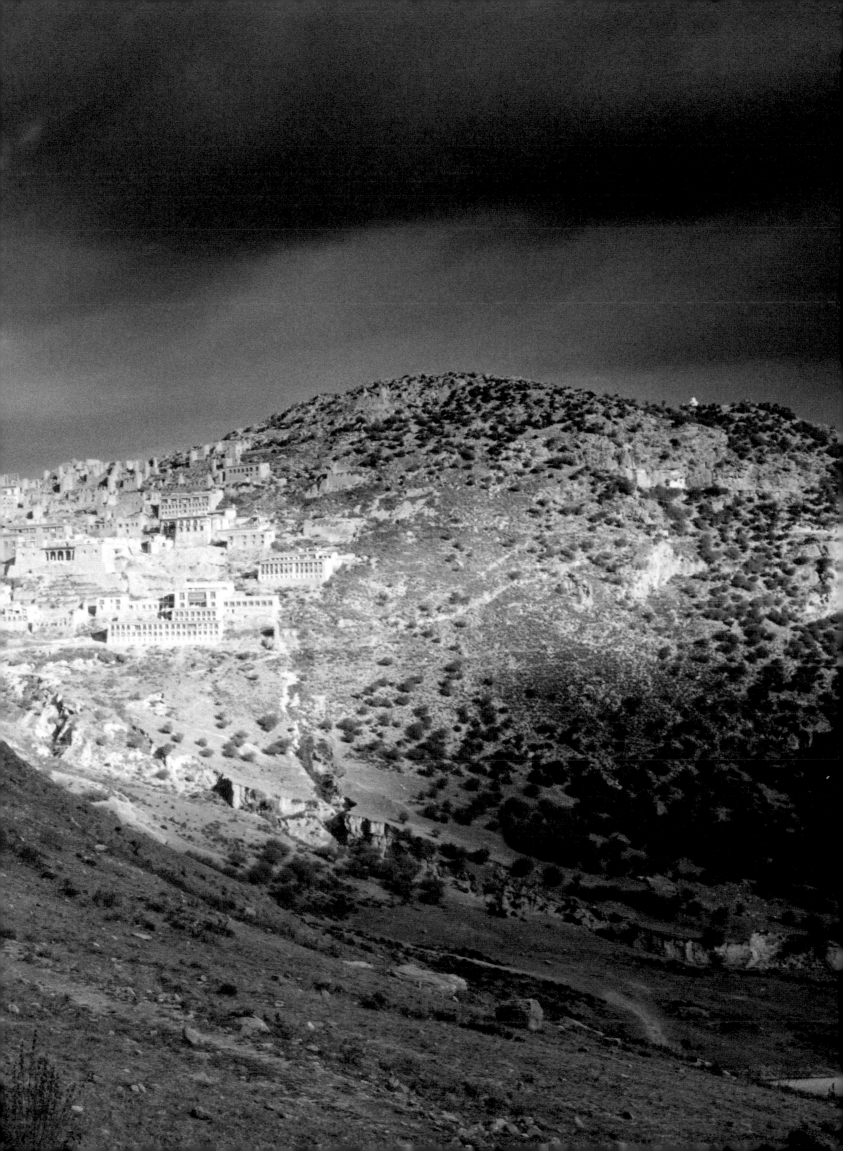

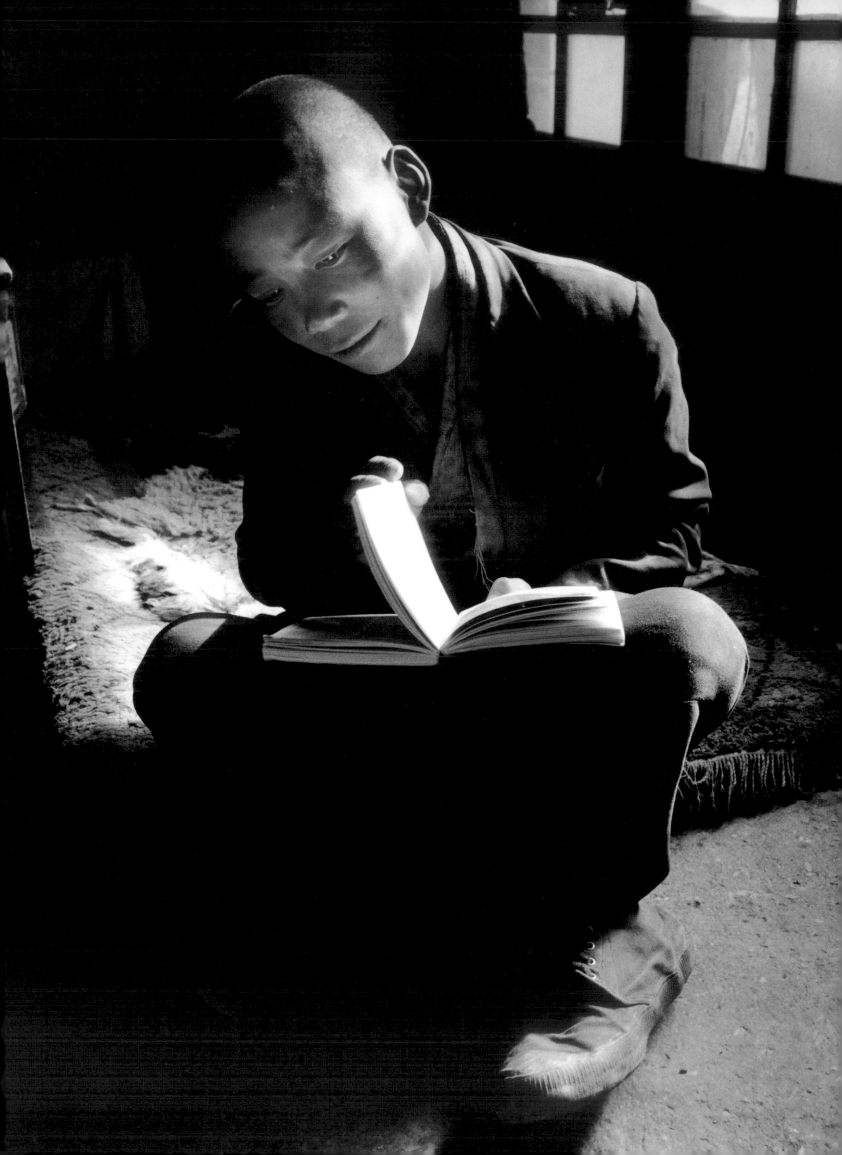

tibet

has captured the imagination of the modern world. It is a distant land that points to a time of lost innocence, a Himalayan Eden, a hidden refuge for the human spirit, which brings forth serene images of monks in beet-red robes, praying, barely visible in the low light cast by flickering butter lamps. Tibet stands as a still point in our free fall toward a shaky future. As we in the West struggle with the pace and panic of contemporary life under the greenish buzz of fluorescent tubes and the paper-thin shadow of illusionary wealth, we imagine Tibet to be like some perfectly balanced antique timepiece.

Before I traveled to Tibet I was well aware of the utopian Shangri-la myth and imagined I would see monks in red robes praying under the morning sky; high desert nomads with their luxuriant hair in 108 braids, their fur coats bejeweled with huge, chunky necklaces of coral, turquoise, and amber beads; herds of yaks and antelope running beside pale green, white-rimmed brackish lakes beneath snowcapped mountains; a riot of blue, yellow, and red prayer flags blowing and snapping wildly in a mountain blizzard. And the truth is, I found all this and more.

Certainly, Shangri-la is a seductive and pervasive myth. It is a comfort to believe that somewhere on this planet there is, or at least there once was, a place not spinning further and further, faster and faster, from the basic truths about the mysteries of life and the inevitability of death. We can only hope that a sheltered enclave still exists where philosophy, compassion, and

human dignity have not bent to the winds
of change. But the peace and beauty of
Tibet should never be viewed through the
rosy tint of exotic Shangri-la-ism. The hard-
ship and basic human survival of the
Tibetan people should not be trivialized into
a cultural cliché. In Tibet, the picturesque
must never overshadow the politics.

AFTER SPENDING much time with
Tibetans, in towns, in refugee villages, and
on the isolated Chang Tang Plateau, I have
learned that the ecological and human har-
mony taught and practiced in Tibet for
more than a thousand years is not an illu-
sion. If any people or any country is ripe for
idealization or ready to be romanticized, it
is the Tibetans and Tibet. But those same
Tibetan qualities of idealism, romance,
magic, and faith that inspire a growing fol-
lowing in the West are the very catalysts
that drive the faithless ones, the Chinese
forces, to commit inhuman acts of bar-
barism in their attempt to destroy the
Buddhist spirit of Tibet. The peaceful, non-
violent Tibetans are easy targets for the
slaughtering Chinese.

Buddhism will never be destroyed, but
Tibetan Buddhist culture might well be.
There has been a half-century agenda of
genocide against the Tibetan people orches-
trated by China that has resulted in more
than 1.2 million deaths and a campaign of
cruelty that only madmen or envoys of evil
could dream up in their darkest night-
mares. Tibet, one of the gentlest and most
passive nations on Earth, has suffered such
unthinkable violence that it must seem as
though Buddha has turned his back on this
mountain desert high in the Himalayas.

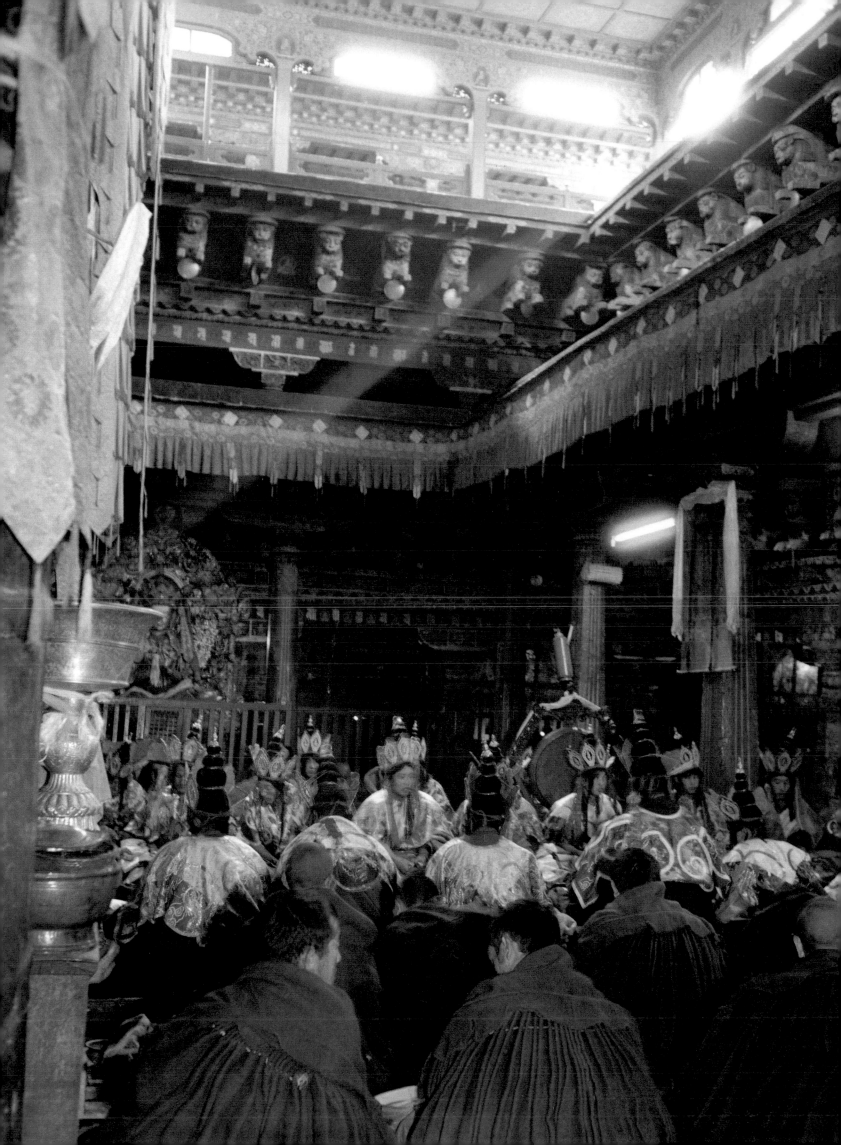

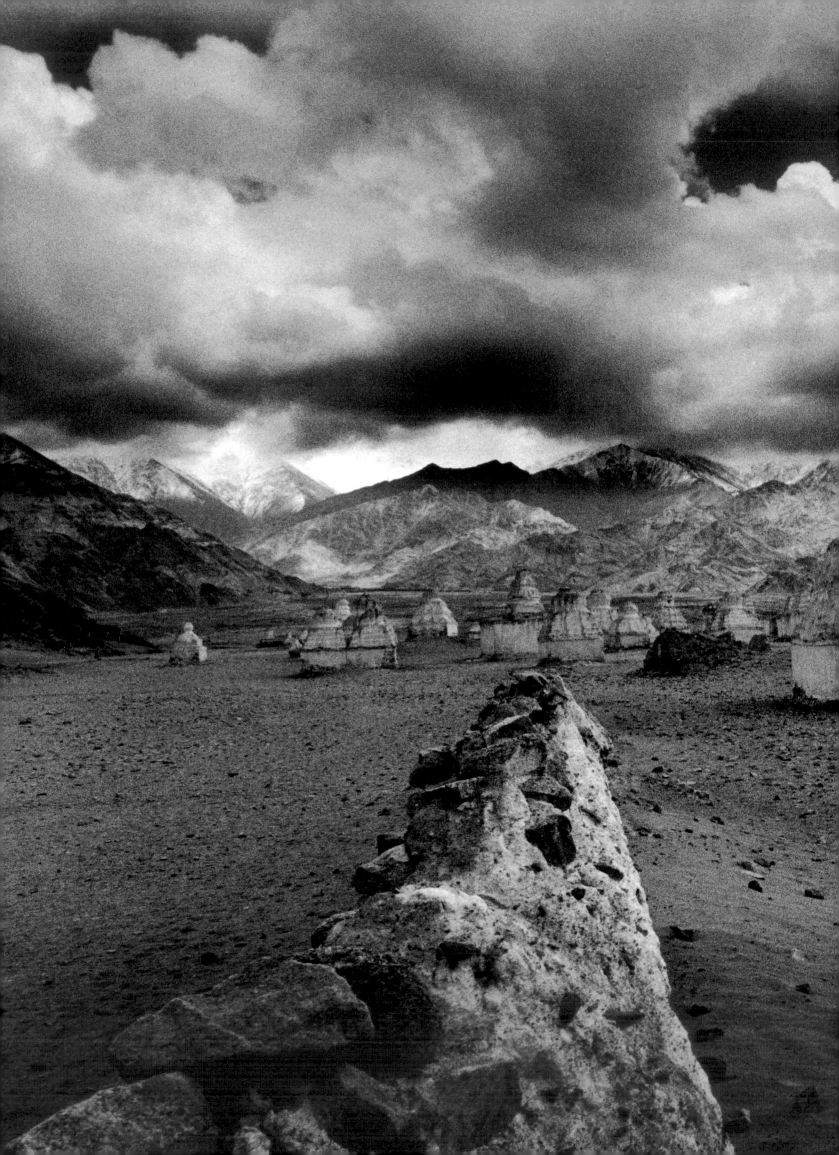

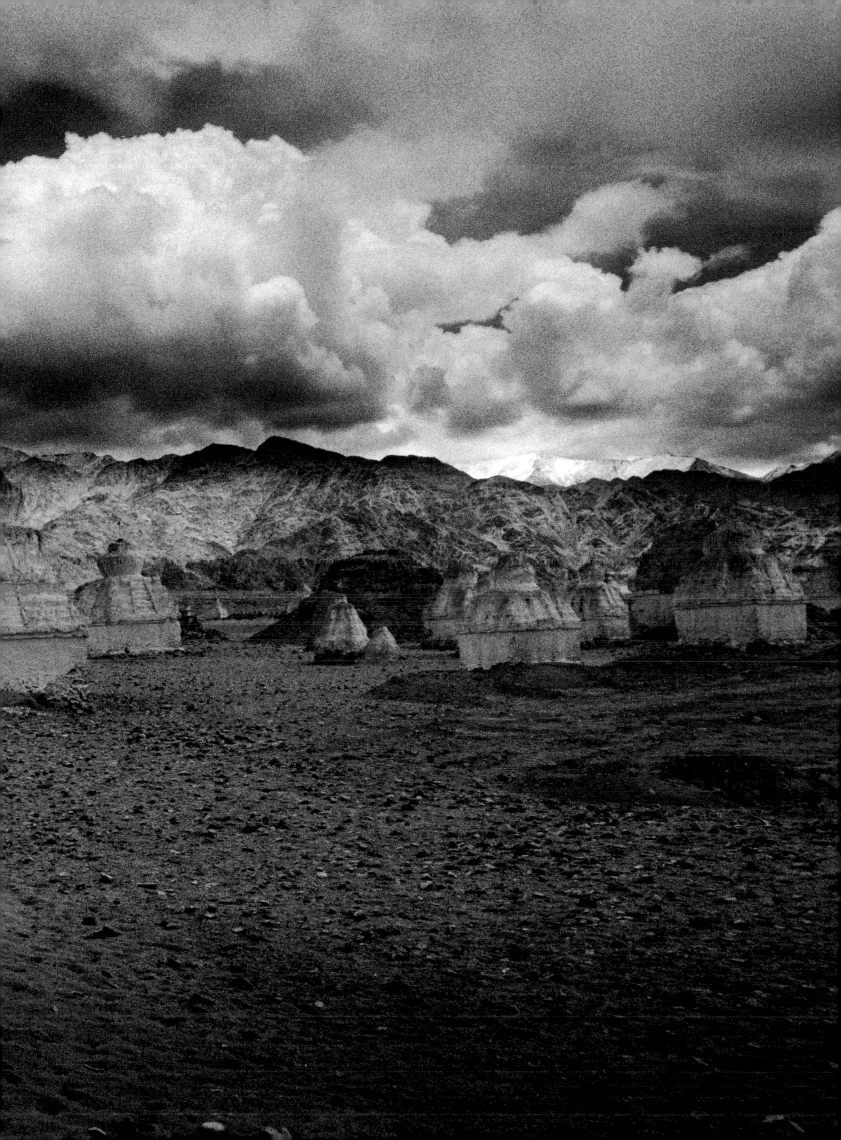

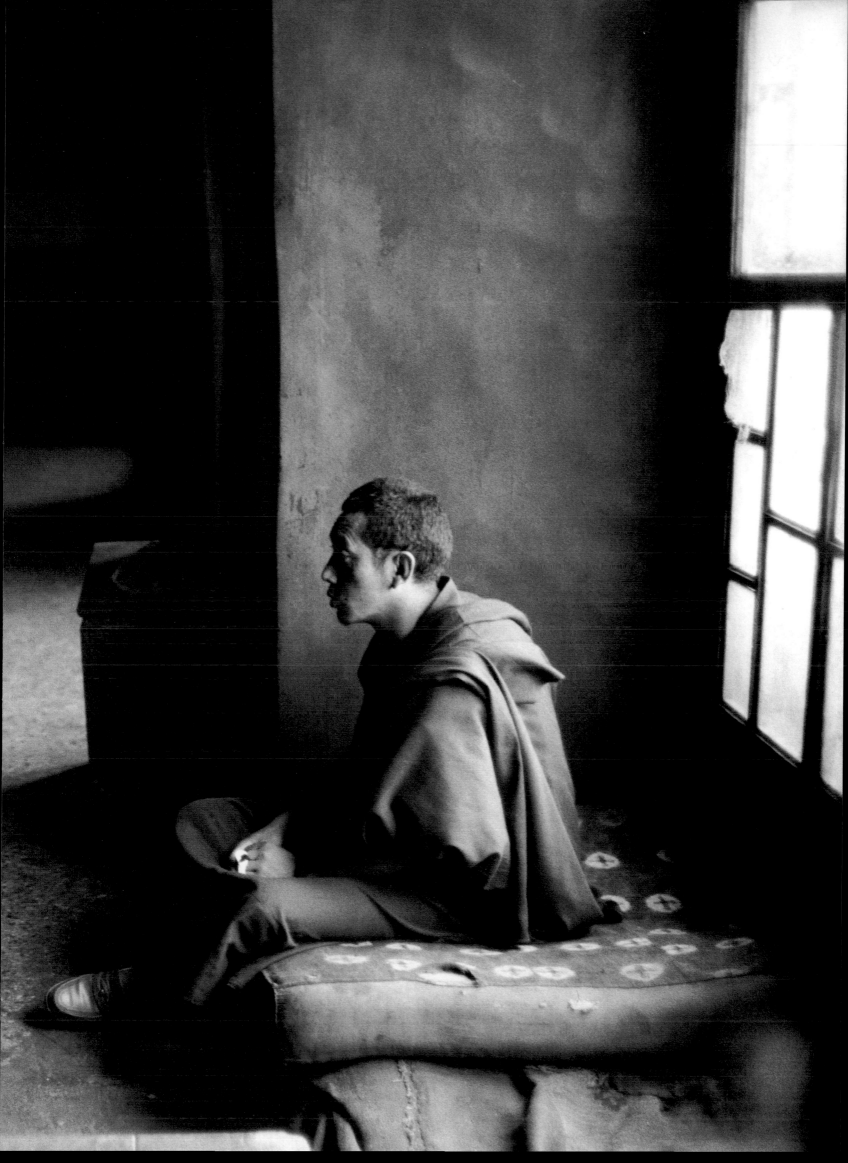

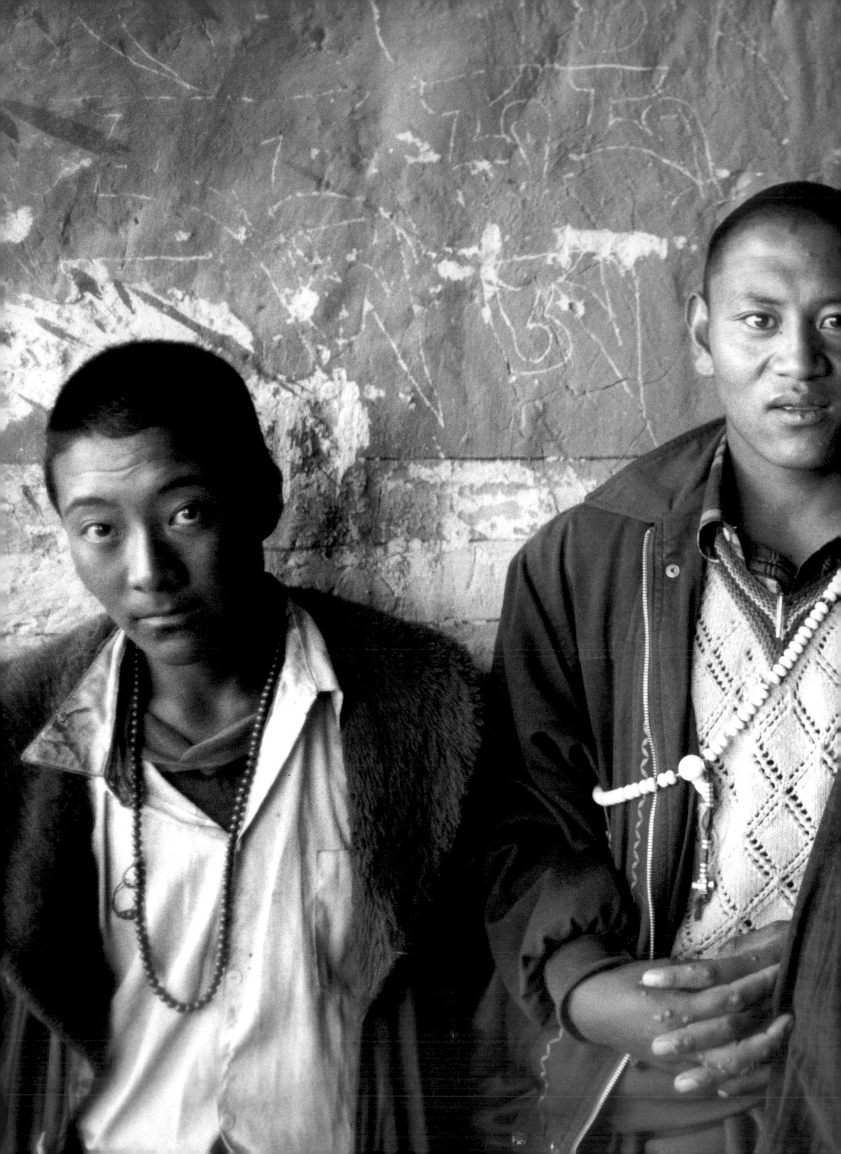

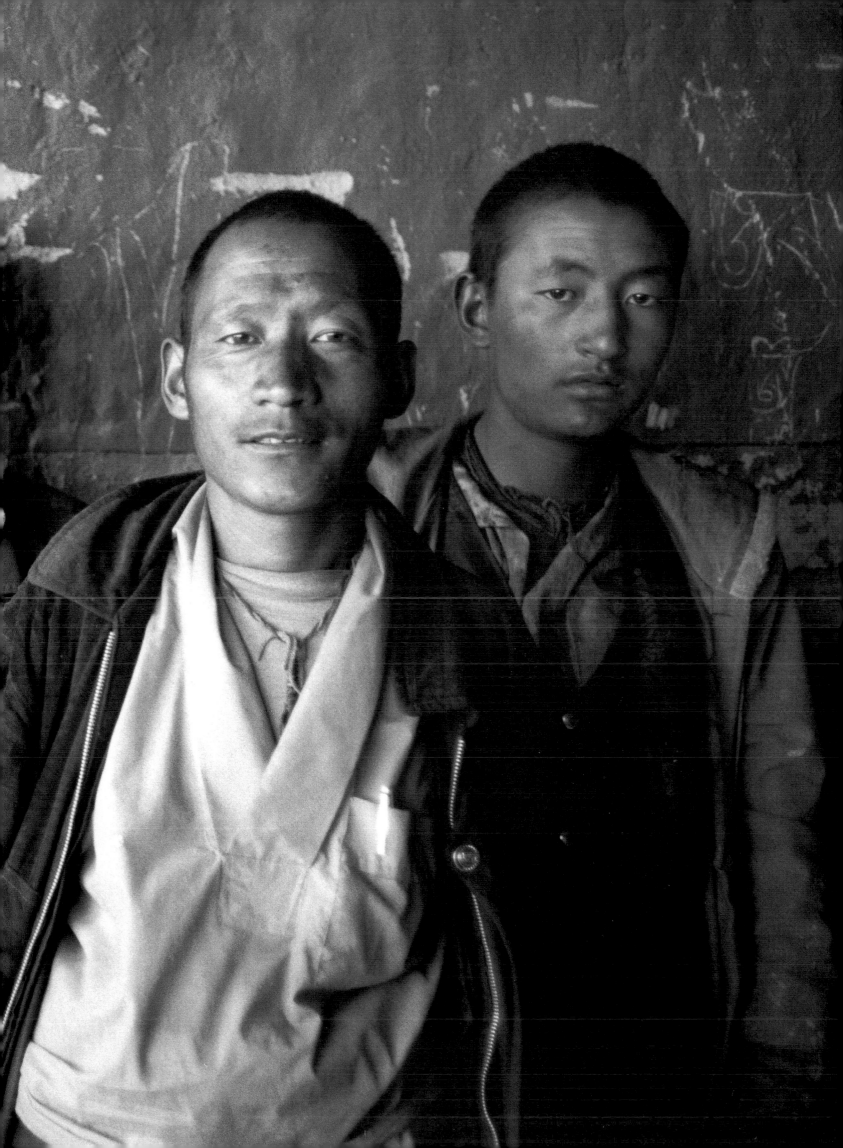

But Tibetans know better. To them the Chinese are not evil, only ignorant. Tibetans believe the Chinese cannot help but act the way they do. They are to be pitied, not hated.

His Holiness the Dalai Lama was once asked if he was not angry with the Chinese for what they are doing to Tibetans. "I sometimes feel rather irritated," he answered, "but as a practicing Buddhist, upon reflection, there are more reasons to feel concern for the one who creates the problem, who causes others to suffer. There is more reason for concern for the aggressor than for the victim. Why is this? Because the one who causes the problem sets in motion an entire karmic process, which will bring him negative consequences in the future, even if it is a very distant future, whereas the victim is already suffering the consequence of negative action in the past. For the victim, the result ends there. If I think in this manner I am able to develop true compassion for those people." [6]

How do you break the spirit of an enemy who does not hate you? You cannot. The Chinese might as well try to make the pillars of Lhasa's Jokhang temple dance.

The truth is, Tibetans live under Chinese oppression. While looking at the photographs in this book, into the faces of Tibetans with their expressions of deep human dignity, it is important not to forget that these same people live daily under a ceaseless campaign of oppression and genocide. The Tibetans' survival against decades of well-planned destruction of their very culture and spirit is the reason these photographs should be viewed in the first place. It is the reason I traveled to Tibet.

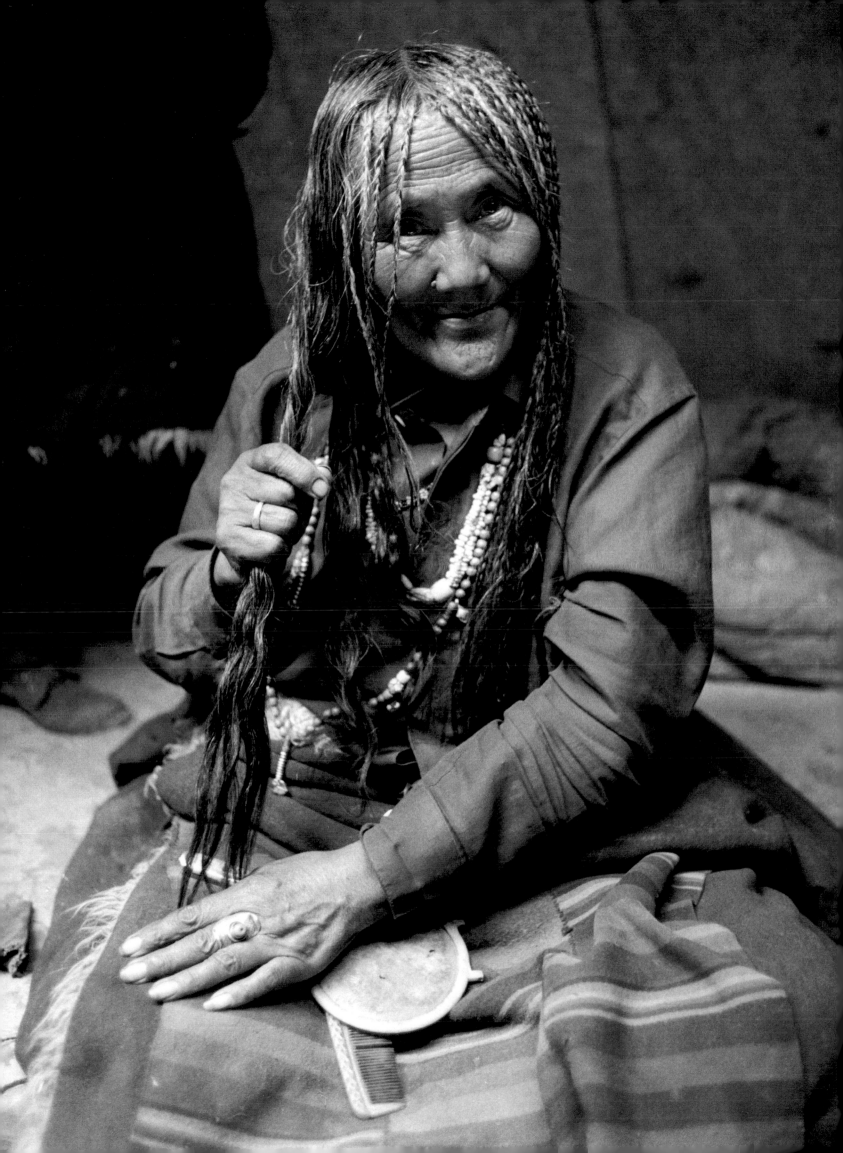

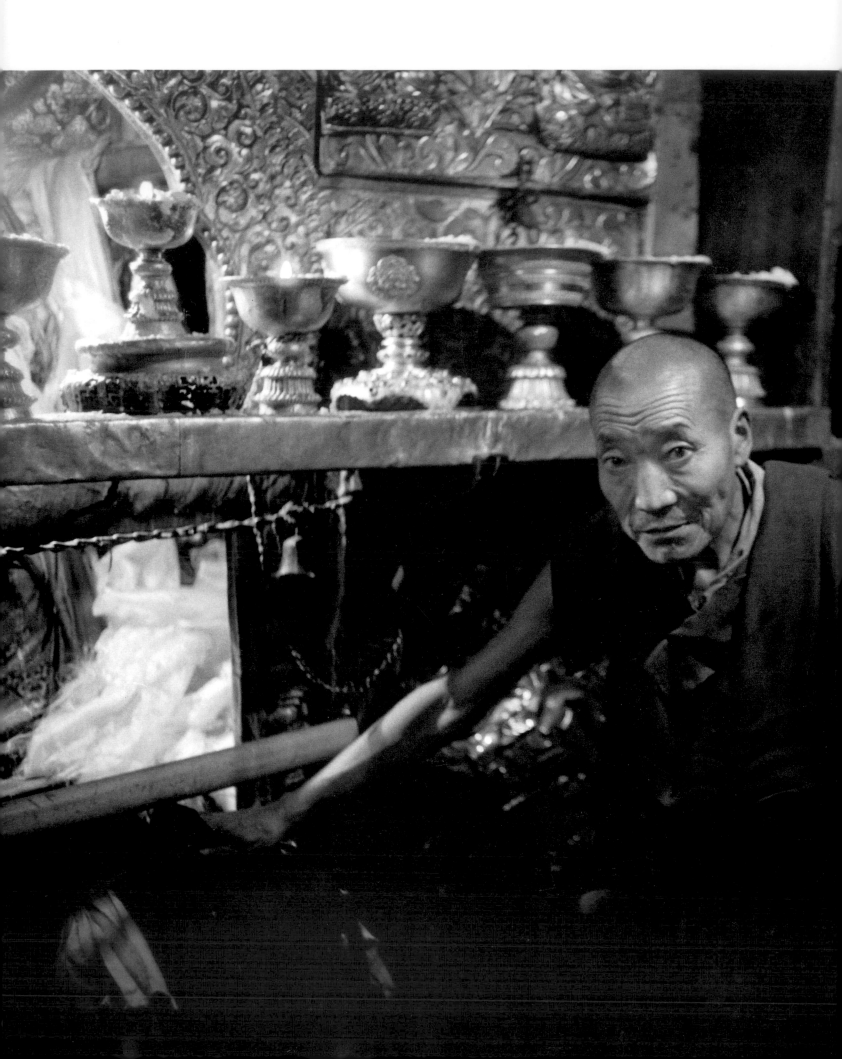

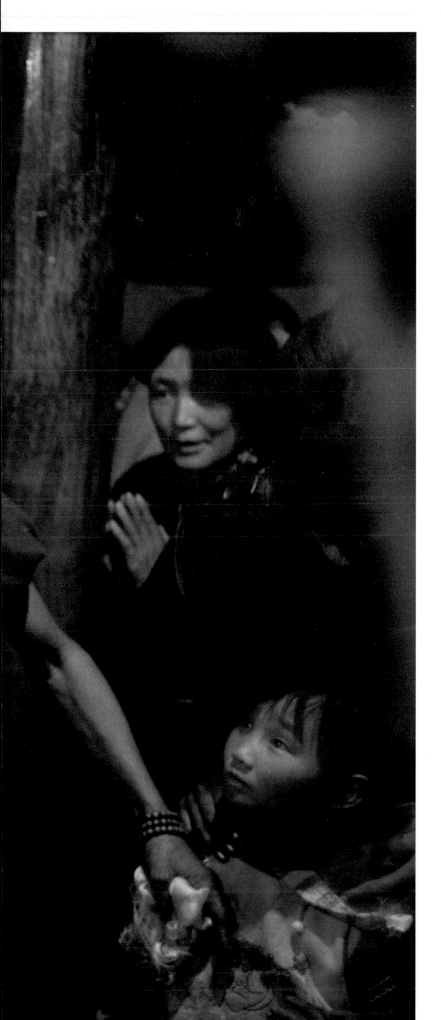

The Tibetan historian Tsering W. Shakya has studied the ways Westerners have viewed Tibet.[7] First came the missionaries who imposed their foreign ethics and beliefs on the Tibetan people in the seventeenth century. The thinking there was that Tibetans were ignorant and incapable of knowing what was best for themselves. After the missionaries, the travelers arrived. Since the nineteenth century, travelers have come to Tibet for exploration and adventure rather than to convert. To the traveler, exotica, jingoism, and machismo were the rules at hand. This viewpoint was well expressed in Heinrich Harrer's book *Seven Years in Tibet*, in which he saw Tibetans as "happy little people full of childish humour."[8] For many travelers, it was about the "otherness" of the Tibetans: an undiscovered primitive sense of mystery, barbarism, and sacredness. Then came the diplomatic, or good old boys', concept of Tibet as a country of strategic importance — exemplified by the British invasion of 1903. For Britain, Tibet was an uncivilized place in which to find horses for the Indian army, as well as a new market for Indian tea. Still today, many journalists view Tibet as medieval, as an archaism in the twentieth century where a cruel modernity, courtesy of the Chinese, may save Tibet from dragging its prayer wheels into the next millennium. And, of course, human rights and progress can never share the same seat on the economic express.

Recently Tibet has begun to enter mainstream consciousness in the West through New Age spiritualism and pop culture. Many contemporary celebrities have embraced the cause of Tibet. Poets and per-

formers such as Patti Smith and David Bowie have written songs about Tibet. Movies of Harrer's *Seven Years in Tibet* and Melissa Mathison and Martin Scorsese's *Kundun*, the story of the present Dalai Lama's family, have done much to bring an awareness of Tibetan culture to Westerners. The composer Philip Glass's use of Tibetan musicians in his sound track for the film *Kundun*, and their appearance in his subsequent performance at New York's Lincoln Center, furthers the popular understanding of Tibetan culture. In Washington, the actor Richard Gere appeared at the International Campaign for Tibet's "Stateless Dinner," which took place at the same time that Chinese President Jiang Zemin was being feted with a State Dinner at the White House. Gere also appeared on *Larry King Live* with the Dalai Lama, himself now a popular culture icon. And *The New York Times* ran a feature entitled "The Hollywood Love Affair with Tibet: How One Fantasy Land Holds Onto the Heart of Another," in which it quoted Robert A. F. Thurman, a Columbia University scholar, as saying that "the Tibetans are now the baby seals of the human rights movement."[9]

Of course the popularization of Tibetan Buddhist culture has had its fair share of skepticism. One of the more outspoken skeptics is Orville Schell, a journalist specializing in China-Tibet relations, who bluntly says, "The idea is that even the materialist West will be saved by the spiritualism of the Tibetan Buddhists. It is total nonsense." Schell, like many Westerners, is cautious about the current adoption of Eastern spirituality. What is viewed in one culture as faith can be seen by

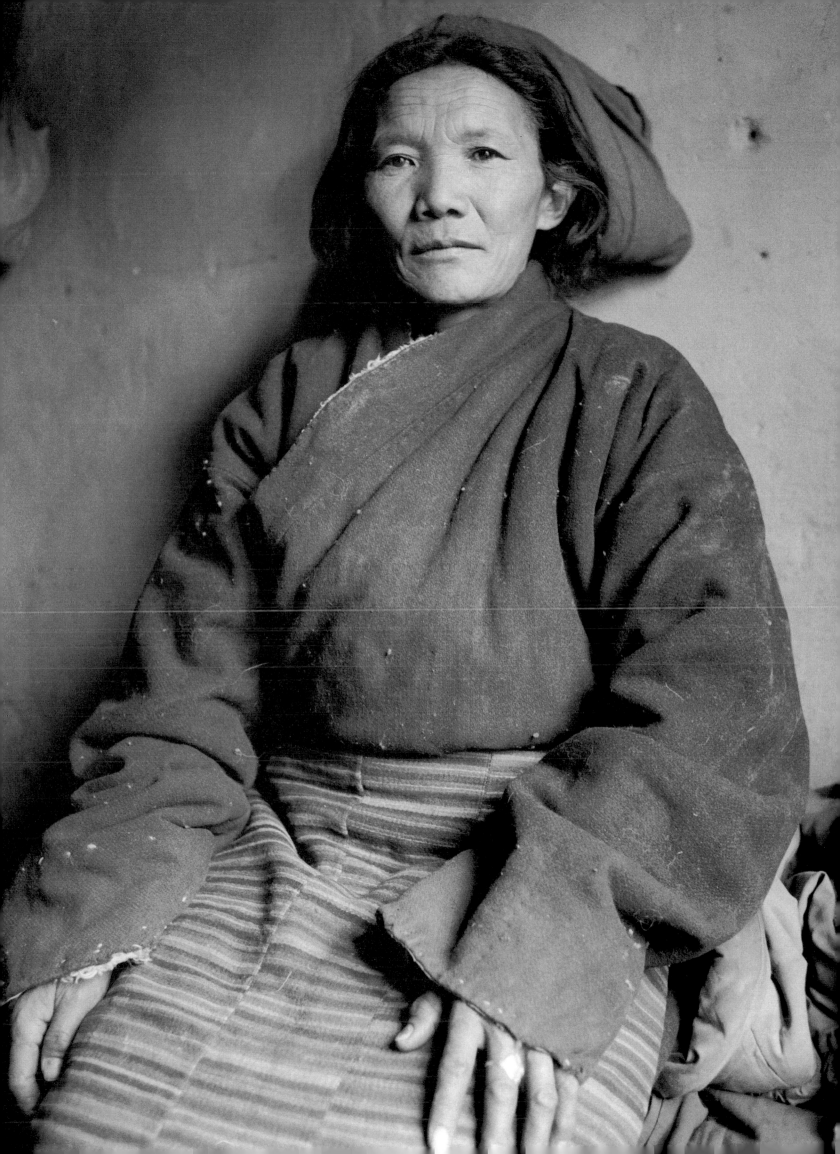

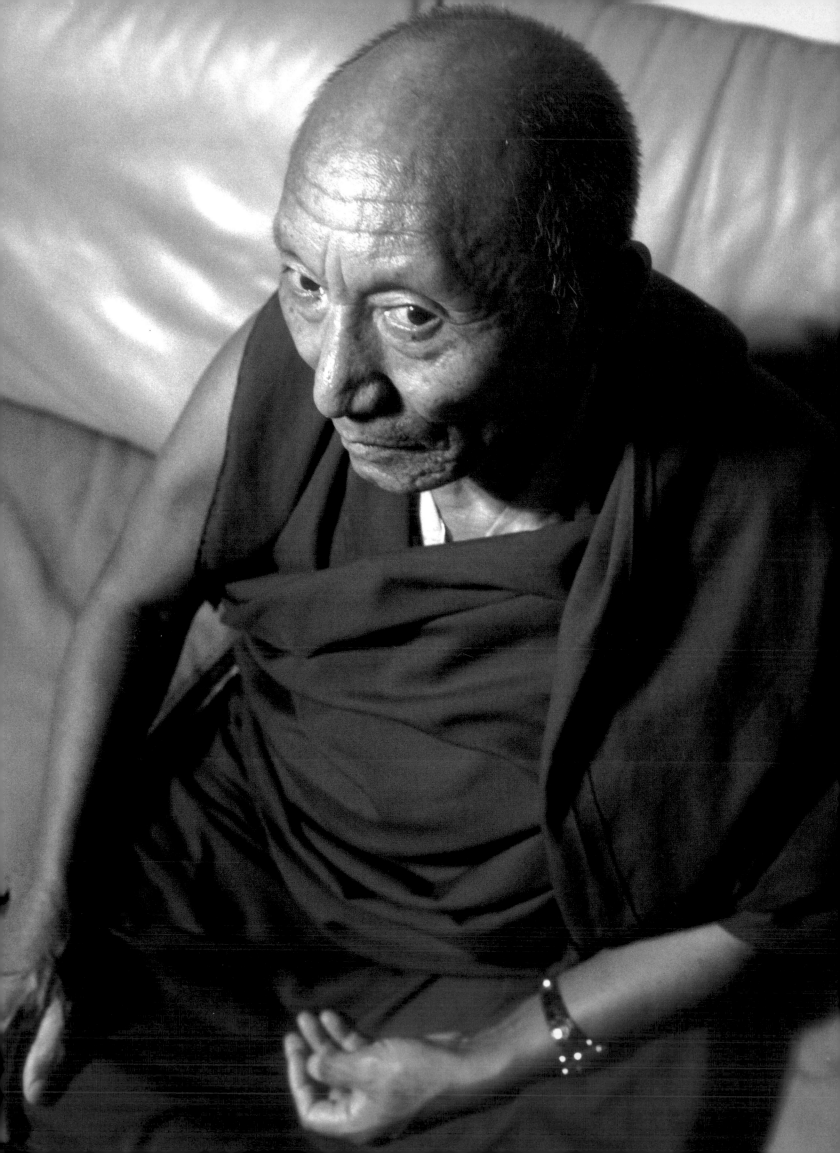

another as fad or fashion. Yet as with any true faith, be it Buddhism, Judaism, Islam or Christianity, belief does not miraculously fall into a person's lap or soul. It takes years of training and awareness. If a fad, Tibetan Buddhism has been in fashion for more than a thousand years.[10]

TIBETAN BUDDHISM is a living culture, but it is threatened with becoming extremely rare, a museum piece. Chinese forces have not only bombed and dynamited more than sixty-two hundred monasteries; they have also tried to destroy the minds and hearts of the Tibetan people by cutting them off from their faith. I met two Tibetans, Palden Gyatso and Ama Adhe, who had spent decades in Chinese prisons. Between them, they had been in Chinese labor camps for sixty years. These two survivors bore witness to what Tibet experienced during Mao Zedong's Cultural Revolution. It was humbling to shake Ama Adhe's hands, knowing that the Chinese had "inserted fine bamboo all the way under [her] second fingernail until the skin below the nail was broken at the base of the first joint."[11] Palden Gyatso showed me the kind of electric cattle prod that was forced into his mouth until his teeth loosened in his skull and his sense of taste was permanently destroyed. When I heard Gyatso's and Adhe's accounts of their torture, rape, humiliation, and suffering, I hoped that my photographs would speak of a living culture, despite the death and destruction tearing at its soul.

It is not my place to tell the story of the suffering endured by Tibetans since the

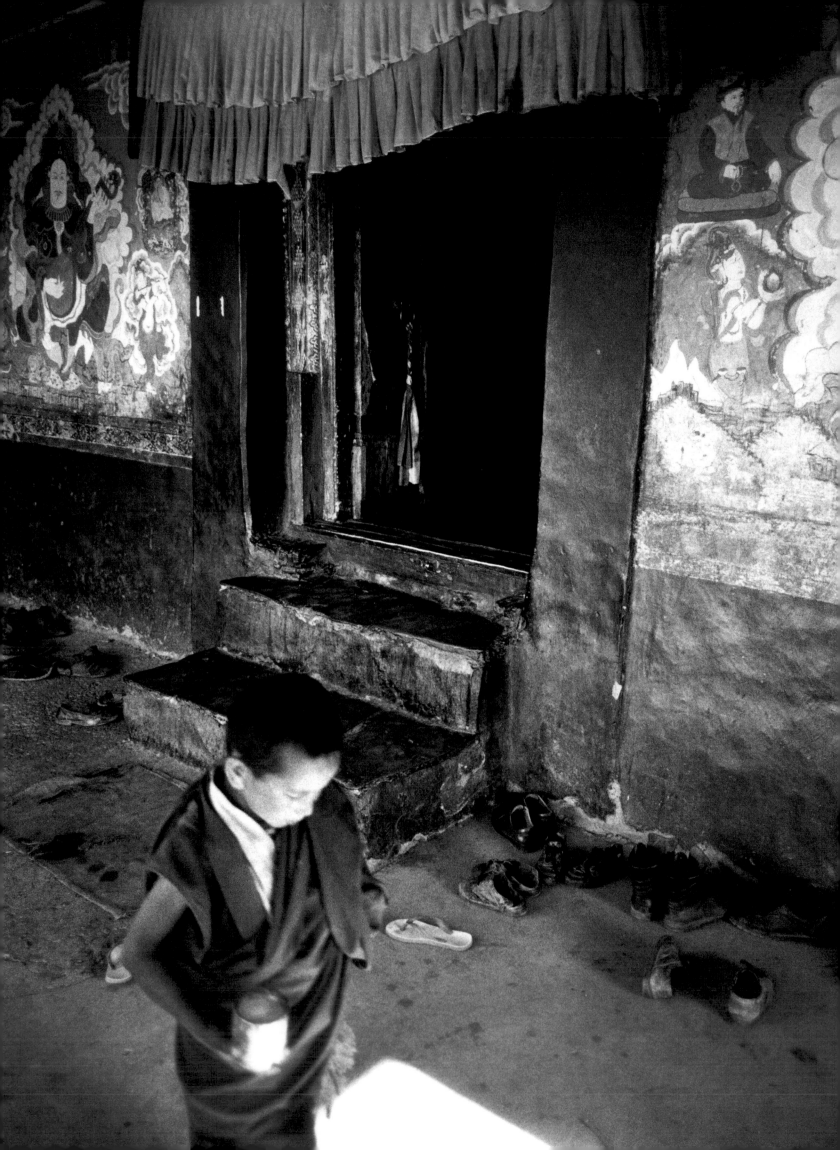

Chinese occupation. Writers such as His Holiness the Dalai Lama,[12] John F. Avedon,[13] Mary Craig,[14] Warren W. Smith, Jr.,[15] Dawa Norbu,[16] Palden Gyatso,[17] and Ama Tapontsang[18] have documented the horrors of China's inhumanity in Tibet with chilling eloquence. Yet I am pleased that my photographs have been used to raise awareness of Tibet's struggle for self-determination and human rights. The International Committee of Lawyers for Tibet (ICLT)[19] has reproduced my photographs in its publications on human rights abuses in Tibet. The ICLT recorded that "today . . . there are 1,042 known Tibetan prisoners of conscience, including 51 children. . . . According to the Tibet Information Network and Human Rights Watch/Asia, the use of torture is common in Tibet prisons. Methods of torture include: shocking with electric cattle batons; beating with bars and sticks; branding with red-hot shovels; scalding with boiling water; hanging upside down or by the thumbs; kicking with boots; attacking with dogs; exposing to extreme temperatures; depriving of sleep, food and water; forced strenuous 'exercise'; solitary confinement; sexual violence; threats of torture and death."[20]

One of the most shocking aspects of the Chinese occupation is the forced sterilization of Tibetan women. In an article on this subject, the ICLT used my photograph of a nomadic woman with her herd of goats in the Ngari region of western Tibet. In many ways this is one of the more idyllic photographs I have taken. It is a wonderfully warm image that captures the woman in the late-day sun while in the

distance yak-hair tents are scattered across a dramatic Tibetan landscape. The accompanying text shatters Shangri-la like a bullet through a stained-glass window: "Gross violations of women's reproductive freedom are not uncommon in Tibet. Some of the most disturbing reports are of 'blitz' campaigns of mobile family planning teams, which have gone into remote villages of Tibet and carried out forced abortions and sterilizations of virtually every woman of child bearing age, regardless of the number of children, age, or health. These barbaric practices, says the Chinese Centre for Human Rights and Democracy in Dharamsala, 'constitute an immediate threat to the survival of Tibetans as a distinct people.'"[21]

For many years, Chinese government policies have been aimed at reducing the Tibetan population. After all, it was Mao's intention to bring in four Chinese settlers for every Tibetan.[22] Now, though, cultural suffocation is not enough. The government intends to "improve national qualities" and weed out "births of inferior qualities."[23] These are brutal facts, and I do not want my photographs to lie or hide the truth behind the picturesque.

Howard Chapnick, author of *Truth Needs No Ally*, has written "Photojournalism is rooted in the consciousness and consciences of its practitioners. The torch of concern, a heritage of humanistic photography, has been passed from generation to generation, lighting the corners of darkness, exposing ignorance, and helping us to understand human behavior. It bares the truth and sometimes it lies. It informs, educates, and enlightens us about the present, and it illuminates the past."[24] I could not agree more.

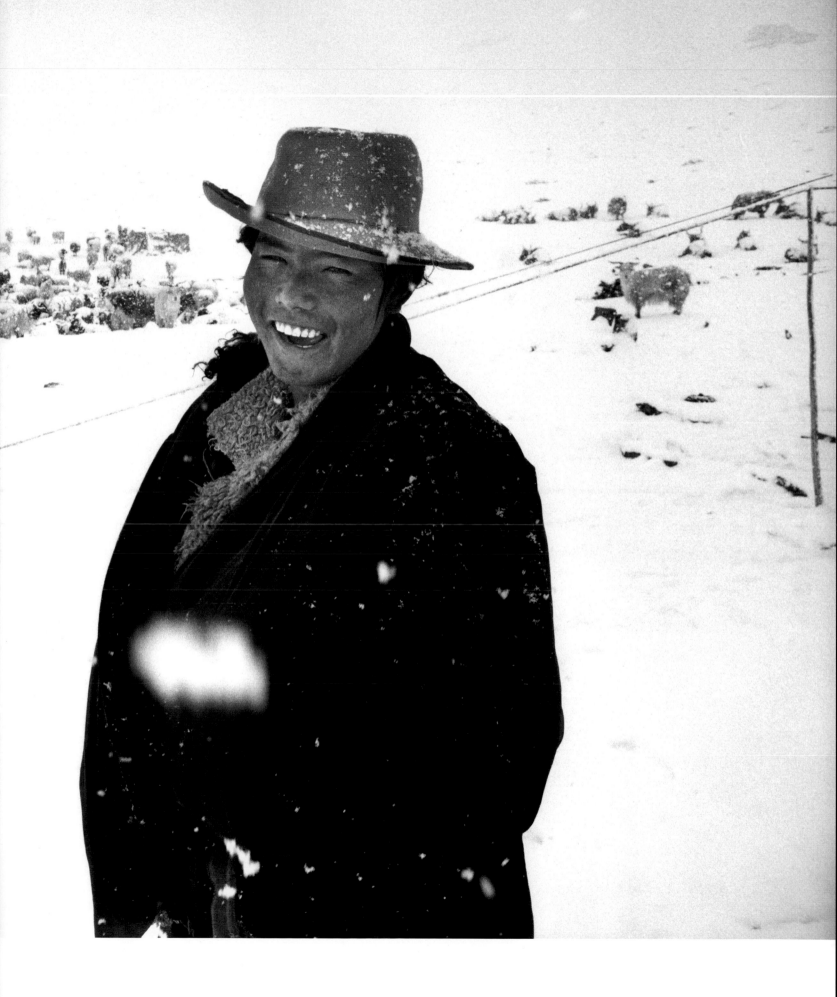

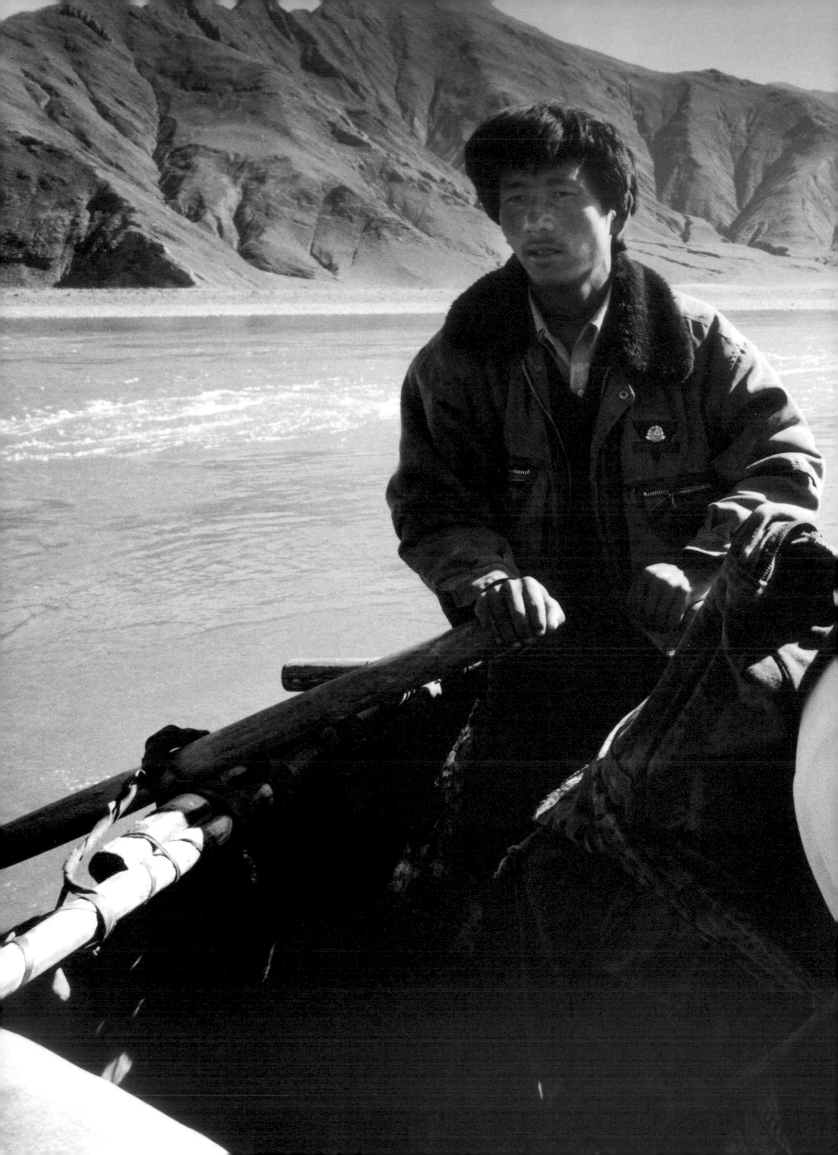

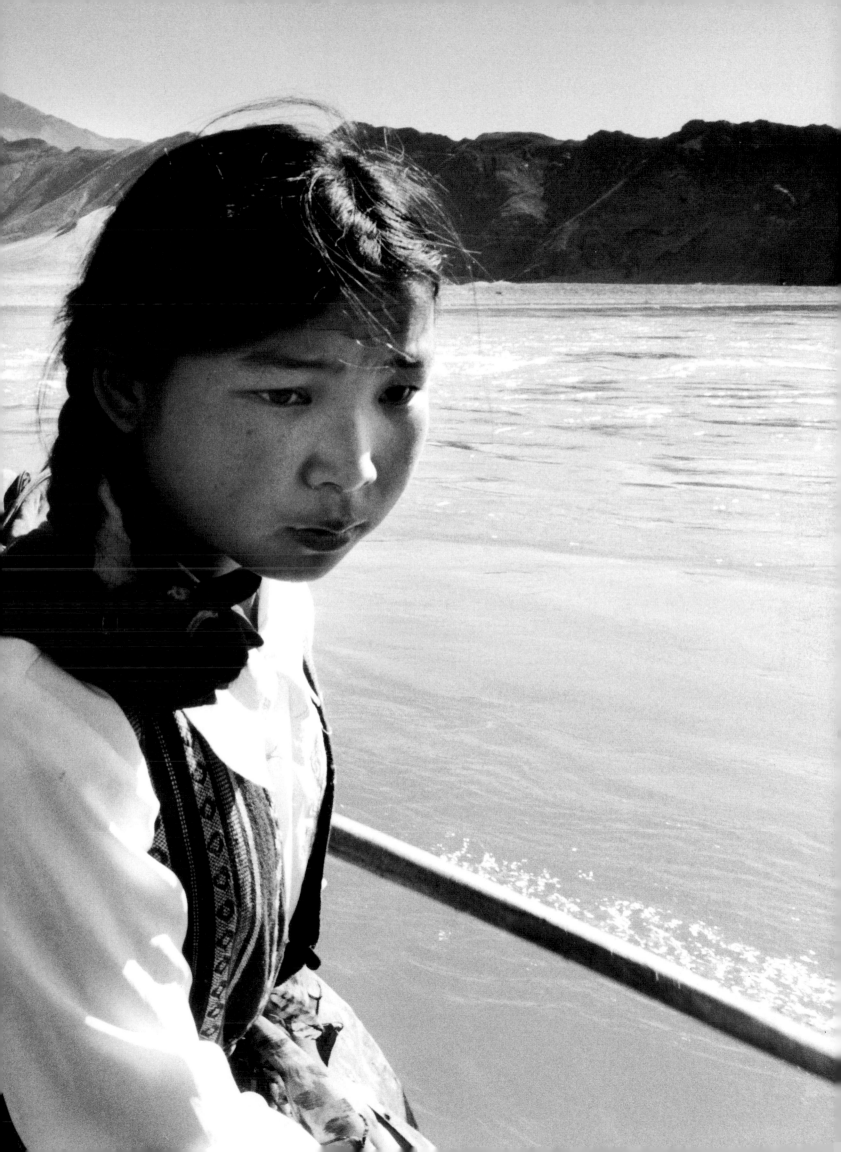

His

Holiness the Dalai Lama once suggested that the world should spend less time trying to understand outer space; rather, we should look to inner space. In Tibet, inner space is not only the meditative Buddhist mind; it is also the sacred, candlelit interiors of the temples.

Tibetan light has its extremes. High in the Himalayas there is a clear distinction between inner and outer, or sacred and natural, light. The outer light of this country, the highest on Earth, is so harsh that nomads who fall asleep while tending their herds, with their heads in the sun and their feet in the shade, have been known to awaken with burned noses and frostbitten toes. As extreme as this may sound, the one day I forgot to protect the backs of my hands from the Tibetan sun, the next morning they were charred with blackened flakes of solar-fried skin, shedding snakelike from my fingers. The light cast by this sun is a brittle, diamond-white light. Even the distant snowcapped peaks are knife-edge sharp, as if an arm's length away. Tibet's light cuts through the thin mountain air in the most acidic way and bites hard into your eyes.

Late in the day and early in the morning, when the sun is low and rakes across the barren landscape, sight is reduced to a tight-eyed squint. The nomads of the Chang Tang Plateau face this light every day. When I traveled to many of their tent encampments, I saw the damage that a life in the Tibetan sun could bring. Many men and women in their forties and fifties

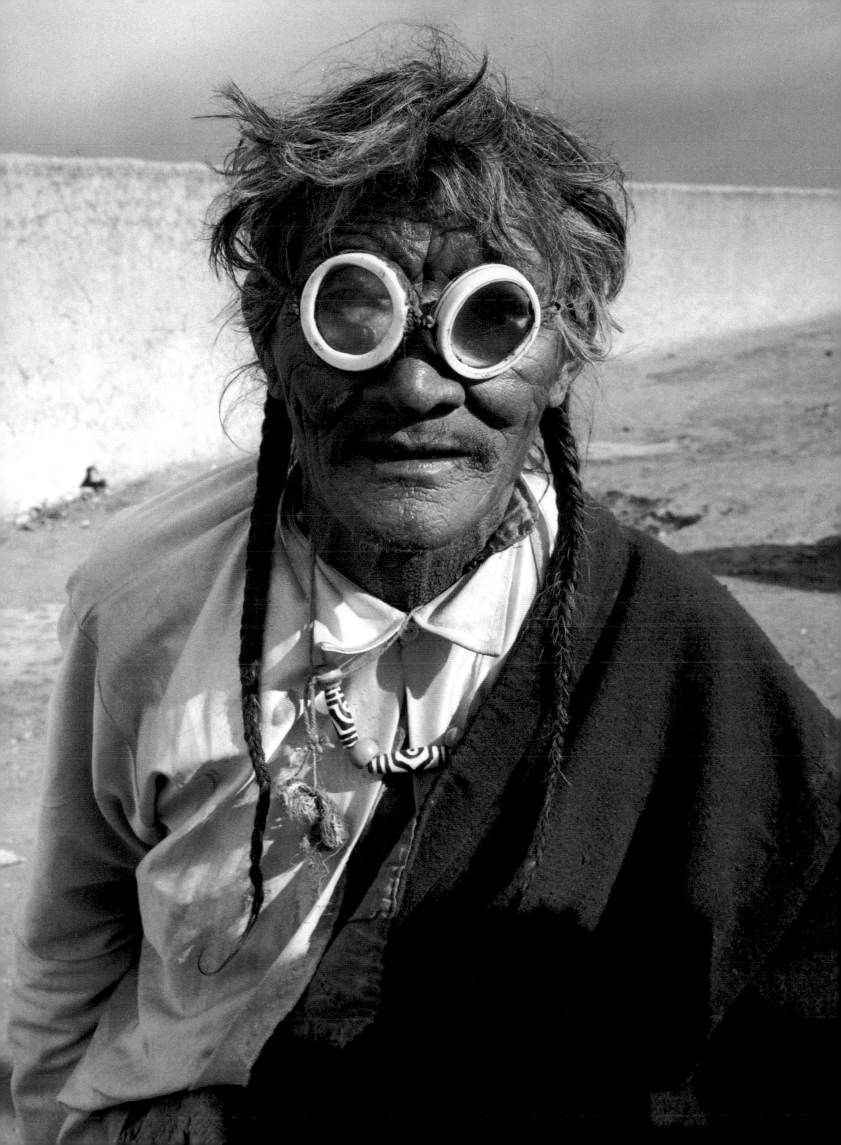

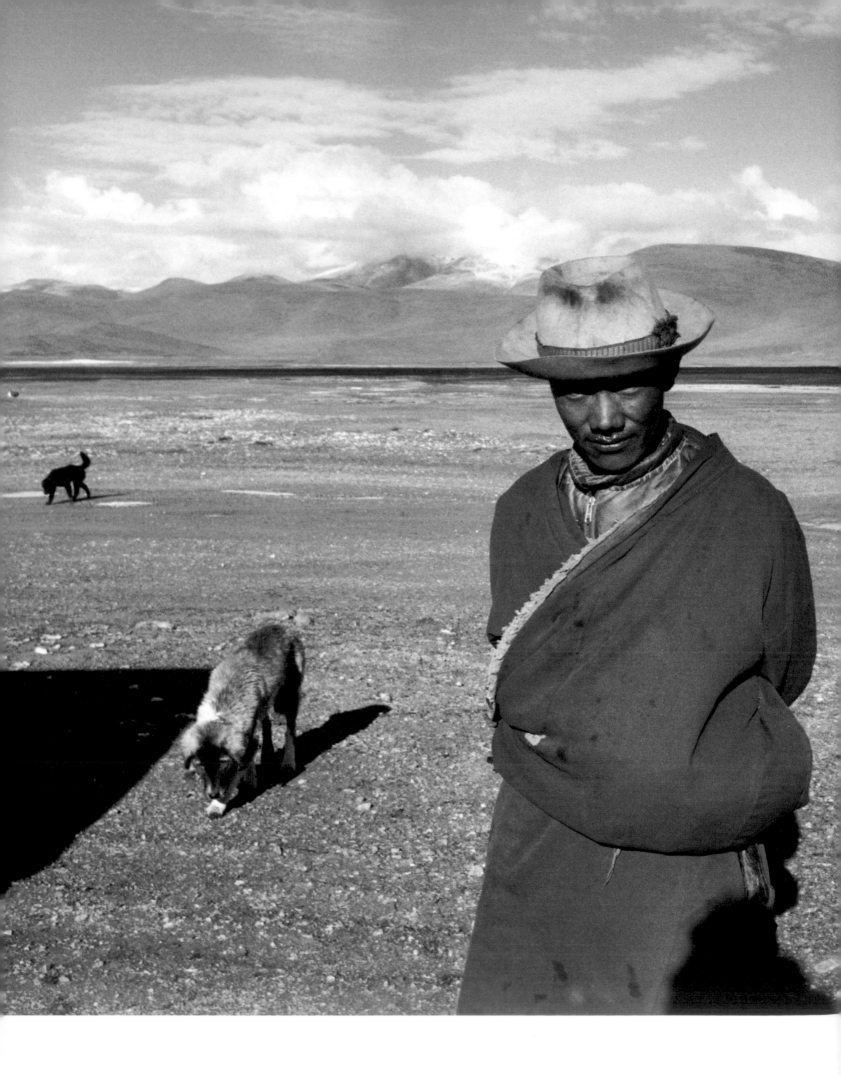

had their eyes ruined by the unsheltering high-altitude atmosphere that does nothing to stop the ultraviolet rays. Eyes literally dry up in people's skulls from the relentless 3,400 hours of sunlight per year.

IN OCTOBER 1998, a vicious early blizzard hit the Tibetan nomadic communities on the Chang Tang Plateau in Ladakh, India. This snowfall could not have come at a worse time, because the nomadic families were heading for their winter pastures. Such a blizzard left them stranded with little food and fuel. I had visited several families in the hardest-hit areas of Sumhdo and Samed in southern Ladakh. As many as three thousand nomads along with their animals were affected by this brutal snowfall. Hundreds of families went missing and many of those nomads who survived suffered from another common Tibetan eye problem: snow blindness.

The landscape of the Chang Tang Plateau is so harsh that the Tibetans themselves refer to this desolate plain that runs across Tibet into northern India as "the land of no man and no dog." Because winter is three quarters of the year, nothing grows in the Chang Tang's frozen soil. Nomads are forced to exist totally on what their herds can provide, meat and milk. Many Westerners are puzzled, because these Buddhist nomads are not vegetarians. But for Tibetans, vegetarianism has never been an option.

I remember, on my way south to Mount Kailash, stopping at a nomadic camp between Ali and Toling in the far west of Tibet near India's border. I wanted to boil some water for tea and noodles. There

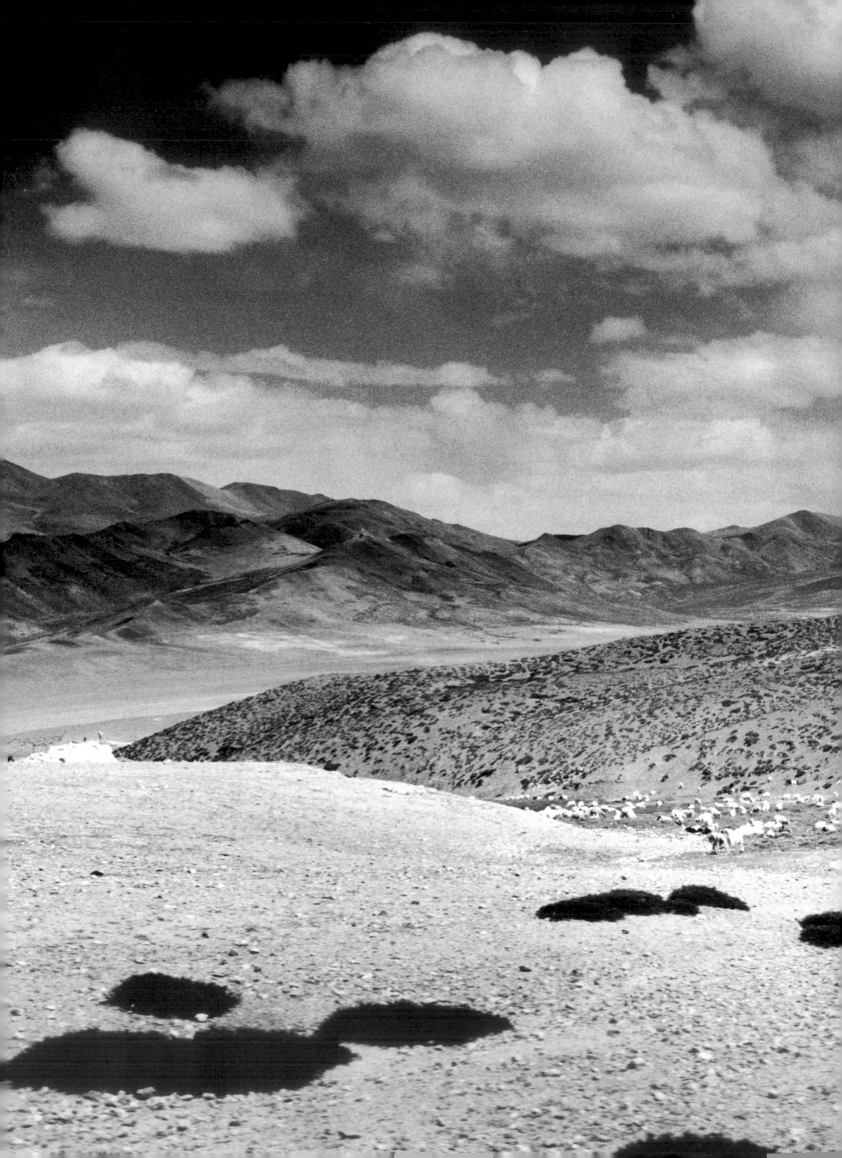

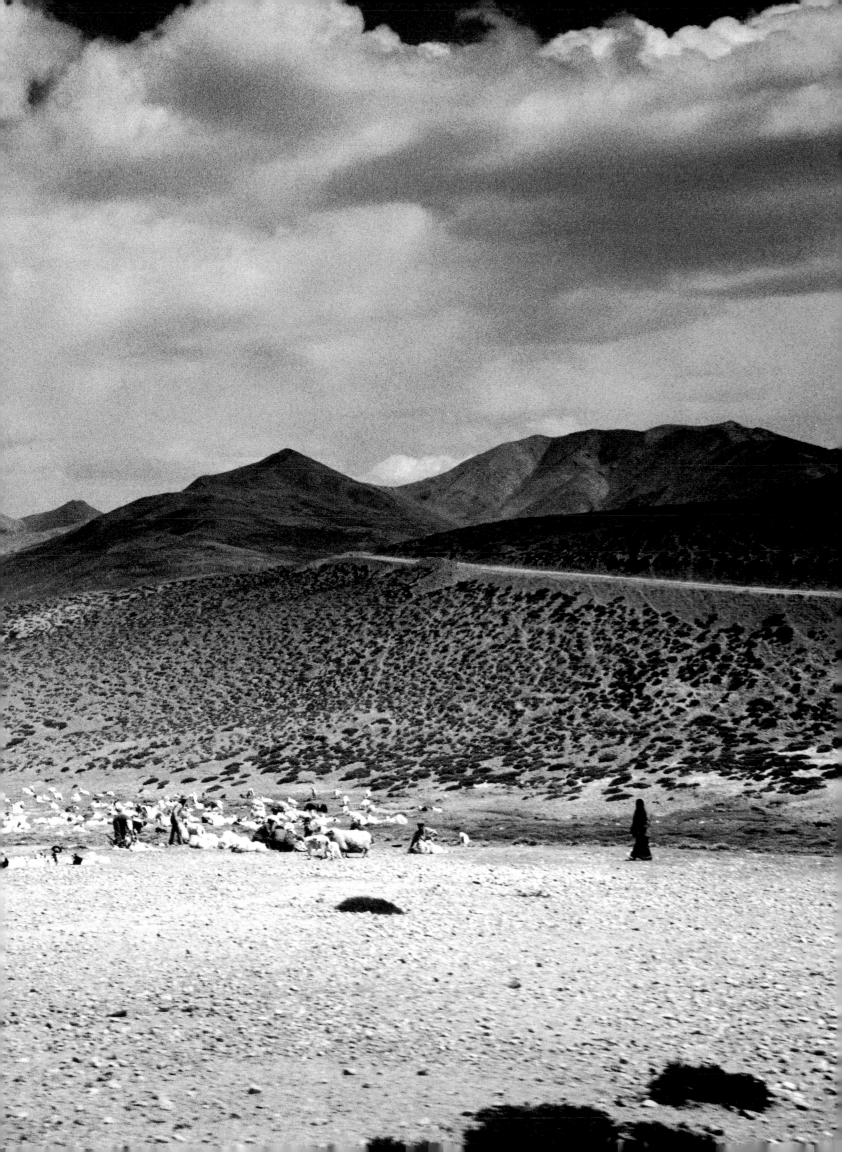

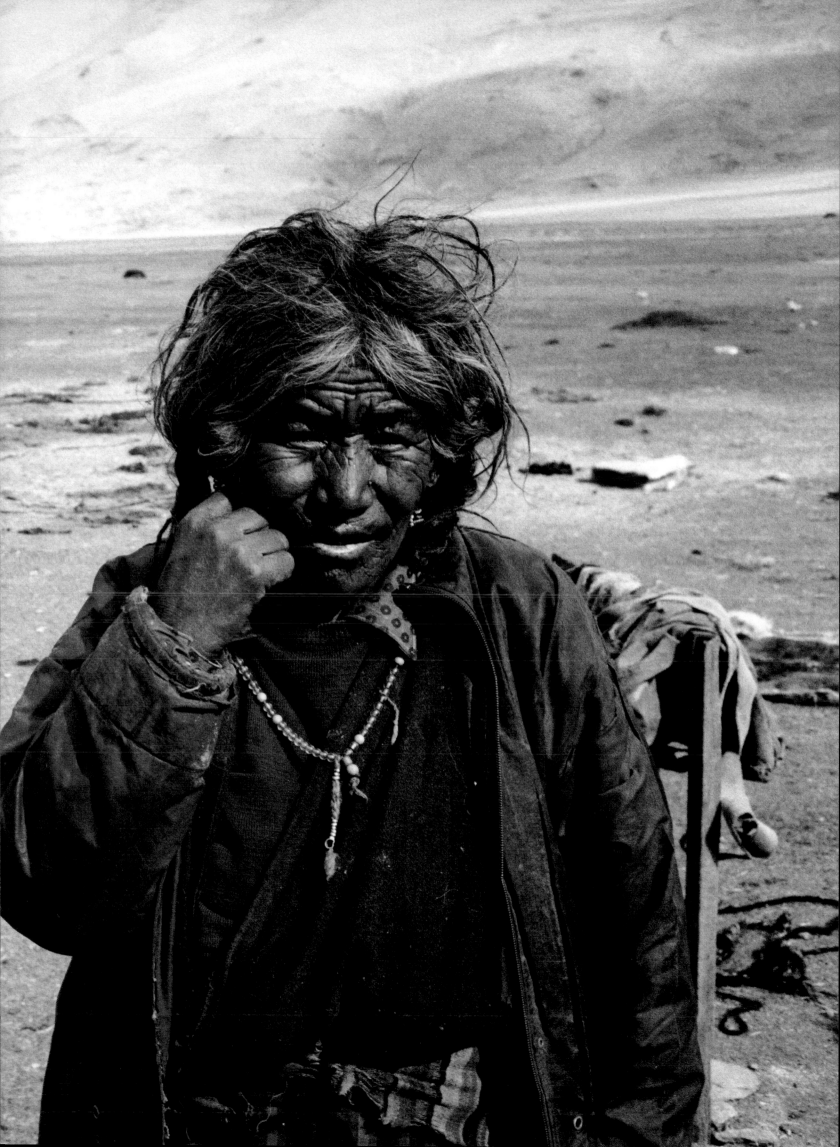

were no roads in this part of Tibet, only many parallel tracks spreading across the plateau in a series of long, shallow ditches that were constantly rerouted to the right or to the left each time a track got ruined by rain, snow, or the Chinese trucks bringing supplies to the army outposts. Some areas had dozens of tracks, and a driver had to judge which was the safest, because getting stuck in a rut out there could be disastrous. It could be many days before another vehicle passed that way.

When I stopped, the nomads pulled out their blackened pots and kettles, lit their fires of goat and sheep dung, and crowded around as the water boiled. One boy with a well-worn sweater and a warm laugh showed me a large goat herd where women were tying up the animals head to head for milking. The harsh light made all the women's faces black, featureless silhouettes. I moved closer to the line of tethered goats and could feel the coolness of the approaching night on my back. At this time of year, late summer, there are two daily milkings: one in the morning, then one later in the day. Many families keep their goats together, and milking is a communal time for women to chat and for children to play. The young boy in the worn sweater kicked the rear ends of the goats to keep them in line as the women, crouching with their buckets, shouted at each other, their voices carrying through the chill mountain air.

The landscape of these nomads is a barren place. In this nothingness and this treeless expanse of harsh, unrelenting light, there exists a heightened purity, a profound clarity. Here on this Himalayan

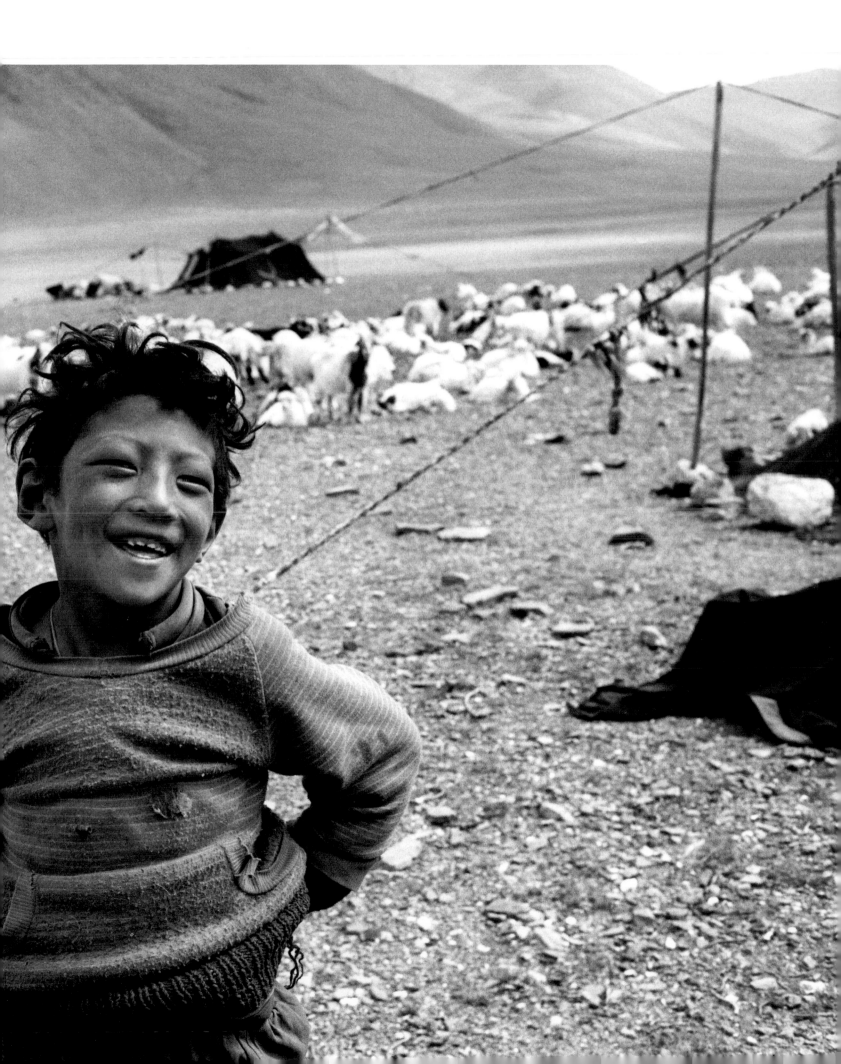

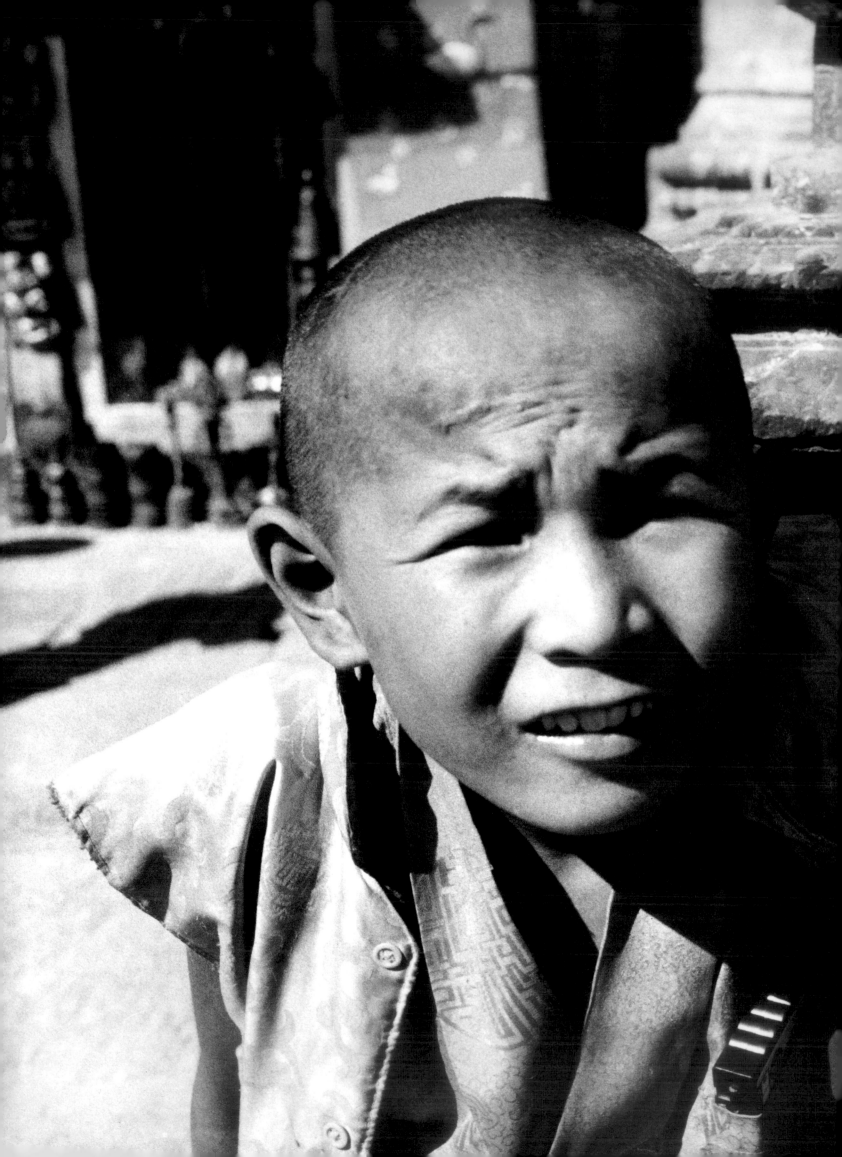

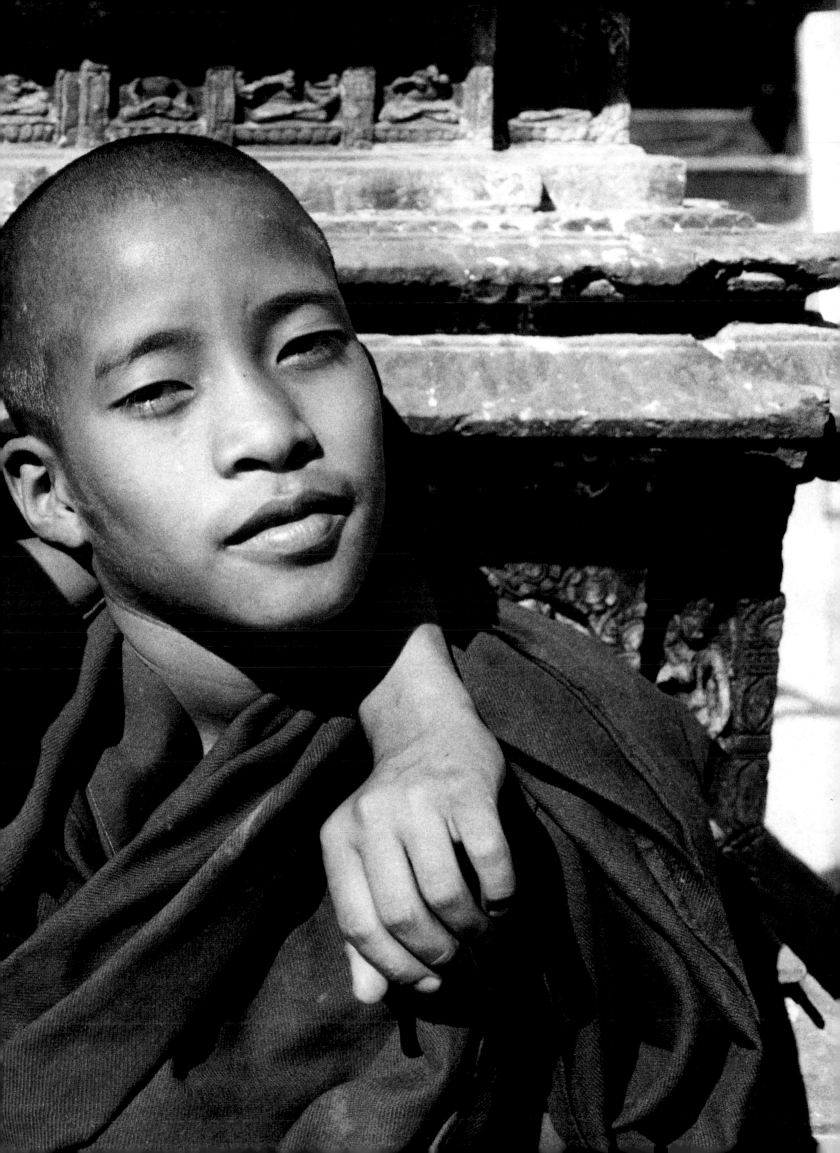

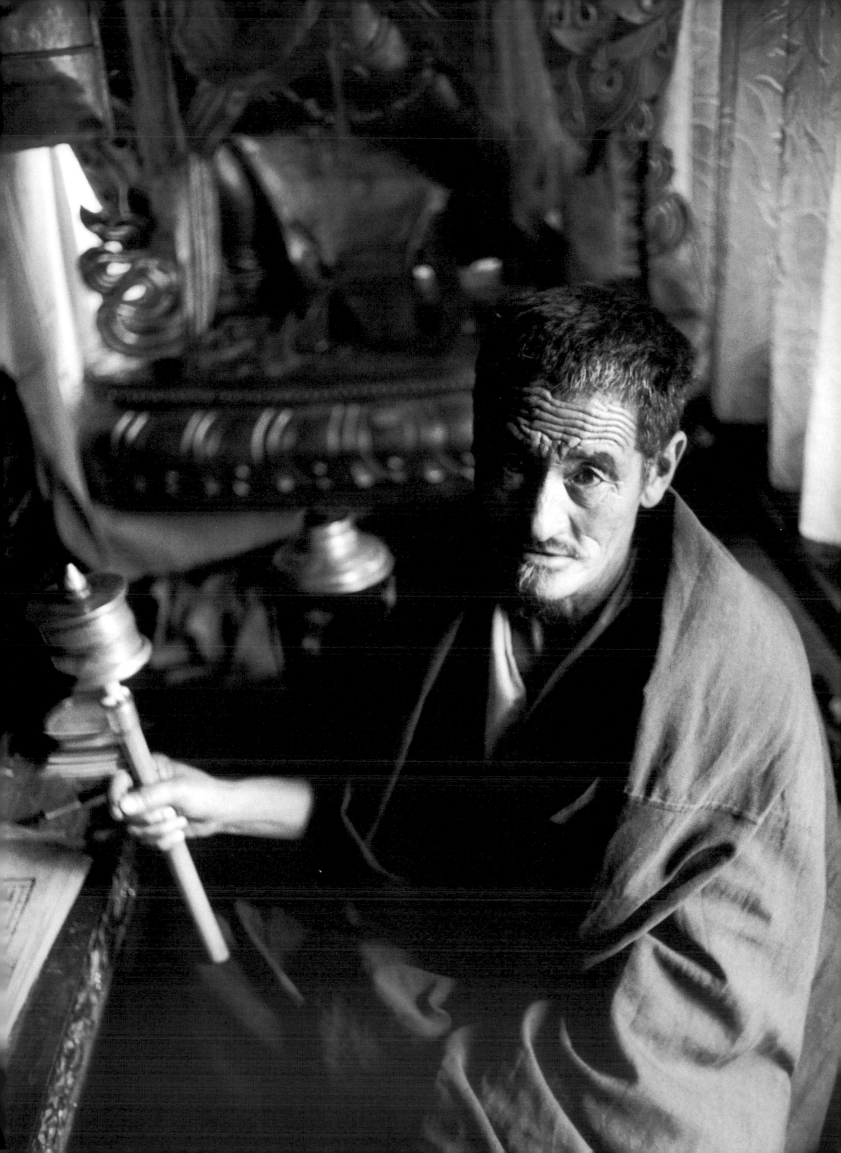

plateau lives a fragile ecosystem shared by mountain flowers, desert animals, and nomadic herdspeople.

A 1993 report entitled "Nuclear Tibet," released by the International Campaign for Tibet, documented a local Tibetan doctor, Dr. Tashi Dolma, who had treated over a five-year period seven nomad children, all of whom had subsequently died of cancer after grazing their animals adjacent to a Chinese nuclear base. The use of these delicate grazing lands on the Tibetan plateau as sites for dumping nuclear waste and for building nuclear missile stations illustrates China's disregard for the core Buddhist belief in an interdependency with nature. It also shows China's unabated cruelty by consciously jeopardizing the safety of Tibet's nomadic communities.

THE INNER LIGHT of Tibet's monasteries is as soft as the outer light of its landscape is hard. Within the Buddhist temples and shrines darkness is illuminated solely by butter lamps. Inside, thin mountain air is replaced by the thick, heavy smell of burning yak butter. It takes a few moments for sun-strained eyes to begin to see in this dimly lit waxen world of glinting brass, juniper incense, and burning butter. If you try to steady yourself by touching the walls or by reaching for a nearby pillar, your fingers will rest on a thick cushion of butter soot. Everything in these Tibetan shrines is coated with layers of burned yak butter. At first you are unable to see that the floor, the walls, the hanging *tangkas* (cloth paintings) around the room are blackened

and slick with grease. As you step, cautiously, your feet slip and slide on the buttered stones underfoot, and the low light cast by the huge brass bowls flickers from many burning wicks as you find your way. The light is golden and touches the equally golden faces of the surrounding statues of Sakyamuni (the historical Buddha) and Tibetan deities. Visiting pilgrims enter the shrines with their chalice lamps and drip melted butter into larger candles stationed by the altars. These pilgrims navigate the rounded steps in soft, leather-soled boots, never slipping on the waxy stones.

Many of the pillars and sections of the walls of these shrines have coins and small pieces of paper money pressed into their yielding, buttery surfaces. Candlelight catches them and the coins seem to be tumbling through the darkness. Nearby, floor-to-ceiling shelves of manuscripts are also black with fatty soot. The overall sensation is one of an alchemist's study: very secretive, very private, an inner sanctum.

THE OCCUPYING CHINESE do not respect the Tibetan people, their spirituality, their land, or their culture. Since 1959, China's Cultural Articles Preservations Commission has been systematically cataloging every item of any value in Tibet's monasteries for eventual shipment to China. Thousands of scriptures the commission considered worthless were set ablaze in public bonfires, and those that were not burned were used as wrapping paper in shops or as padding for shoes. Some sacred texts blasphemously were used as toilet paper.

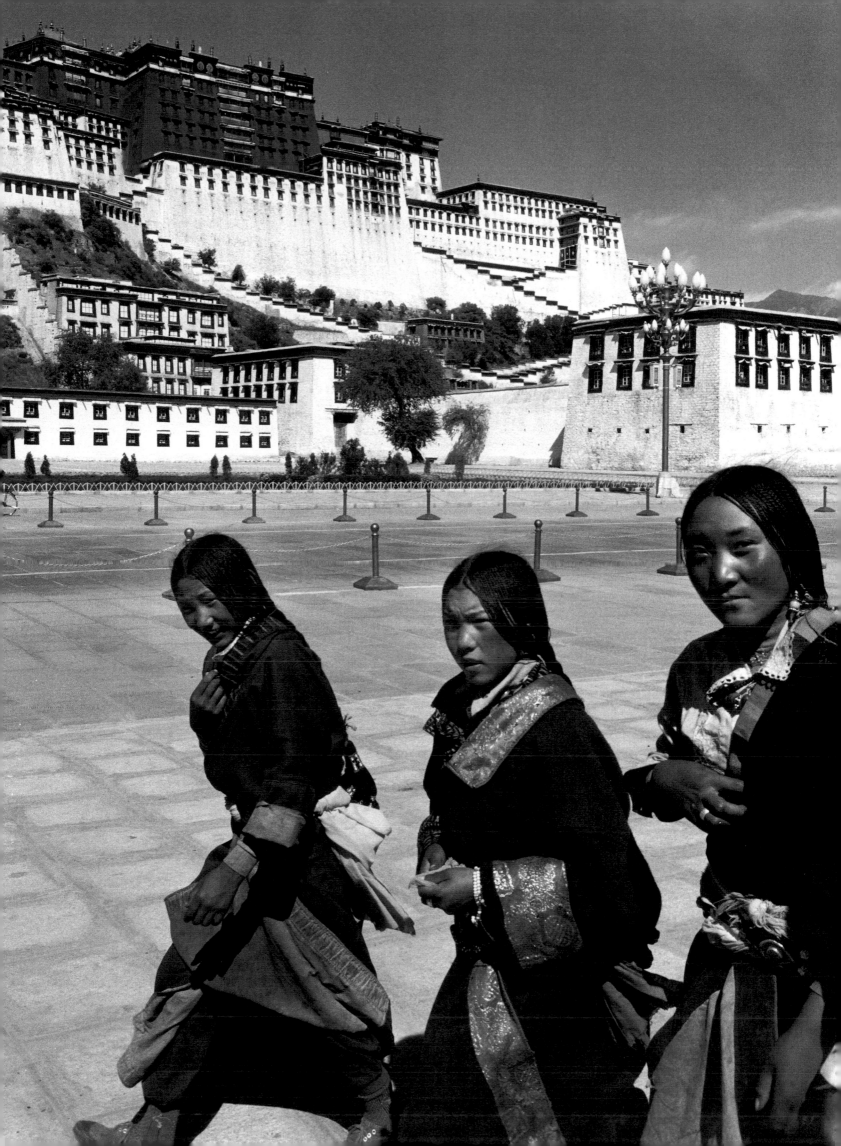

In 1995, when I visited the Tibetan monasteries near Lhasa, I wrote in my journal, "Photos of the Dalai Lama are everywhere. Some have American dollar bills stuck to their cheap frames with butter or bits of wire. Pilgrims who cannot give money, give rice or corn as an offering." By 1997, when I returned, the Chinese government had made it a crime against the state to display photographs of His Holiness the Dalai Lama.

Ironically, the Chinese left images of Mahakala, the Tibetan deity of wrathful suffering, who wears a crown of human skulls and often holds a raw human heart in his hand.

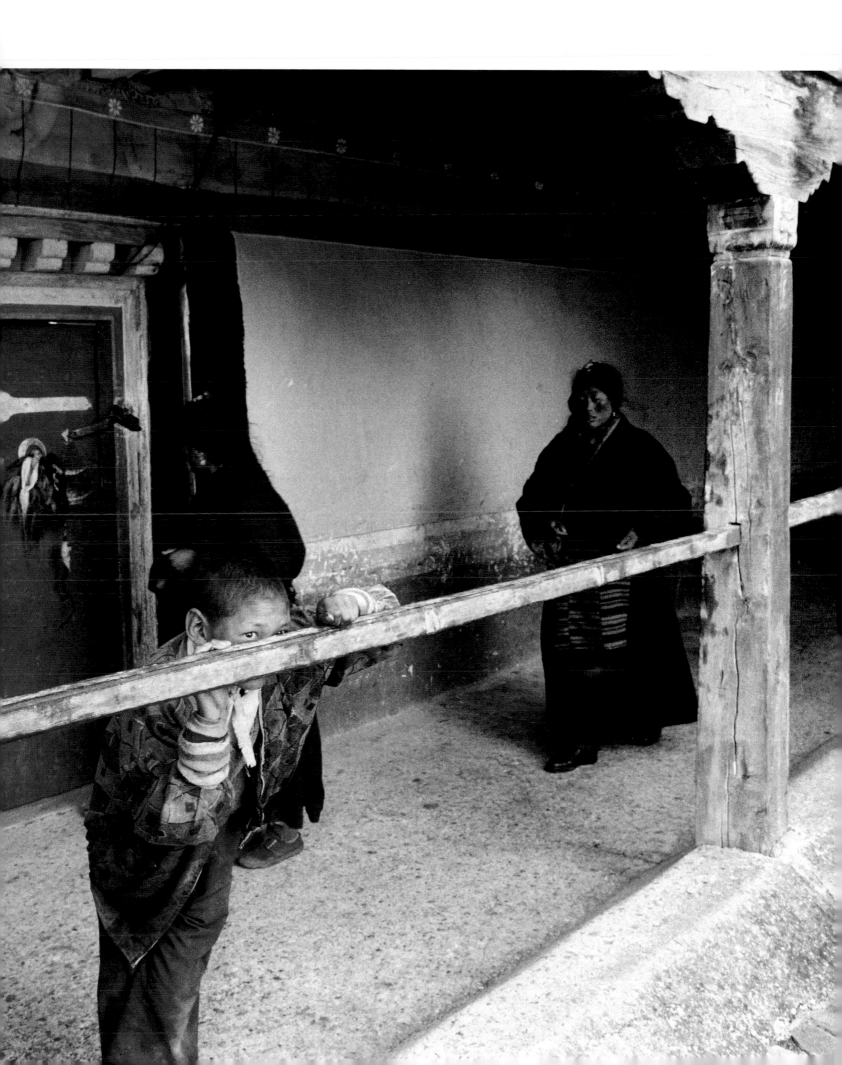

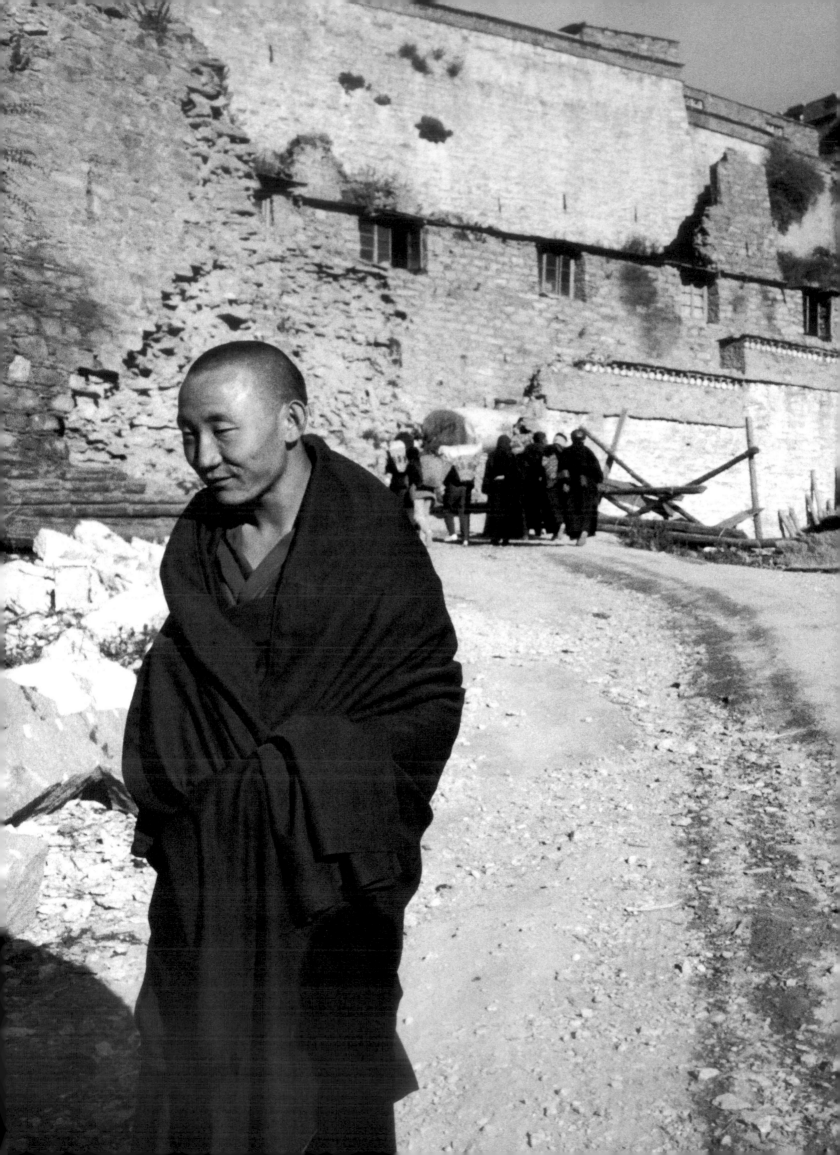

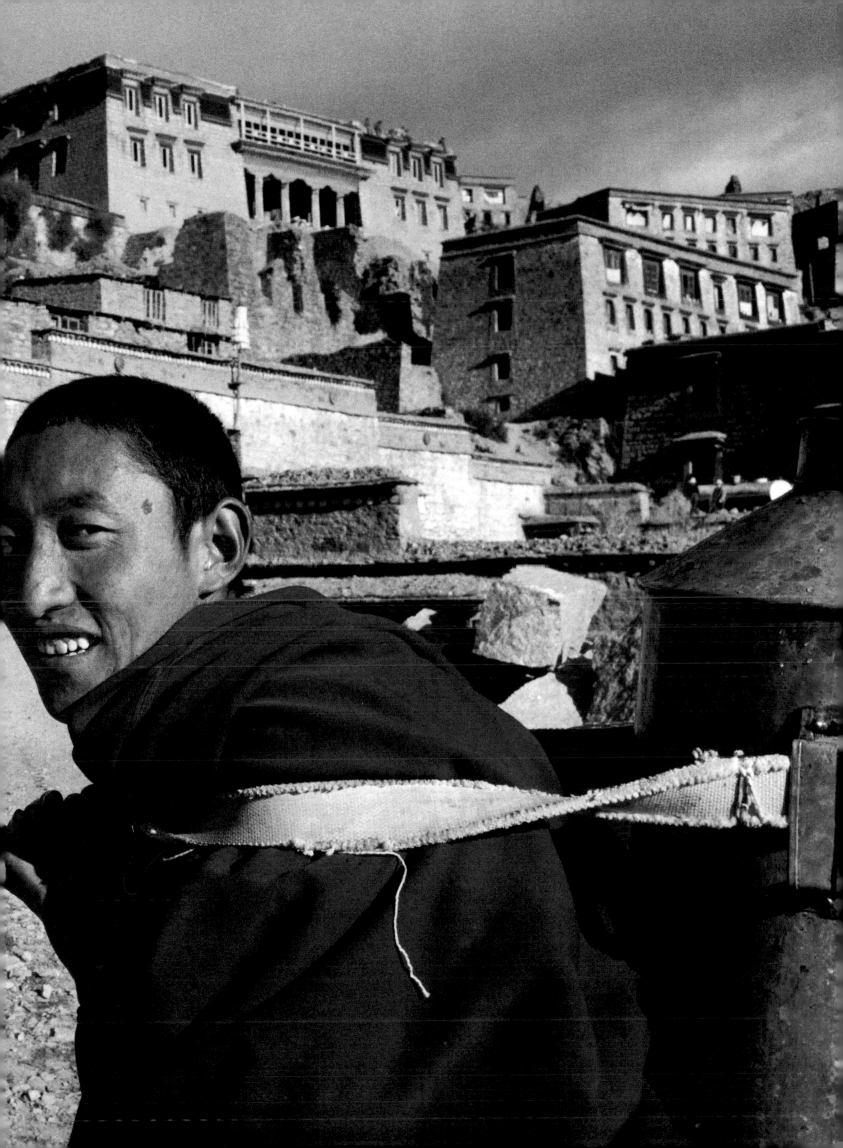

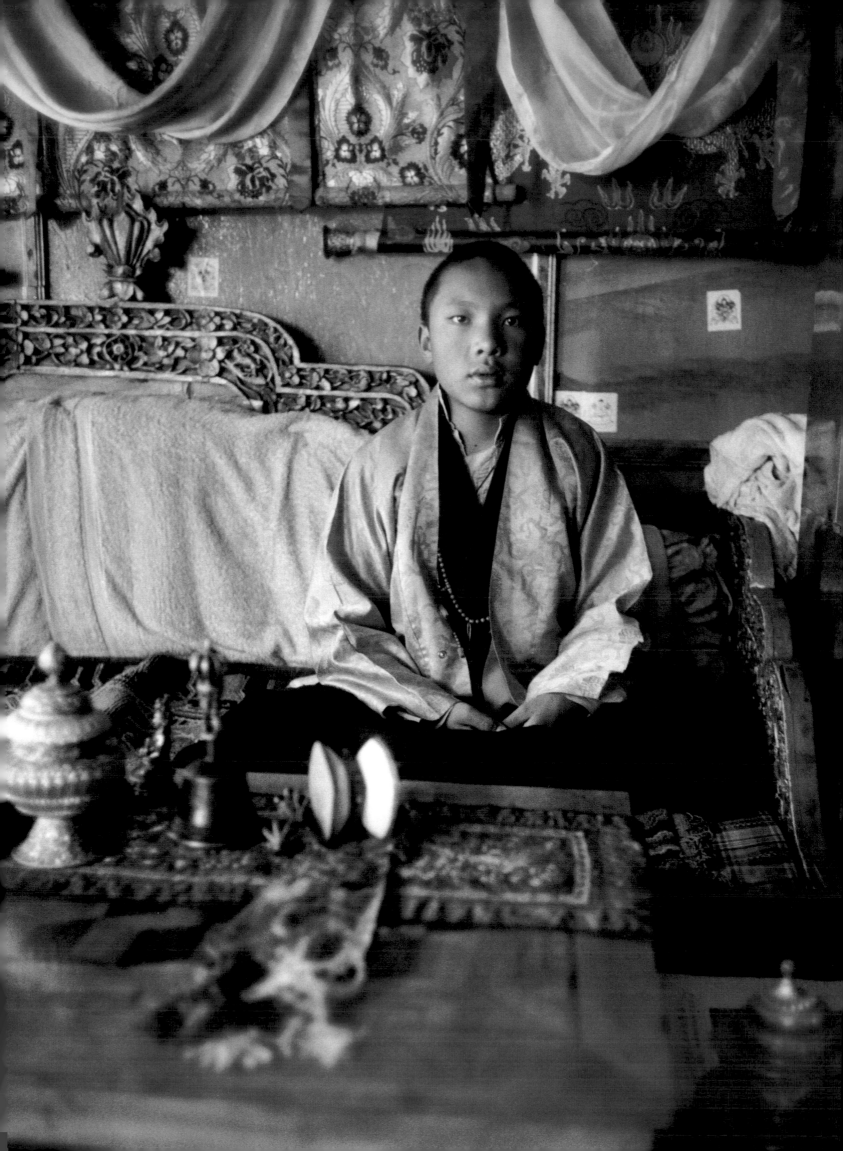

when

the movie *Lost Horizon* came out in 1937,
Europe was witnessing the rise of Nazi
tyranny, and the world was tumbling into
another devastating war. As things be-
come blackest, people need to believe that
somewhere else sanity and humanity pre-
vail. Tibet, that hidden kingdom of spiri-
tuality and nonviolence, was viewed as
such a place, a living Shangri-la, an oasis
of health and happiness. Although
aggrandized through myth and hyperbole, Tibet was
in reality a fully spiritual and humane culture
for centuries before the Chinese occupation.
Today, Tibet still struggles to retain its ancient
culture, which is centered on a
long-held belief in altruism
and compassion.

I first sensed the physical and spiri-
tual splendor of ancient Tibet at Ganden
Monastery, high in the mountains near
Lhasa. Ganden was the greatest Tibetan
monastery to be destroyed during the
Cultural Revolution. In 1966, artillery fire
and dynamite leveled the home and tem-
ple of two thousand Gelugpa monks into a
landslide of rubble that slid down Drokpa
Ri Ridge into the valley below. Today, as
the monastery is slowly rebuilt, almost
four hundred monks live there.

Upon arriving in Lhasa, I heard that
Ganden was located on one of the most
breathtaking ridges in all of Tibet. But
when I tried to get a driver to take me
there, I was told that I needed to be with
an official tour group. In Tibet's monaster-
ies, official tours often mean that visitors
are programmed to meet only Chinese-
indoctrinated monks. No free discussion is
allowed with Tibetan monks who might

gain foreign sympathy. If I tried to get to Ganden as an individual traveler, I would be turned back at the roadblocks by the Chinese police. But one Tibetan driver said he was willing to pick me up before sunrise, in the hope of beating the early morning roadblocks. It was a risky gamble that he wanted to try. I agreed to the plan.

It was a beautifully clear and cold October morning in 1995 when we started the forty-kilometer drive from Lhasa to Ganden Monastery. As the sun topped the mountains and we drove along the Kyi Chu River, a wonderful pink light was caught in the rising mist coming off the water. Then, suddenly, my driver frantically motioned for me to lie on the floor of the Jeep. A roadblock was dead ahead. I fell to the floor, pushing my face and shoulder into my camera bag. The Jeep slowed and I heard the driver's window roll down. He said a few words, then without coming to a complete stop we were off again. Within seconds the driver was laughing loudly and thumping his fist triumphantly against the steering wheel. He had outwitted the Chinese police.

Along the way we passed small villages with herds of sheep, yaks, and black pigs that wandered out onto the road. Each village had brightly painted carved doorways and defoliated branches, windblown and skeletal, that supported many tattered prayer flags.

Beyond the village of Dagtse Dzong, where the road deteriorates into a rough mix of holes, rocks, and gravel, I asked the driver to stop so I could walk down to the river. To my left, the sky was as blue as an overhead lake, yet to my right, near

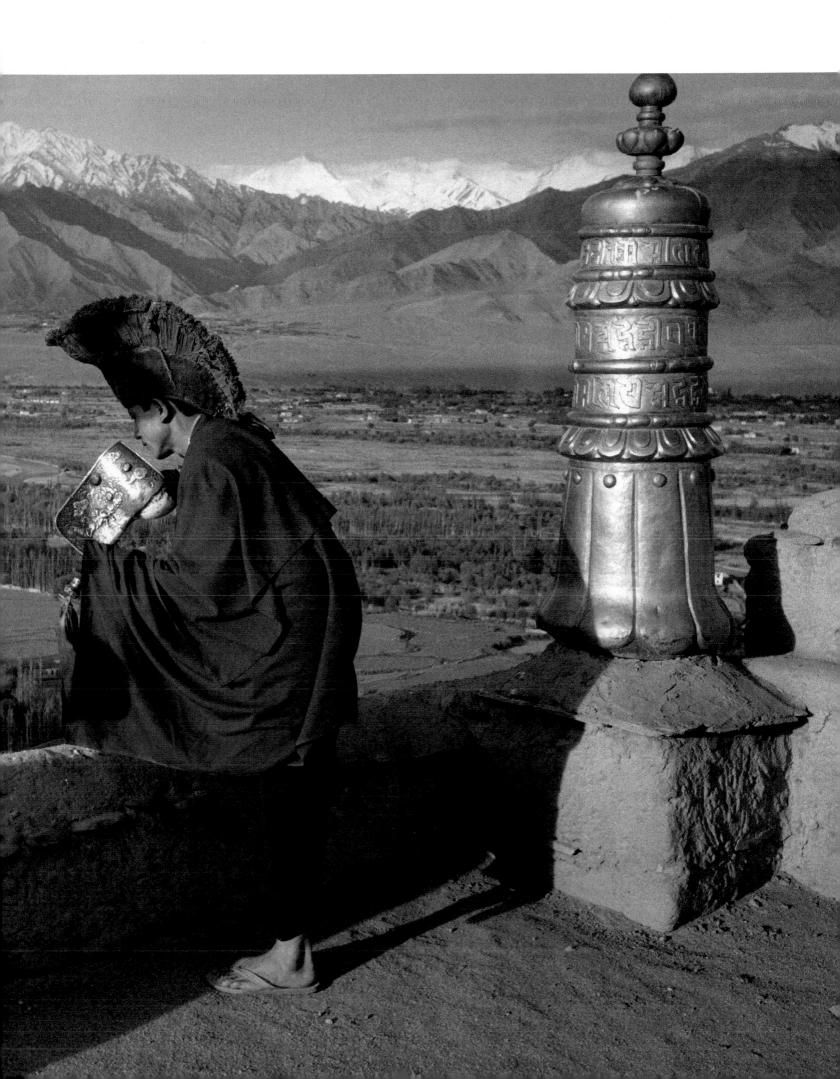

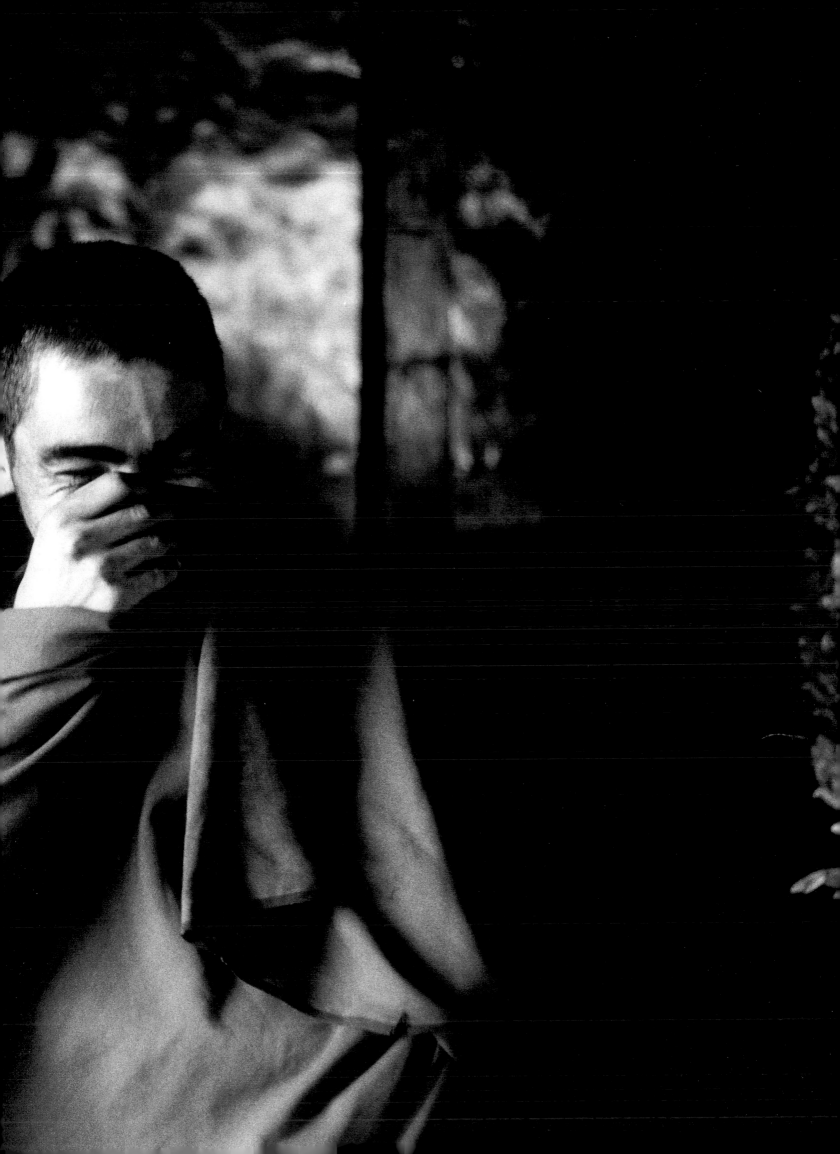

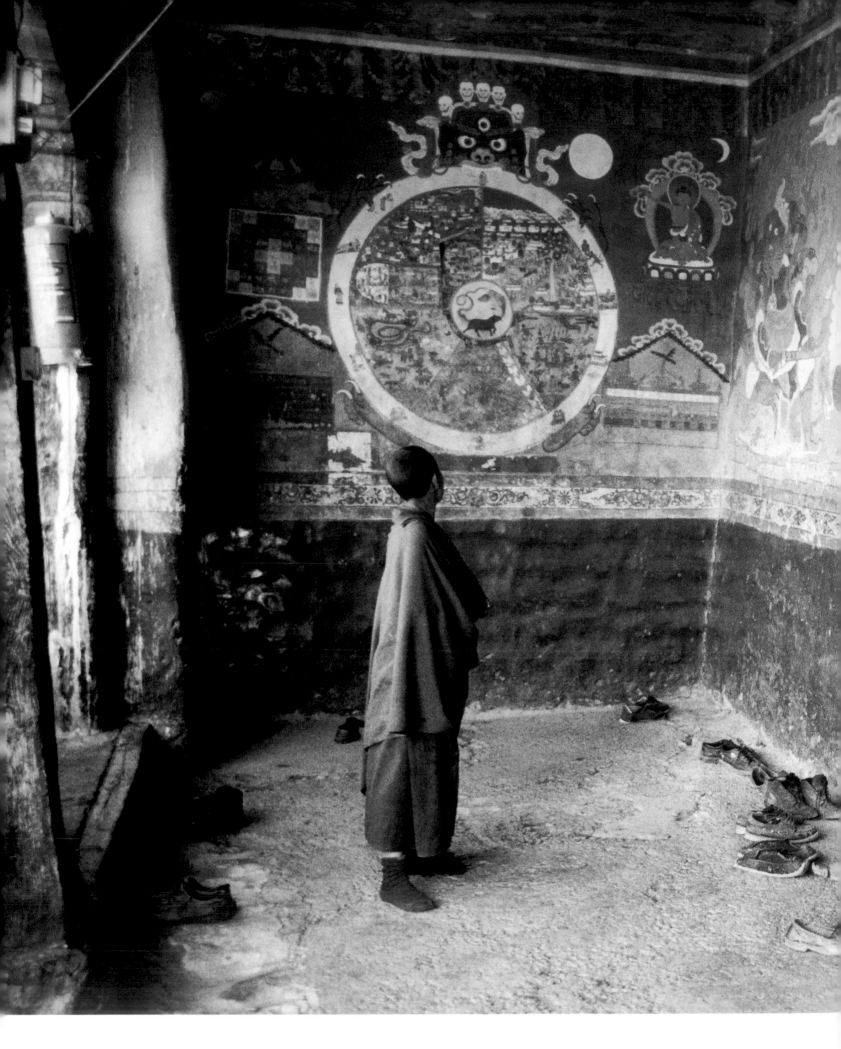

Ganden, large black clouds could be seen. By the water I saw a woman on a sand spit, digging in the soft soil. She was collecting mud into a large sack. I approached her, and she smiled and continued to fill the sack with wet earth. It must have been very heavy, yet she hoisted the sack easily onto her back and carried it across a narrow wooden bridge as if it were filled with straw.

I HAVE SEEN TWO quite different photographs of Ganden Monastery. The first was from the 1920s, and it captured the multitiered magnificence of Ganden as it rose up the side of Dropka Ri Ridge's 14,000-foot slope. Ganden housed the tomb of Je Tsongkhapa (1357–1419), founder of the Gelugpa sect of Tibetan Buddhism. The tomb had silver reliquaries holding the remains of many other Ganden *tipas*, Gelugpa leaders, who had governed the Gelugpa sect for more than five hundred years. Ganden, as seen in this early photograph, was a place of spiritual intensity and unparalleled physical grandeur. Only Lhasa's winter palace, the Potala, could compete with Ganden's architectural splendor. The Tibetan scholar Giuseppe Tucci once called Ganden a "sight out of this world . . . bodiless."[25] The second image was a post-invasion photograph of Ganden in ruins. Following the 1966 Chinese bombing, the darkened husk of this once-grand city in the sky resembled nothing more than a pile of broken teeth discarded across the ridge. I was apprehensive of what I would find at Ganden. It seemed so ironic that, in Tibetan, Ganden means "the joyous heaven."

The eighteen-kilometer switchback road up to Ganden was a steep climb. As we slowly ascended, the sky became blacker and blacker, and the driver put on his headlights. Near the summit, the sun suddenly directed a ray of light through a hole in the darkness, and it luminously spotlit the newly constructed gold roofs of Ganden. The roofs glimmered against the charcoal sky as the white buildings were cradled softly in the basin of the ridge. Then once more the blackness closed in.

The image of the powerful mass of clouds, black and ominous, being pierced by a small, bright shaft of light struck me as highly symbolic. It showed the eternal strength of light over darkness. For a brief instant, a terrible history seemed magically to be reversing itself.

Faith is said to move mountains; it can also rebuild them. At the top of the road, many monks were busy doing construction work. Two young monks, impish with curiosity, followed me around. They showed me the vista over the valley and the *lingkhor*, or pilgrims' circuit, that went around the ridge. We stood, still and in silence, looking toward a distant line of snow-covered mountains. Overhead, a snowstorm was approaching. Within moments, huge flakes of ice whirled around us as the young monks burst into laughter, pulled their robes over their faces, and began running toward a cluster of nearby buildings.

Ganden is a monastery of intense power and position. Monks here believe in the geomancy, or geographical divinity, of Ganden's high-altitude landscape. Many

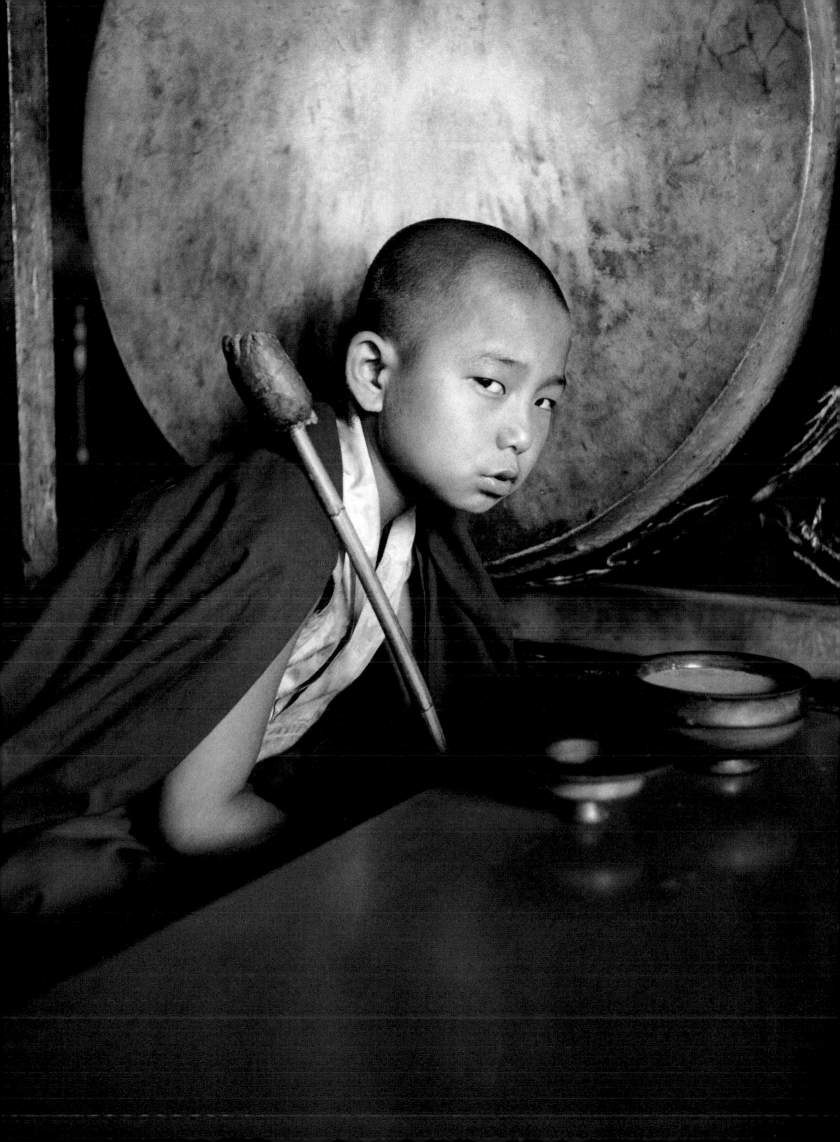

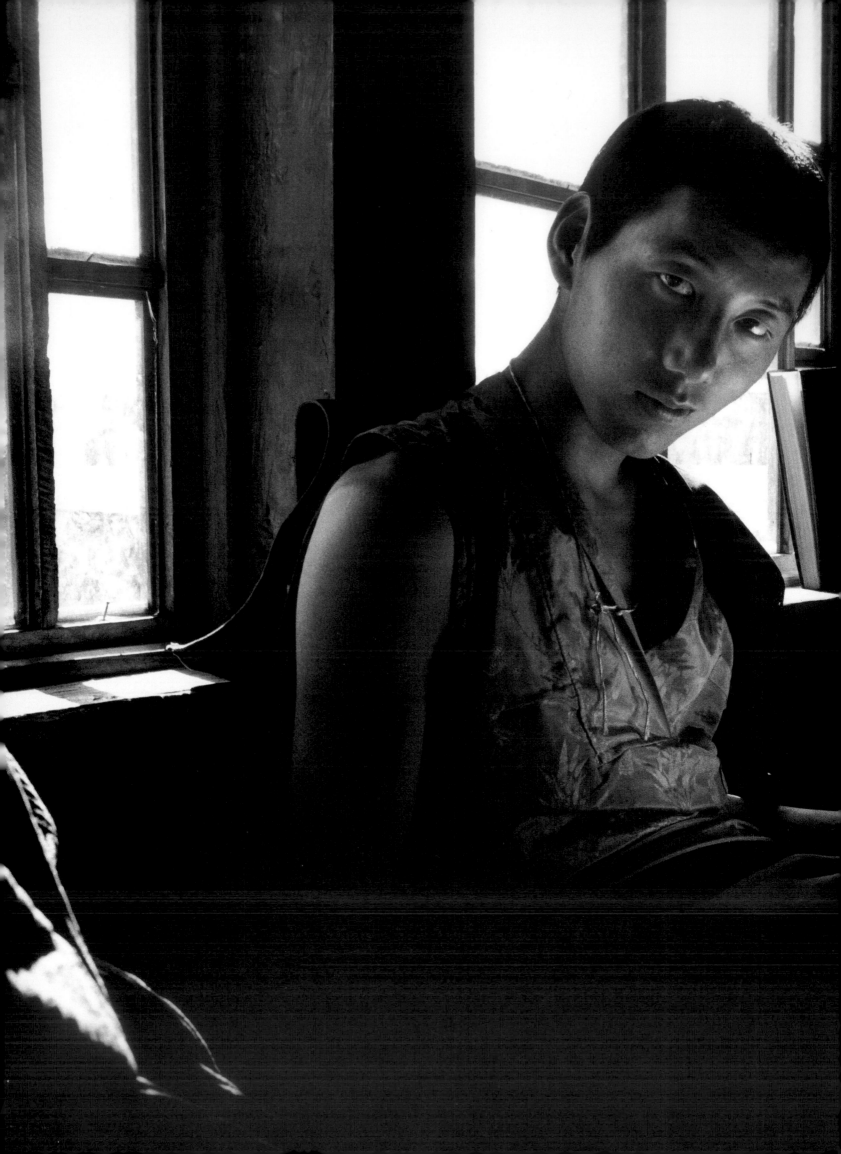

of the sites and rocks on this ridge are places of healing and magic. For example, the *lingkhor* around the monastery is a walk through supernatural landforms. The first site along the path is Vision Rock. Pilgrims stand in front of the rock, their fists curled and held tight to their eyes as mock telescopes. This focused view is said to bring forth unearthly visions.

Farther along the *lingkhor* is Ganden's sky-burial site. In Tibet, because the ground is frozen much of the year and because wood is extremely scarce, both interments and cremations are replaced by a ritual called sky-burial. This is a simple process of respectfully sectioning up the body of the deceased into many pieces by a *tomden*, or yogin butcher, who spreads these fragments over the hillside for the vultures to pick clean. As the birds descend, the *tomden* yells "*Shey! Shey!*" — "Eat! Eat!" Often the stripped bones are pulverized with a stone mallet and mixed with *tsampa* (roasted barley flour) and once more fed to the vultures. Sometimes the defleshed bones are collected by the monks; musical instruments are fashioned from leg bones and bowls from human skulls. Somehow I find it comforting to think that our mortal remains could be recycled into a Tibetan horn.

Ganden's sky-burial site is a place for pilgrims to roll on the ground and to rub away bad karma accumulated from past sins. A bit farther down the *lingkhor* is the Gauge of Sin, which checks if pilgrims have rubbed the ground hard enough. Squeezing through this narrow opening in the rock, pilgrims can breathe easy if they come out the other side. If they get stuck,

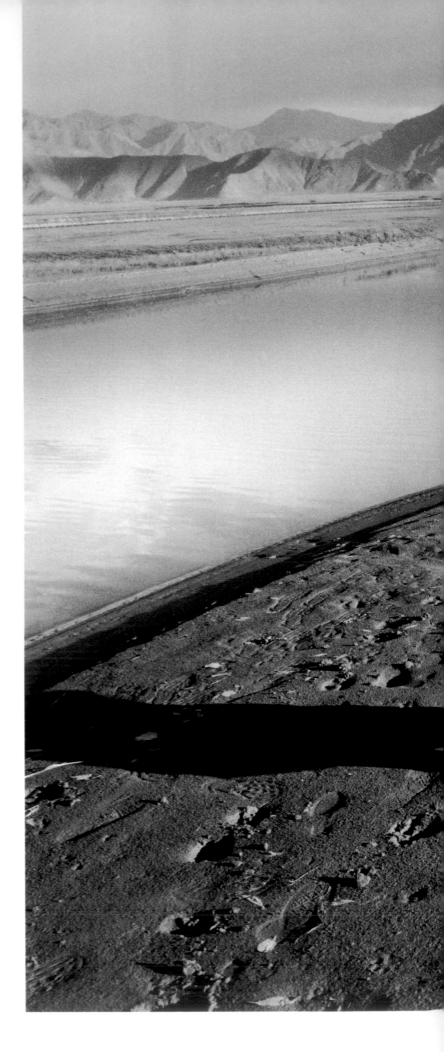

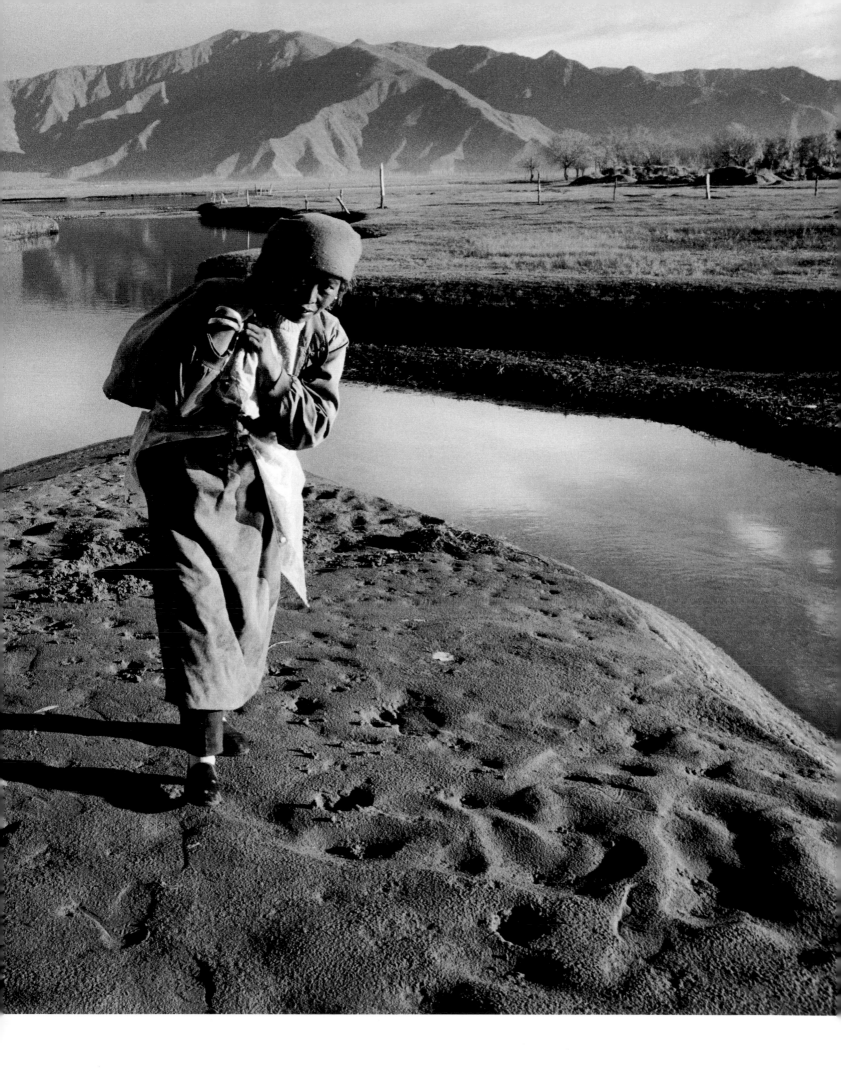

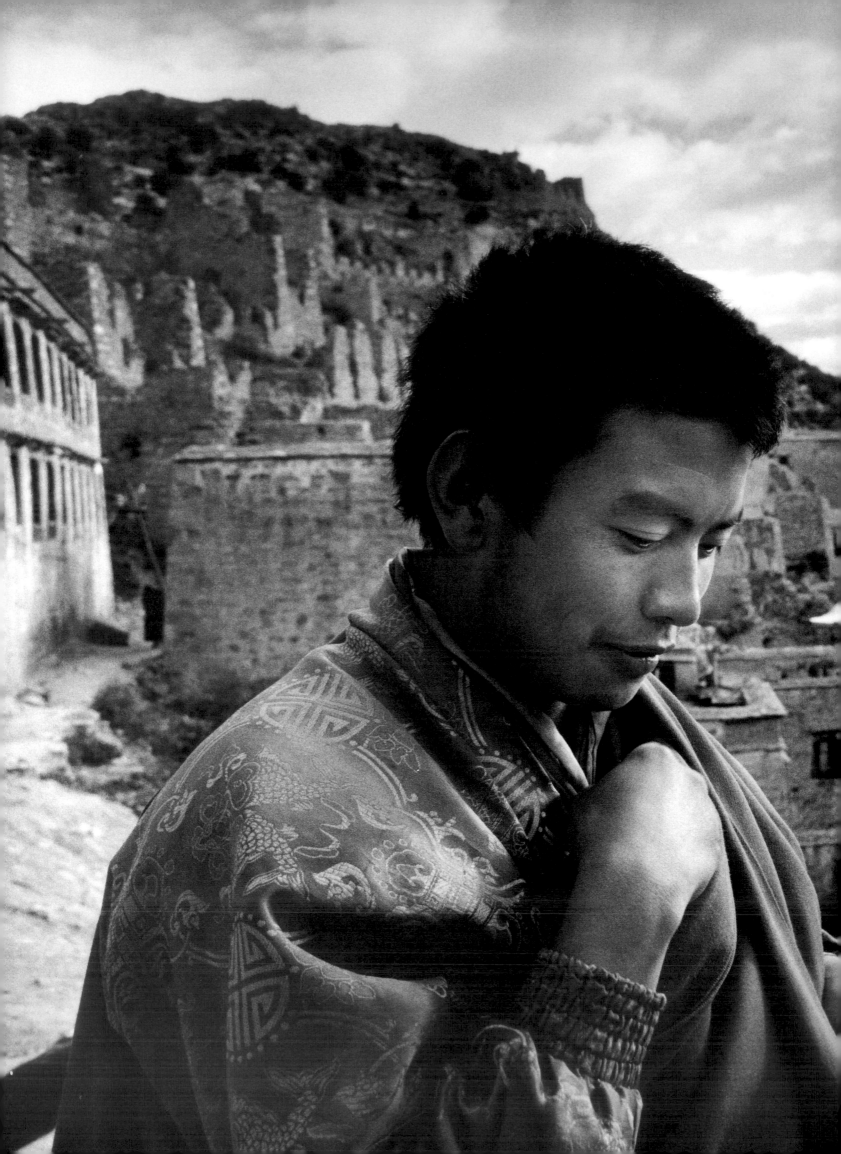

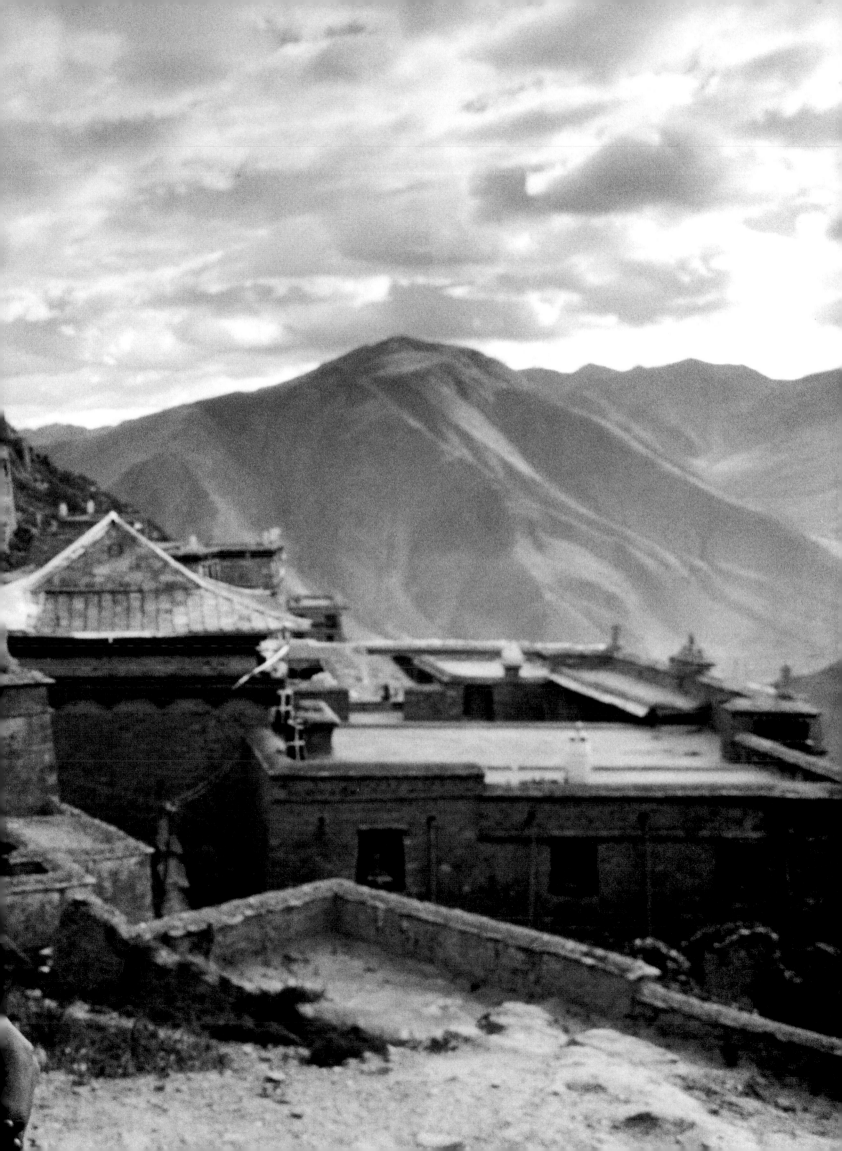

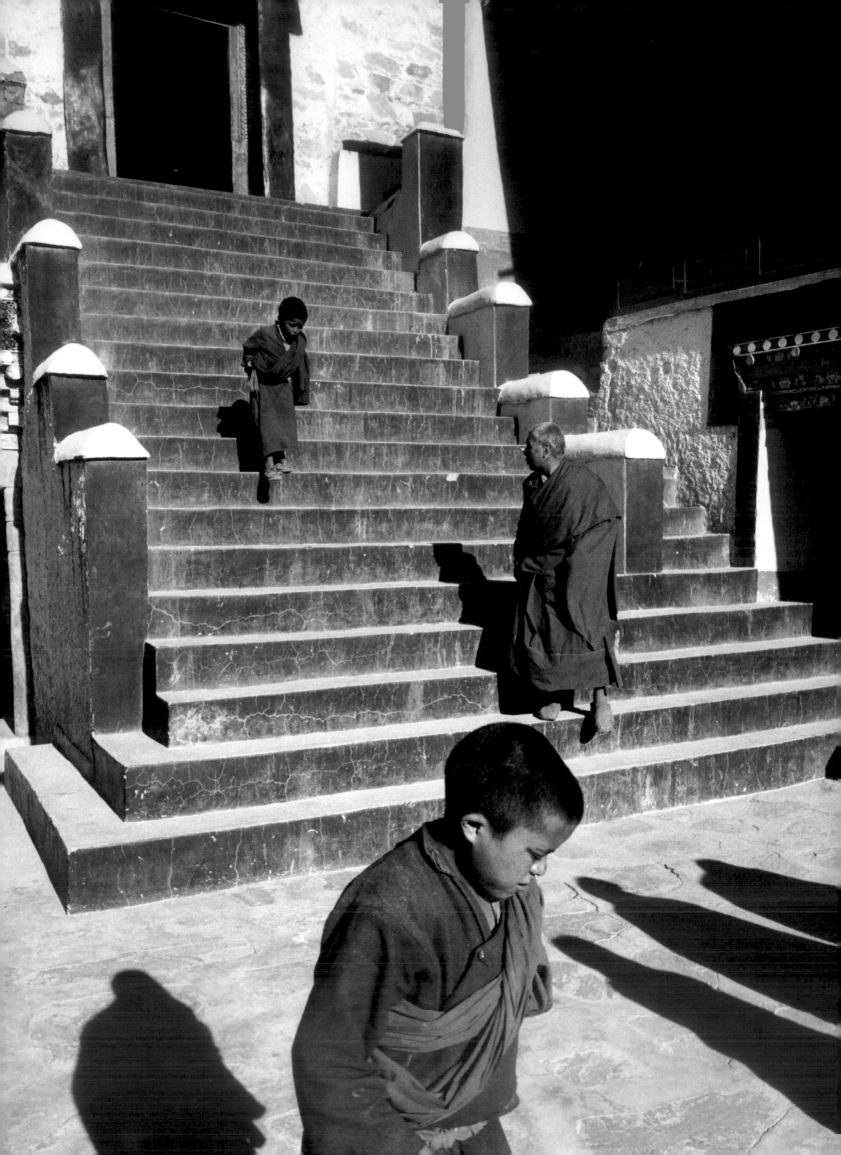

they are too fat with sin.

In a place like Ganden Monastery, a rock that generates supernatural visions, a section of ground that rubs off sins, and a narrow geological gauge of bad behavior do not seem so far-fetched. Often in Tibet, I found I could suspend my empirical mind-set and open up to the Tibetan world of wonder. Magic is not a trick in Tibet; it is a truth.

THE STORM OVER Ganden increased, the wind picked up, and the heavy snow continued to fall. Within seconds the air was thick with leaf-sized snowflakes. The two monks, running in front of me, hustled me into their quarters, where they sat me down on a carpeted floor and gave me a cup of that ubiquitous and fatty national drink, yak butter tea. In truth, butter tea is more a salted, cheesy soup than a refreshing drink.

With the horns and the chanting from a nearby temple filtering through the blowing snow, I happily sipped my butter tea. One of the young monks stood up and went to an altar in the corner of his room, and from behind a picture of the Dalai Lama, he pulled out a small pink plastic transistor radio. Placing it by the window, the monk turned the dial until it landed on a clear transmission.

I could not believe my ears, or my bad luck. There I was, trapped high in a Tibetan monastery, during a snowstorm, with Kenny G drowning out the haunting horns of praying monks.

Several months later, on May 7, 1996, tragedy struck Ganden. At 10 P.M., after the monks of Ganden had refused to

remove their photographs of the Dalai
Lama following the orders of the Lhasa
city religious bureau chief, Chinese sol-
diers sent flares into the air and began
shooting at the unarmed monks. Two
monks were killed, and over the next few
days, ninety monks were arrested. One
monk, a fifteen-year-old, was shot and
arrested. He was never seen again. I often
wonder if he was the same young monk
who kept his pink plastic radio hidden
behind a photo of the Dalai Lama.

Monks at Ganden belong to the
Gelugpa order. In fact, the head of the
Gelugpas is the senior abbot of Ganden
Monastery, *not* His Holiness the Dalai
Lama, as is often assumed. The Dalai
Lama is the head of state but not the
Gelugpa *tripa*, or head. The Gelugpa
order is the most disciplined, academic,
and hierarchical of the four orders of
Tibetan Buddhism. To be a Gelugpa monk
is to be contained within an intellectual
and spiritual life, a celibate monasticism
that forms the largest Buddhist order in
Tibet. In 1642, through the institutional
leadership of the Dalai Lamas, Gelugpa
monks became the rulers of central Tibet.
To this day, they are the political and spir-
itual heart of Tibet.

The first rule of a Gelugpa is the with-
drawal from life. This means a monastic
withdrawal, a life on high Himalayan
mountaintops where family is left at the
front gate. This egoless, sexless life may
seem unnecessarily harsh, but such isola-
tion allows the philosophical monks to
focus on their quest to understand the
nature of perception, knowledge, and real-
ity. Gelugpa monasteries, such as Ganden,

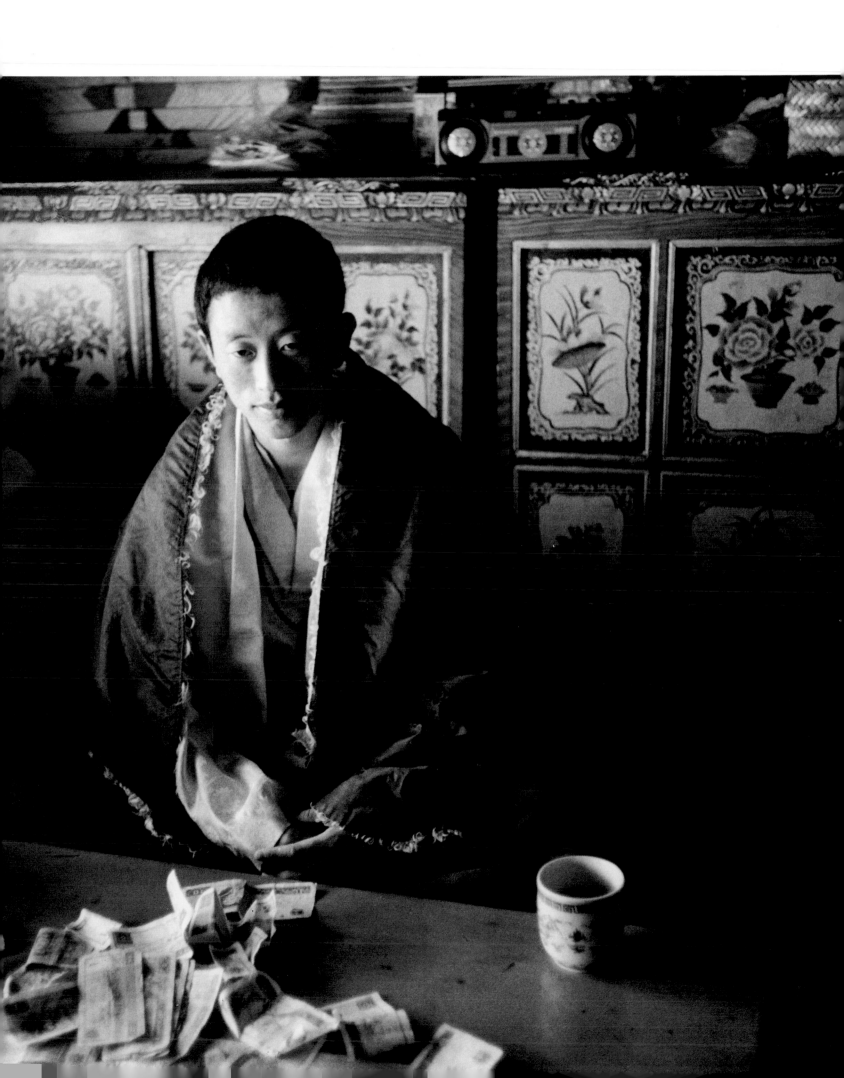

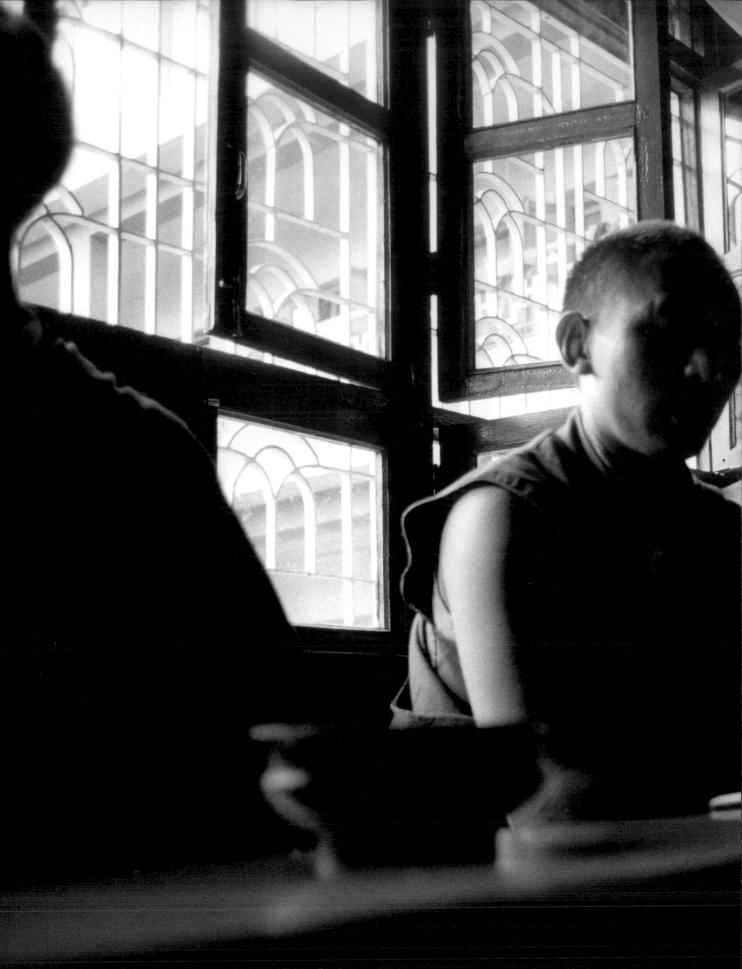

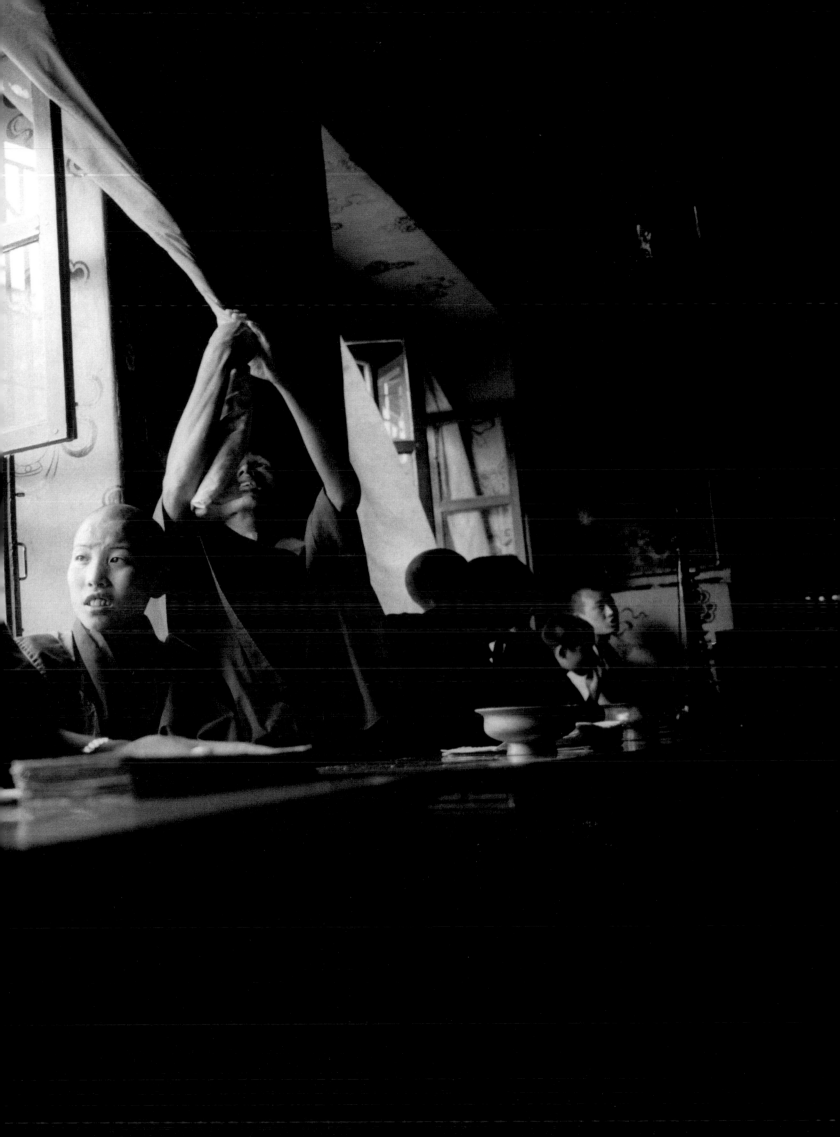

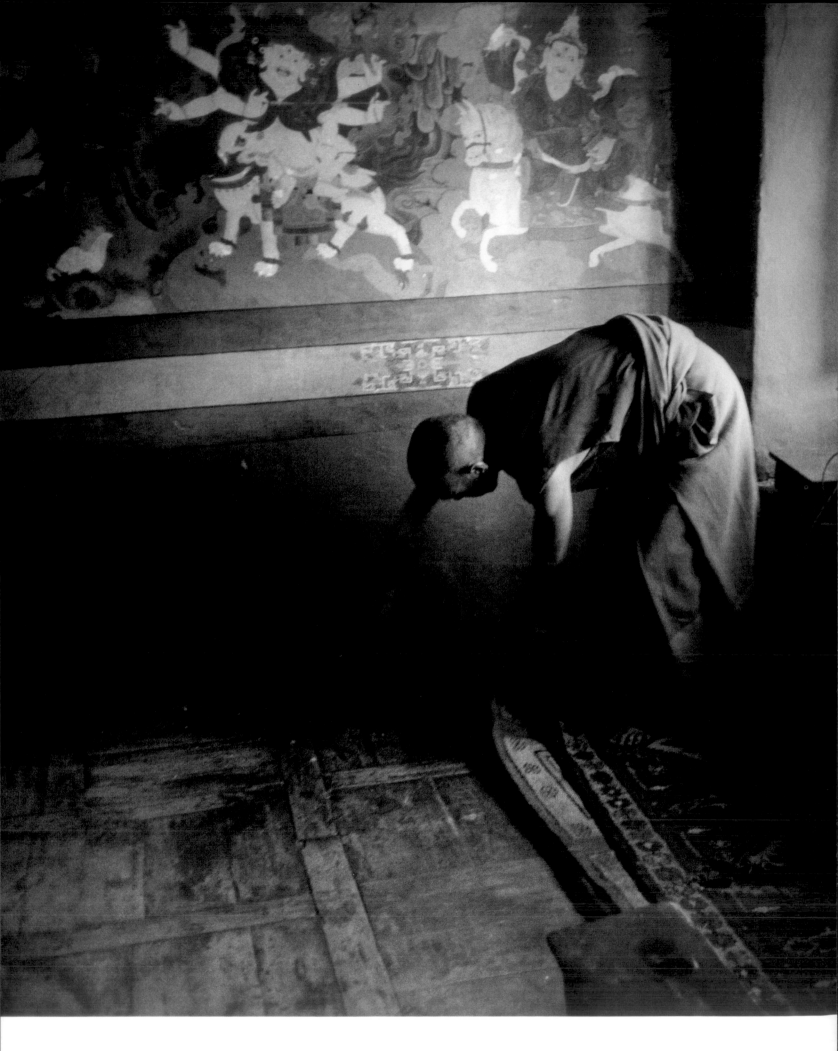

are as scholastic as they are monastic. A young monk, or *trapa*, could come from anywhere in Tibet to study at one of Ganden's colleges, or *tratsangs*. Here he learns the basic laws that guide the Tibetan universe: wisdom and compassion. Yet all this changed at Ganden after the May 1996 shootings. The age-old Gelugpa scholarly tradition has been forcibly replaced by a Chinese-imposed campaign of patriotic education aimed at reprogramming monks. Chinese officials began indoctrinating monks at Ganden and then shifted to Lhasa's Sera and Drepung monasteries before moving on to other monasteries in outer Tibet, giving daily classes in Chinese history, law, and politics. At the end of these sessions all monks and nuns over the age of eighteen have to sign a statement of allegiance to the Chinese state and a rejection of the Dalai Lama; finally, they must be officially registered. At Ganden, in late August 1996, about 150 monks were expelled for failing their patriotic education. Also, many Ganden monks left on their own, traveling to India or Nepal after vacating their monastery to escape persecution or arrest. Currently, one of the greatest centers of learning in Tibet is collapsing, just as it appeared to be getting back on its feet.

I have no idea if the young monk with the pink radio was reprogrammed or if he passed his patriotic education or if he is now in prison, or even if he is dead. But I do know that the scholastic tradition of Tibetan Buddhism at Ganden is being methodically destroyed.

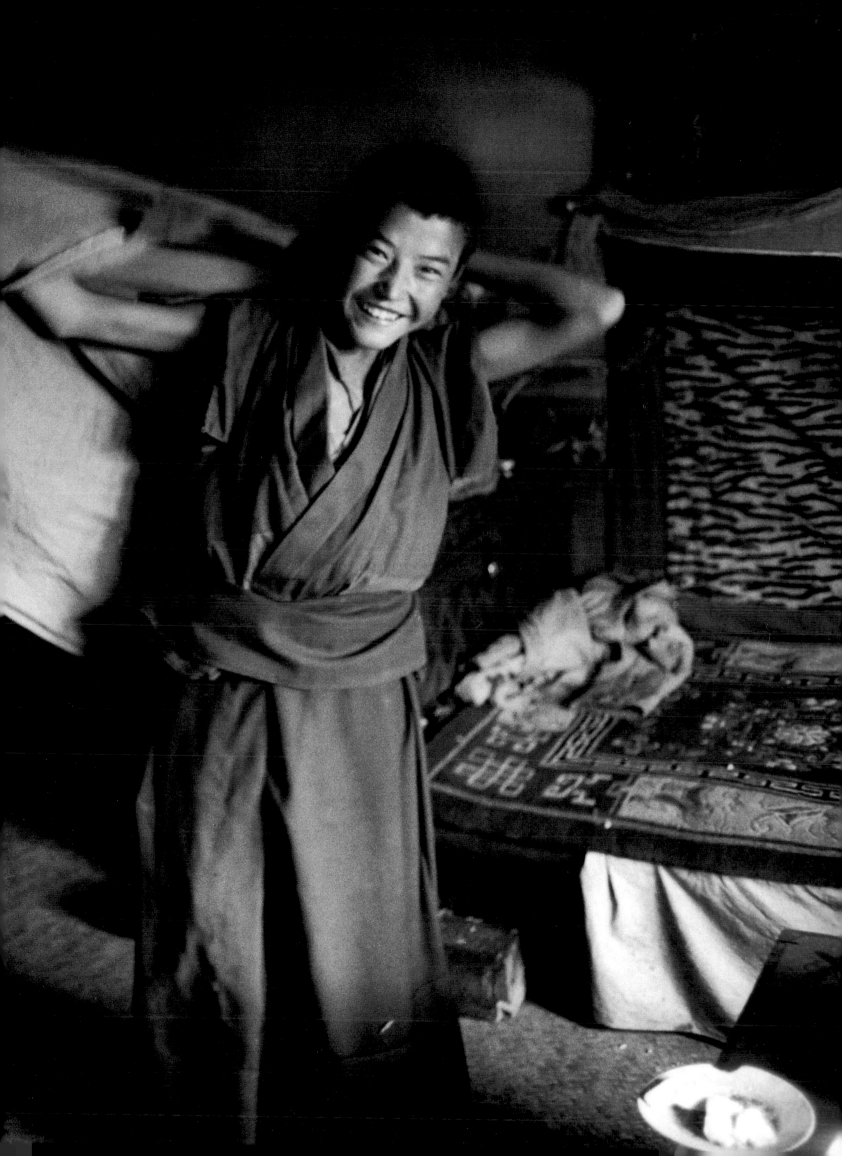

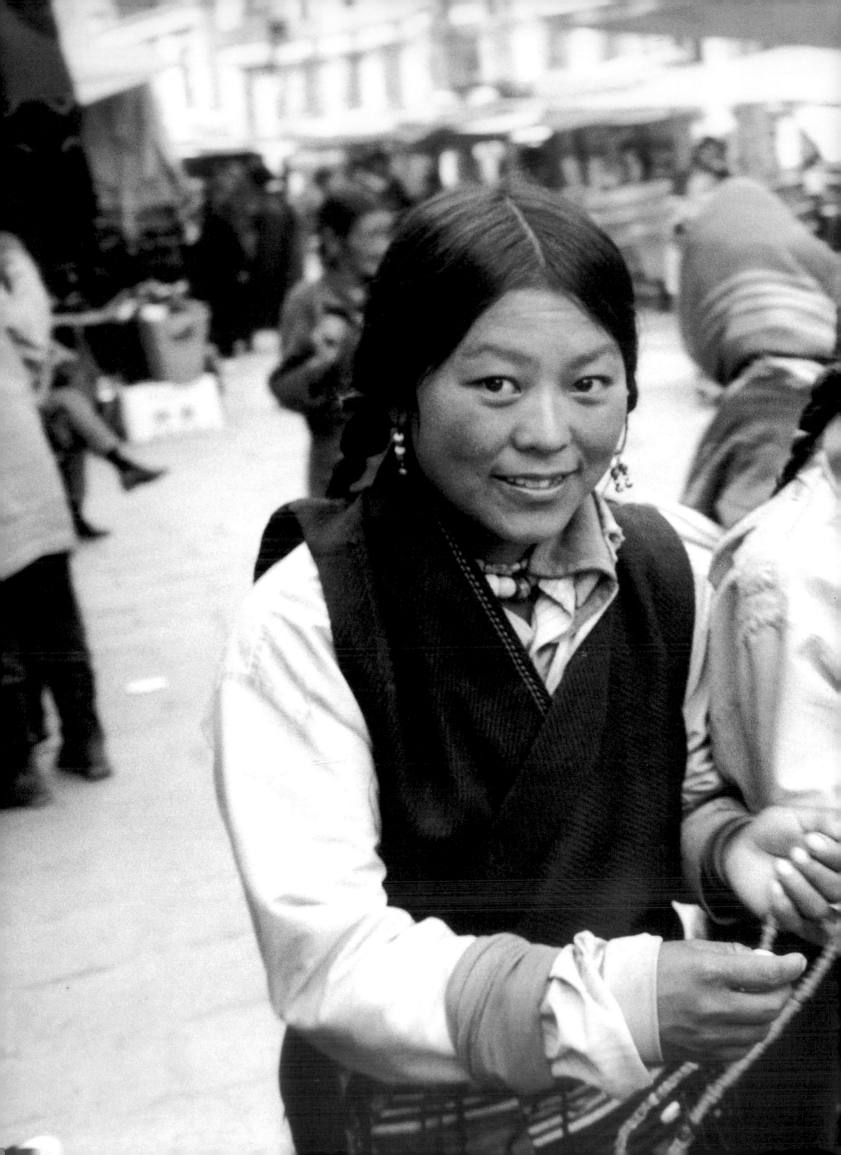

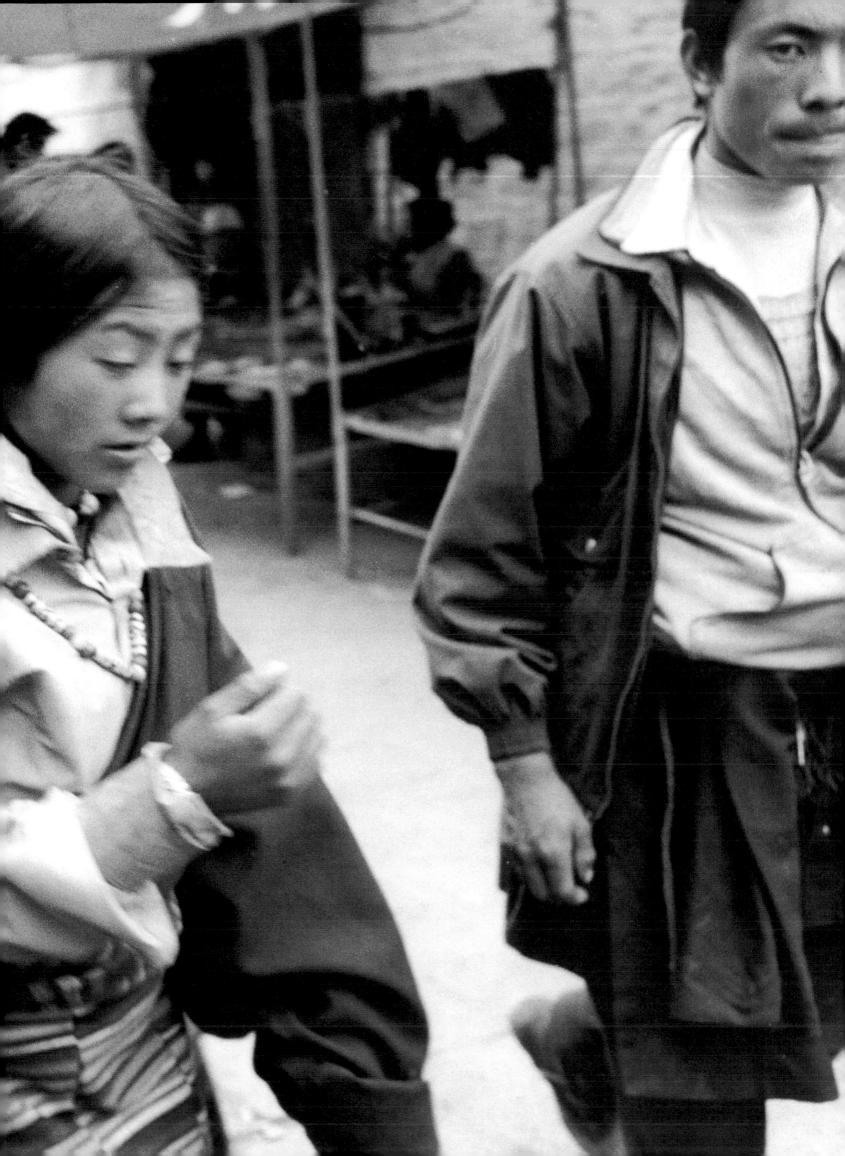

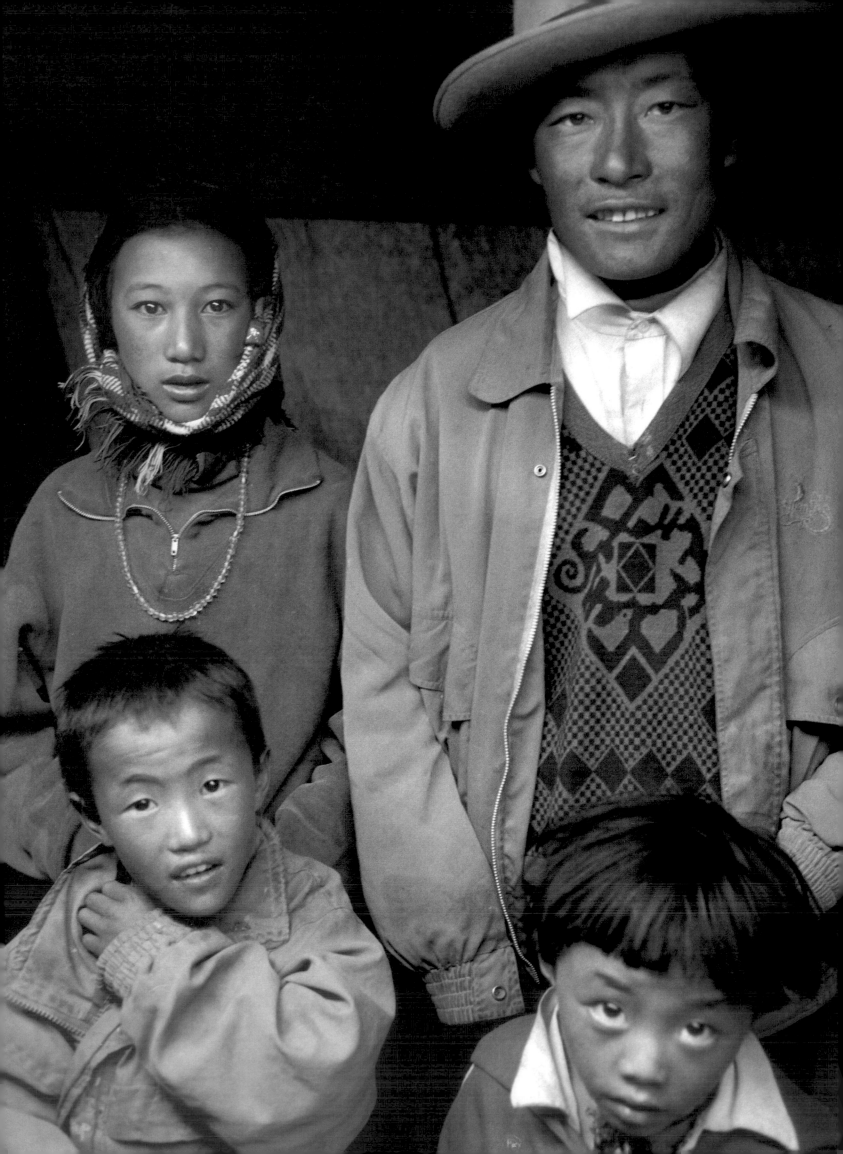

the

Tibetan market street in old-town Lhasa, Dekyl Shar Lam, is a river of animated commerce, high-pitched laughter, and pungent smells. Khampas, handsome men from Kham in eastern Tibet, with long braided hair tied up with tassels of red silk, tend their wooden carts piled with fatless haunches of yak meat. With large knives they slice off thick steaks of the dark flesh. Khampa men walk with a singular sense of arrogance and macho pride. They swagger and strut, wearing heavy wool coats and white shirts, with carved daggers tucked into their belts. Stylish warriors, Khampas command attention and respect.

It was the proud, fearless Khampa guerrillas who led the resistance against Mao Zedong's troops when China invaded Kham from 1956 to 1958. As the Chinese troops orchestrated a traveling circus of horrors, often including public executions by crucifixion, vivisection, and scalding alive, the Khampas trained themselves in commando warfare. Tibetans are peaceful Buddhist people, to be sure, but the Khampas fought back, unlike most Tibetans, who still believed that compassion alone could win out over evil. **The Dalai Lama once said that progress had cost the Chinese people their individuality, for "they not only dressed the same, but all spoke and behaved the same and, I believe, all thought the same."** [26] The Khampas pride themselves on their individuality and have many different leaders who forcefully protect their own commu-

nities. But in 1957, the Khampas joined together because they "just wanted to kill Chinese and get their country back."[27] And, not missing a chance to fight Communism on the world stage, the CIA supported the Kham rebellion by dropping American arms to the Khampa guerrillas. Yet it was not the CIA but the monks who gave the most support to the Tibetan rebels. Consequently, it was the Kham monasteries that the Chinese relentlessly and mercilessly bombed from the air. Along with the monks, the unarmed pastoral nomads also felt the wrath of China's aggressive retaliation after America became involved with the Khampa rebels.

The most notorious civilian bombing was of Lithang monastery in southeast Kham. The Chinese asked the abbots to inventory all the valuable objects in the monastery for shipment to China. The monks refused, and with the villagers, six thousand people locked themselves inside the monastery. For sixty-four days the Chinese laid siege before saying that they would bomb the monastery if the monks did not give up. The monks once more refused. So as a result, more than four thousand people, many of them women and children, were killed. As His Holiness the Dalai Lama soon realized, the Tibetans "would never be able to defeat the Chinese army. And however long it went on, it would be the Tibetan people, especially the women and children, who would suffer."[28]

The author Jamyang Norbu recounts a chilling scene following the Chinese bombing of nomads in eastern Kham: "I

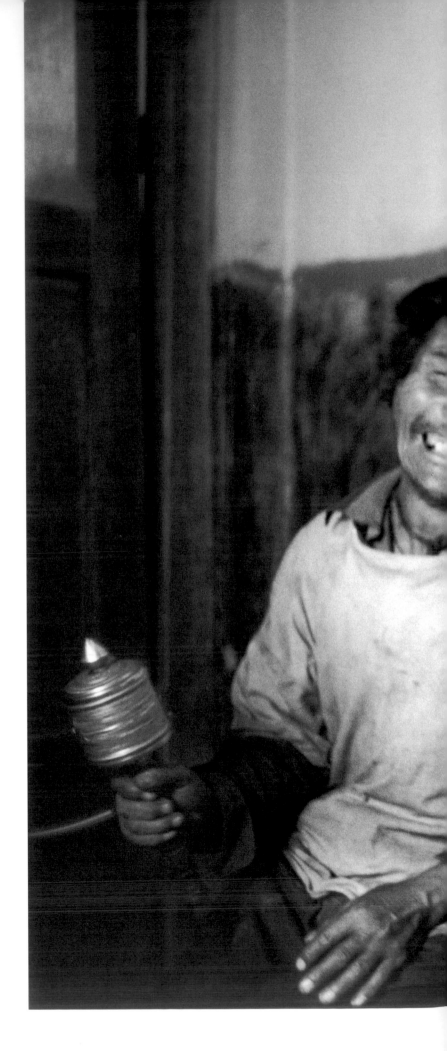

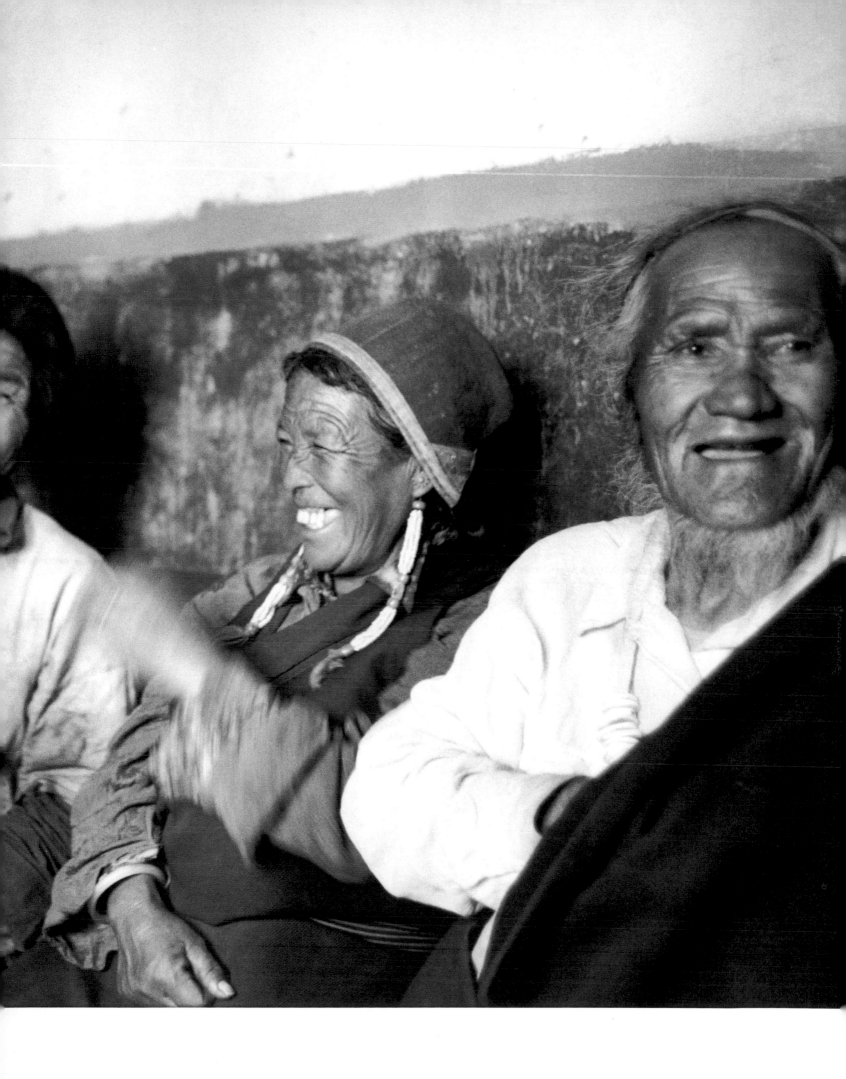

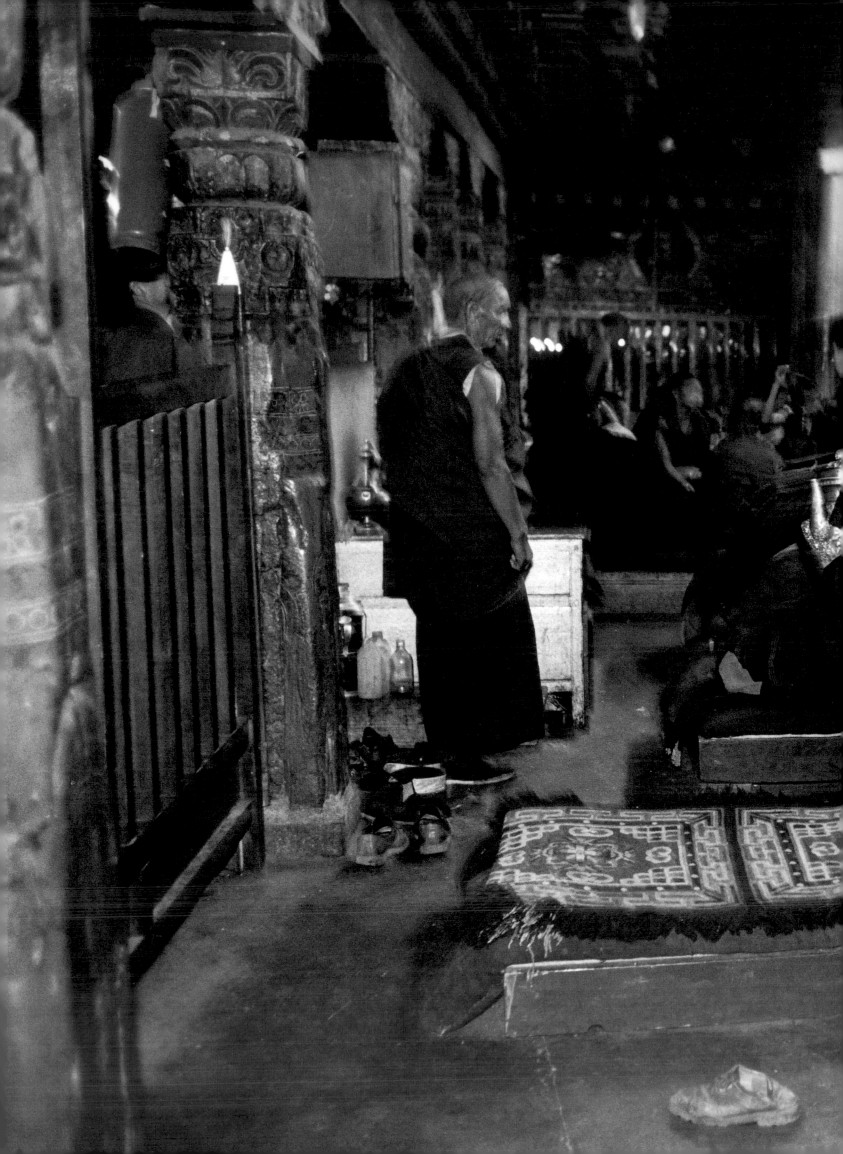

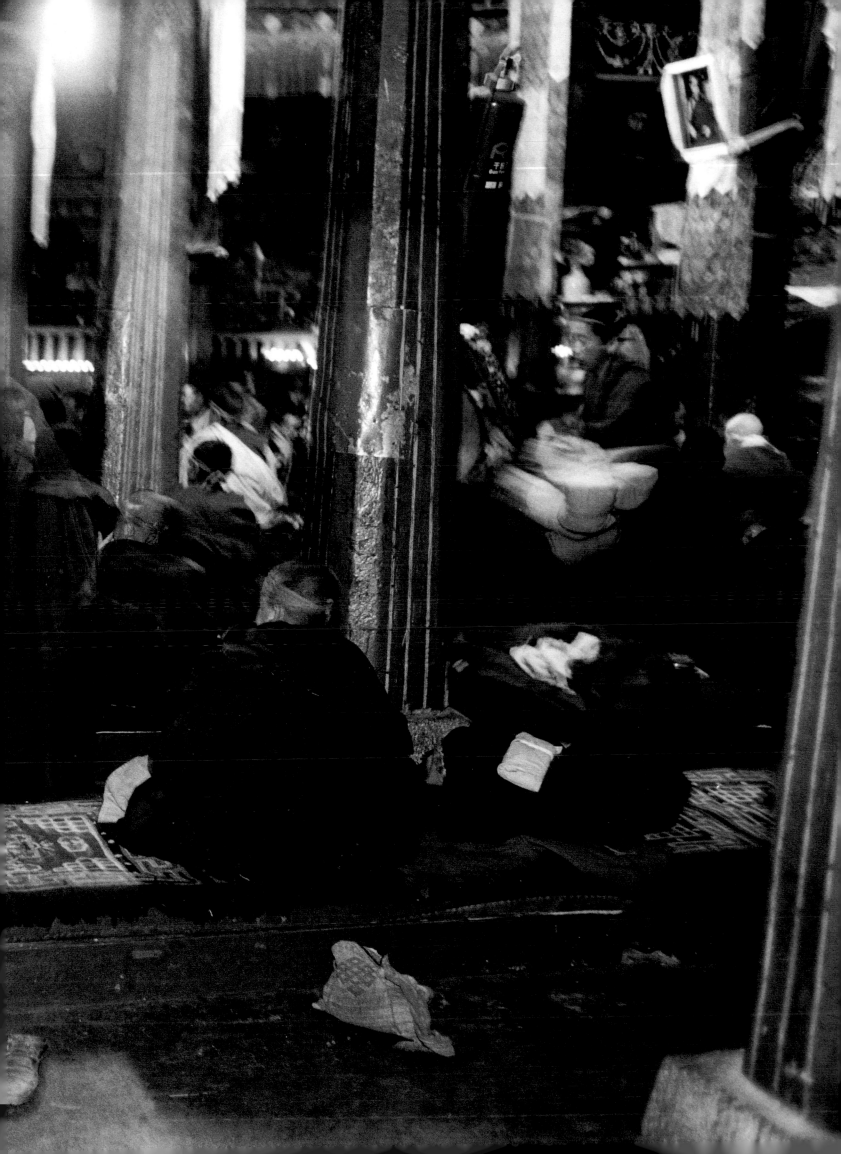

saw a woman lying on the hard earth clutching a baby. Both of them were dead, a dog was savagely tugging at the leg of the baby. But even in death the mother refused to give up her child."[29]

ALONG DEKYL SHAR LAM, glass cases on wheels are filled with strips of cooked meat and piles of oily, fried offal. At night, candles are set in these cases, and the glass steams up from the moisture given off by the warm meat as it combines with the cold air. Merchants sell stainless-steel pots, socks, pens, *mallas* (Tibetan prayer beads), and, increasingly, Chinese-made toys and clothing. It is a street full of greetings and friendship and endless chatter, a meeting place in the heart of Lhasa. Here, Khampa women, wrapped in bulky woolen coats, their long, waist-length braids bejeweled with turquoise rings, amber beads, and large pieces of coral, chat and laugh with each other as they sell their wares. Many of these women, with ruddy, wind-worn cheeks, flash two brilliant metal eyeteeth when they smile. There is a joyous spirit about the vanity and arrogance of the Khampas.

Sadly, though, the last time I was on Dekyl Shar Lam, a whole section of the wonderful traditional Tibetan-style architecture had been razed. The stench from the open sewers made shopping on the street almost impossible. Much of the old city of Lhasa is methodically being torn down and replaced by functional Chinese-run revenue hotels with chrome and blue-mirrored windows. The London-based Tibet Information Network has

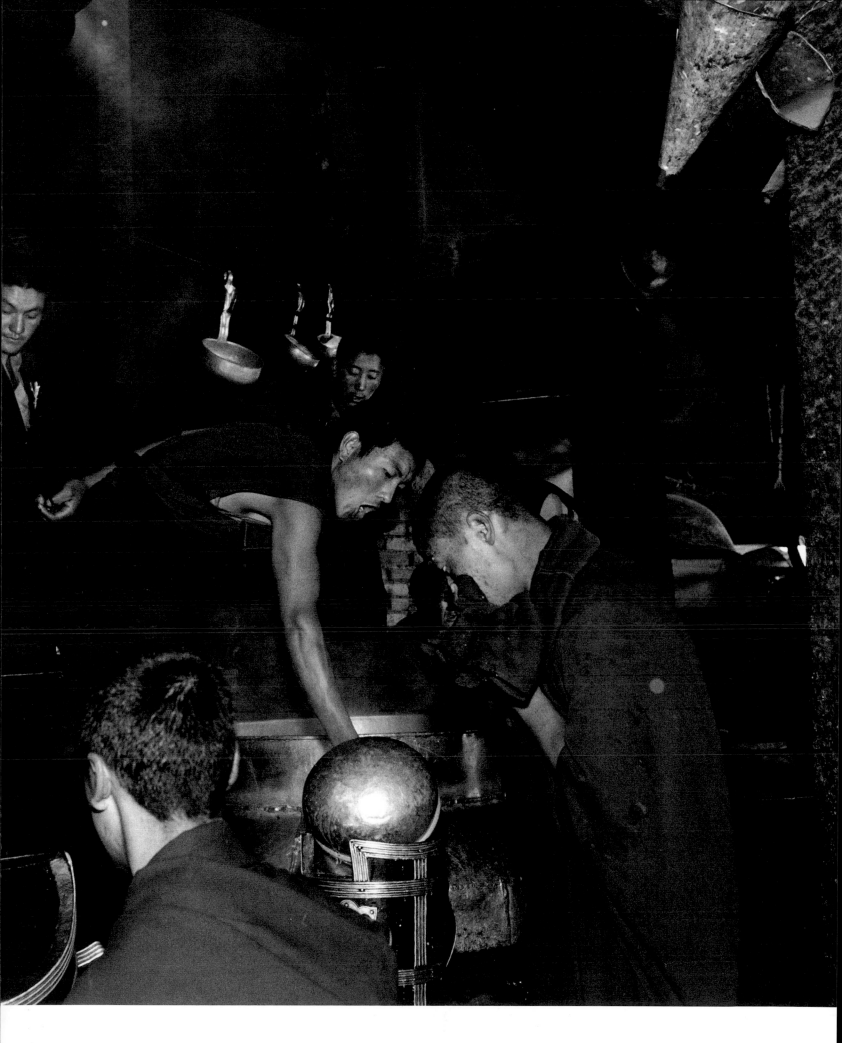

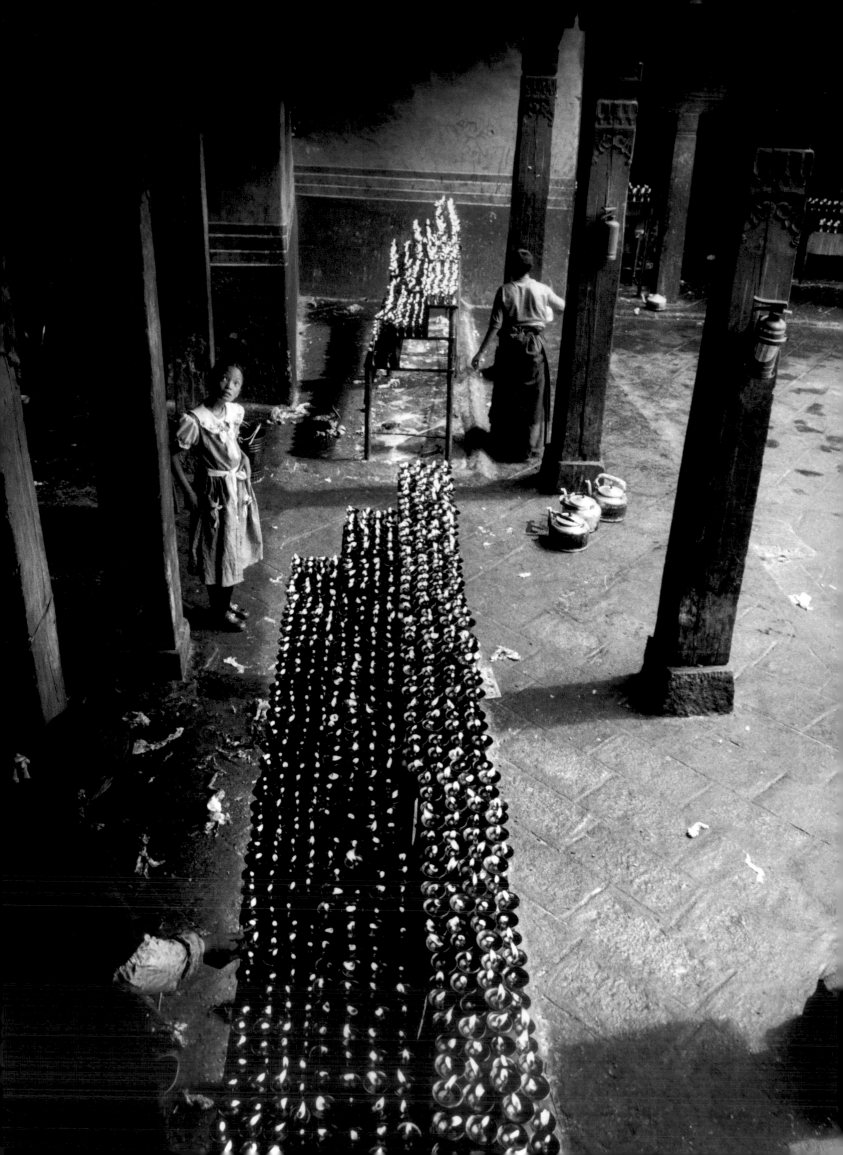

reported that by 1996 the Chinese plan for a five-year wave of modernization in Lhasa had led to the demolition of 350 of the 600 historic buildings in Tibet's capital city. This agenda of destroying Tibet's architectural heritage continues to this day. Tibetan houses and shops are being demolished in a brazen effort to strip away any Tibetan identity from the streets. Even shop signs have been standardized by the Chinese. Old Lhasa is quickly becoming a new Chinatown.

Dekyl Shar Lam leads down to the main Buddhist temple in Lhasa, the Jokhang. Circling the Jokhang is another street market, the Barkhor. The Barkhor is a strange mix of shopping and praying. Pilgrims walk the circular street around the temple, starting and ending at the two large stone incense burners in front of the Jokhang that spill aromatic clouds of juniper smoke across the open square in front of the temple. Many worshipers do the entire route prostrating themselves over and over again. Often protected by oval wooden pads on their hands and leather aprons on their bodies, these hard-core pilgrims are sidestepped by eager shoppers and faster, strolling Buddhists. Some of the young street urchins making the rounds on their bellies are doing it for people who have paid the children to do their prayers for them.

The shops around the Barkhor are changing, too. More and more non-Tibetan stalls are opening up to sell ugly Asian rip-offs of American products: Marlboro cigarette T-shirts, polyester pantsuits, and just plain, plastic junk. The Barkhor used to be the most exotic market in the world.

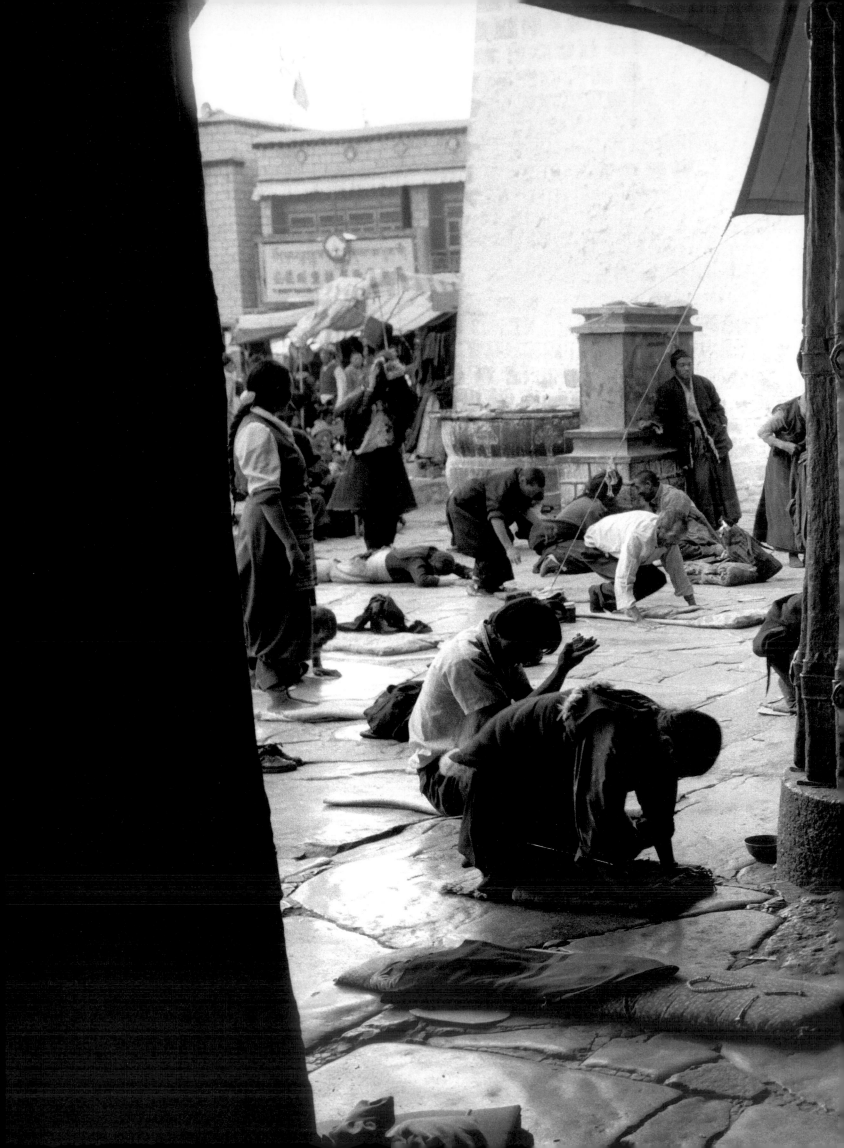

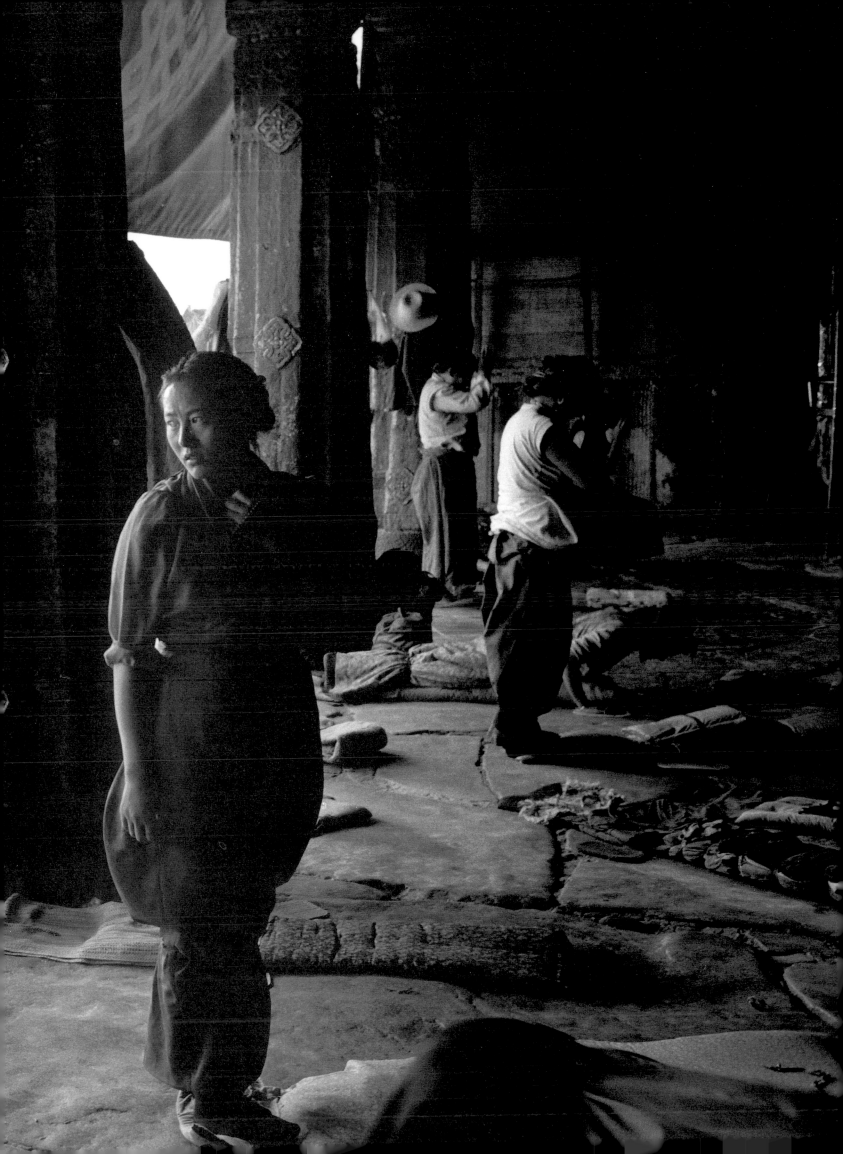

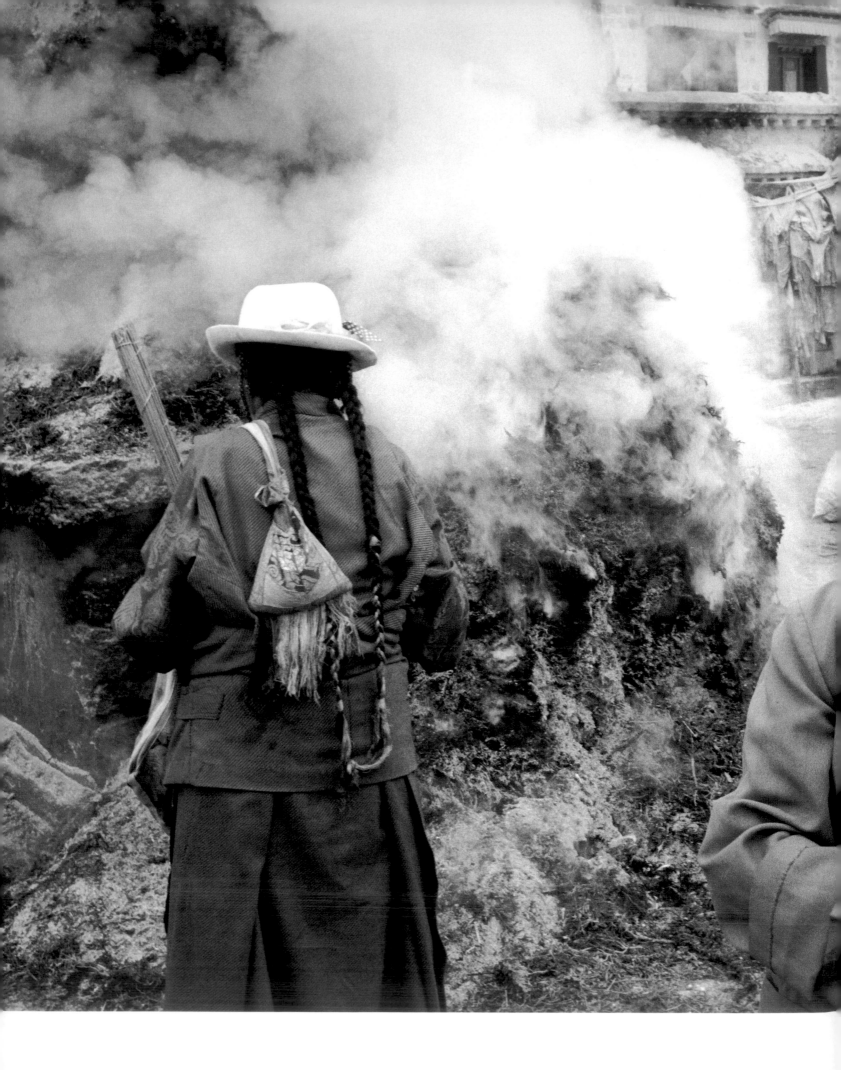

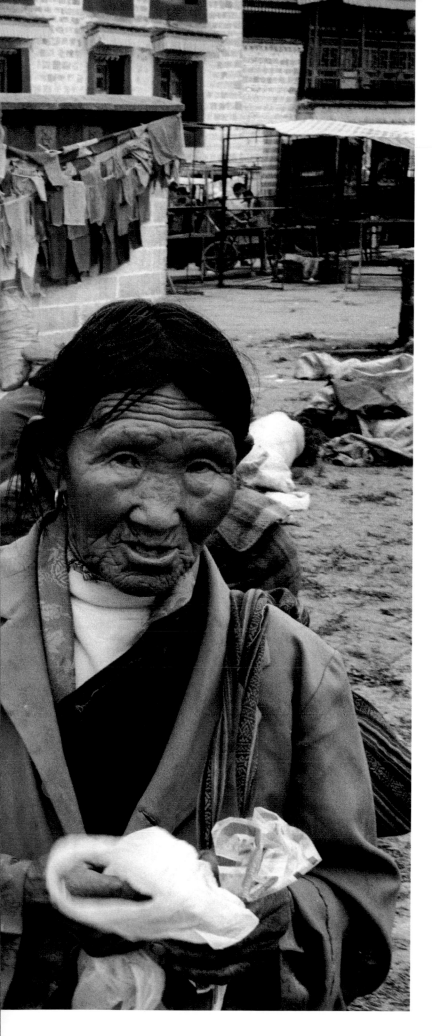

You could buy a carved bowl made from a human skull, a necklace with a river of blue-green turquoise, and detailed ink-encrusted printing blocks of Tibetan prayers in Sanskrit with images of flying horses. You can still see some of these treasures on display, yet the tinny loud-speakers used by shouting Chinese merchants and the annoying blast of Asian pop music are turning the magic and the mystery of the Barkhor into a tasteless mall.

One of the more bizarre versions of Asian pop to be found in Tibet is the Chinese singer Dadawa, who in 1996 had an international hit with her recording of *Sister Drum*. The record is a repugnant Chinese aping of Tibetan culture as a novelty act. Dadawa even appears on the cover of *Sister Drum* wearing a Buddhist nun's robes.

IT GETS UGLIER farther down Tsang Gyu Shar, the long street that runs parallel to the Kyi Chu River. First, you enter a Chinese market. A woman in a straw hat, silk dress, high heels, long blood-red nails, and a gold ring on each of her fingers plunges her hand into a pail of live eels. Her smileless face stares at nothingness as she pushes the squirming eels into a used plastic bag. Overhead, a makeshift fiberglass roof casts an unhealthy green glow over faces and the buckets of half-dead catfish and the crammed cages of half-feathered chickens and pigeons. It is one of the most depressing places I have ever visited. Joyless and cruel, the merchants spit and crouch in the dirt; then, tossing their cig-

arette butts toward the cages, they drink long mouthfuls of cold tea from glass jars.

Still farther along Tsang Gyu Shar there is a long line of Chinese brothels. These are nothing more than storefronts opening to the street. Inside, fake leather couches face the window toward a wide sidewalk littered with candy wrappers and cigarette packages. Seated on the sidewalk in straight-back kitchen chairs are groups of prostitutes, knitting. They wear short skirts and heavy white face makeup that becomes garish and utterly burlesque in the hard sunlight. Their over-red lips seem to float, unattached to their pasty faces. Inside, groups of men and women loll on the sofas. They smoke and drink tea and stare at the street. On the walls over their heads hang large colored posters of fresh vegetables. Every brothel is the same: large glossy posters of vegetables. In the narrow hallway are a number of red and purple velvet doors that lead to closet-sized rooms. By the doorways, baskets of plastic flowers fit perfectly with the garish vegetable posters.

At the end of Tsang Gyu Shar, you can turn up Chingdrol Lam, the street that travels to the statue of Golden Yaks. These chunky yaks commemorate forty years of Tibetan "liberation" by the Chinese. On the way to the yak statue are more brothels. Pimps in oversized suits—large labels still proudly sewn to dangling sleeves—sit with their ladies. "Oversized" is the key word here: large double-breasted suits, wristwatches the size of hubcaps, and sunglasses as big as wind-shields. It is a far cry from old Lhasa, the

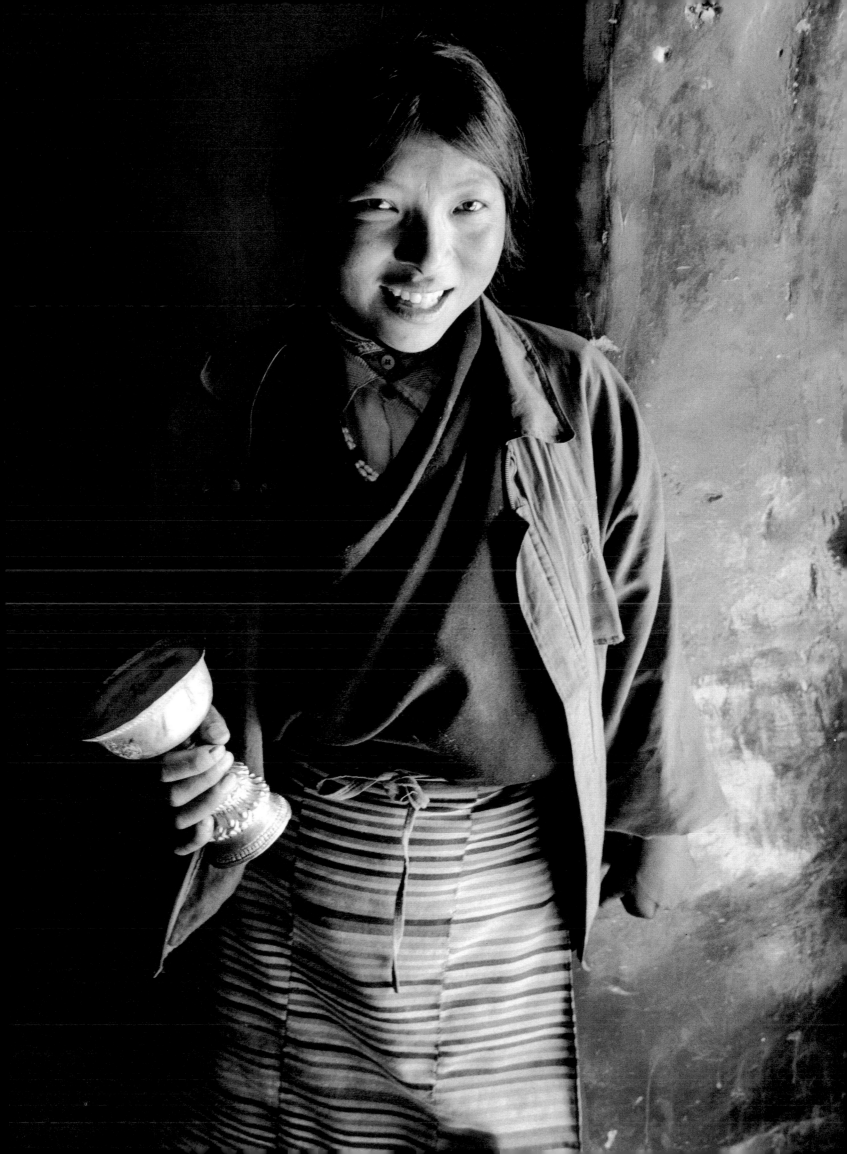

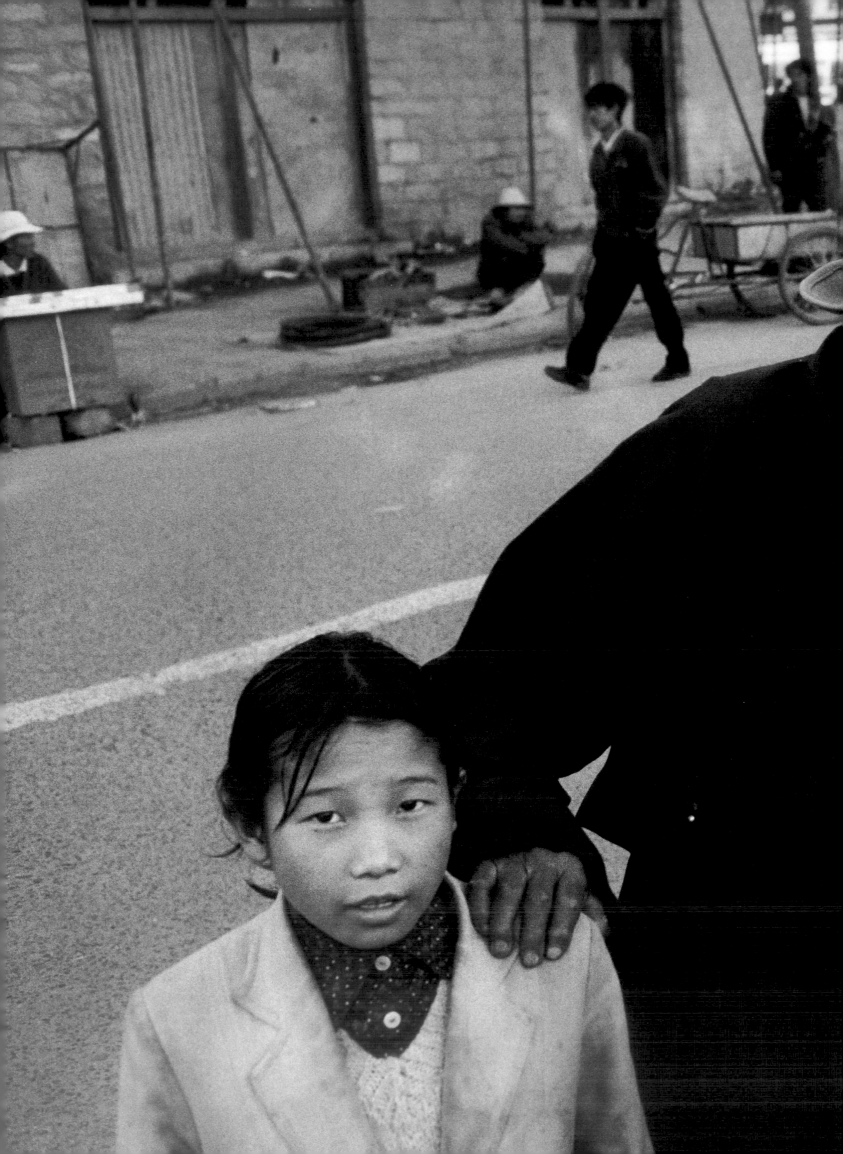

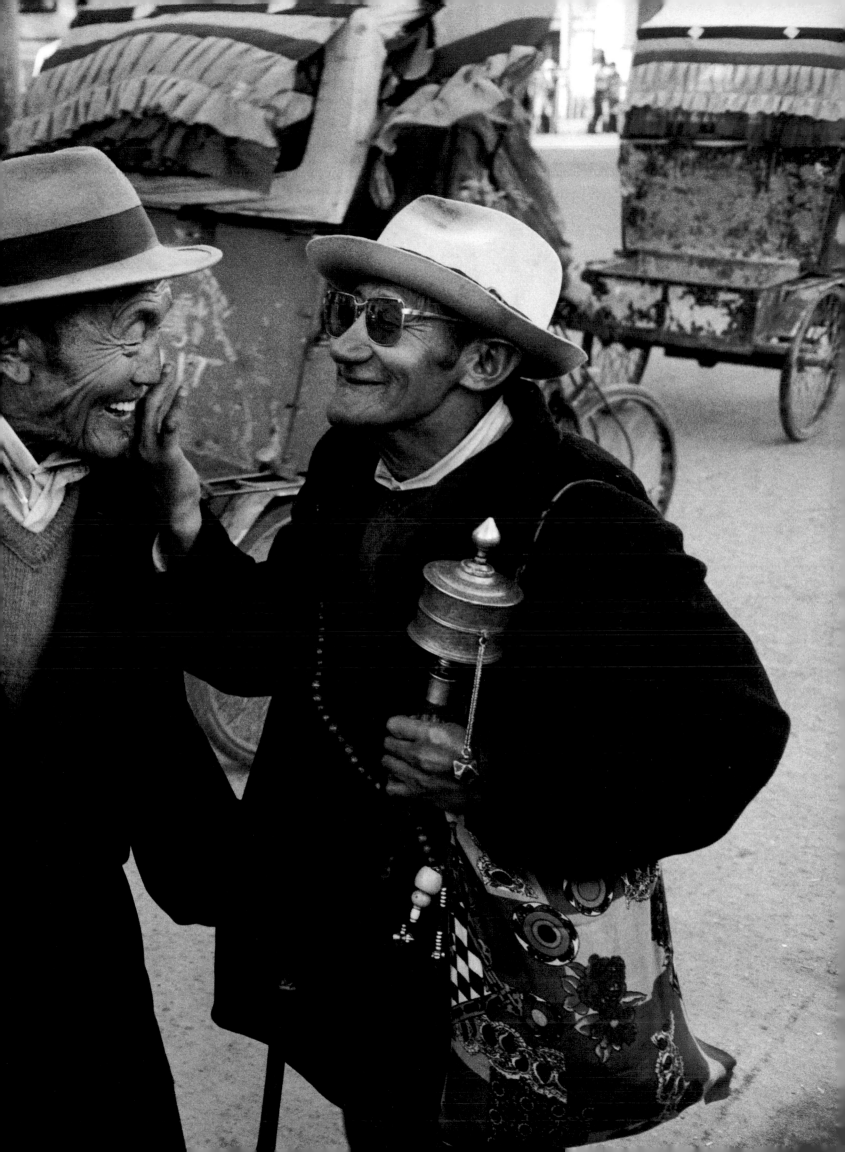

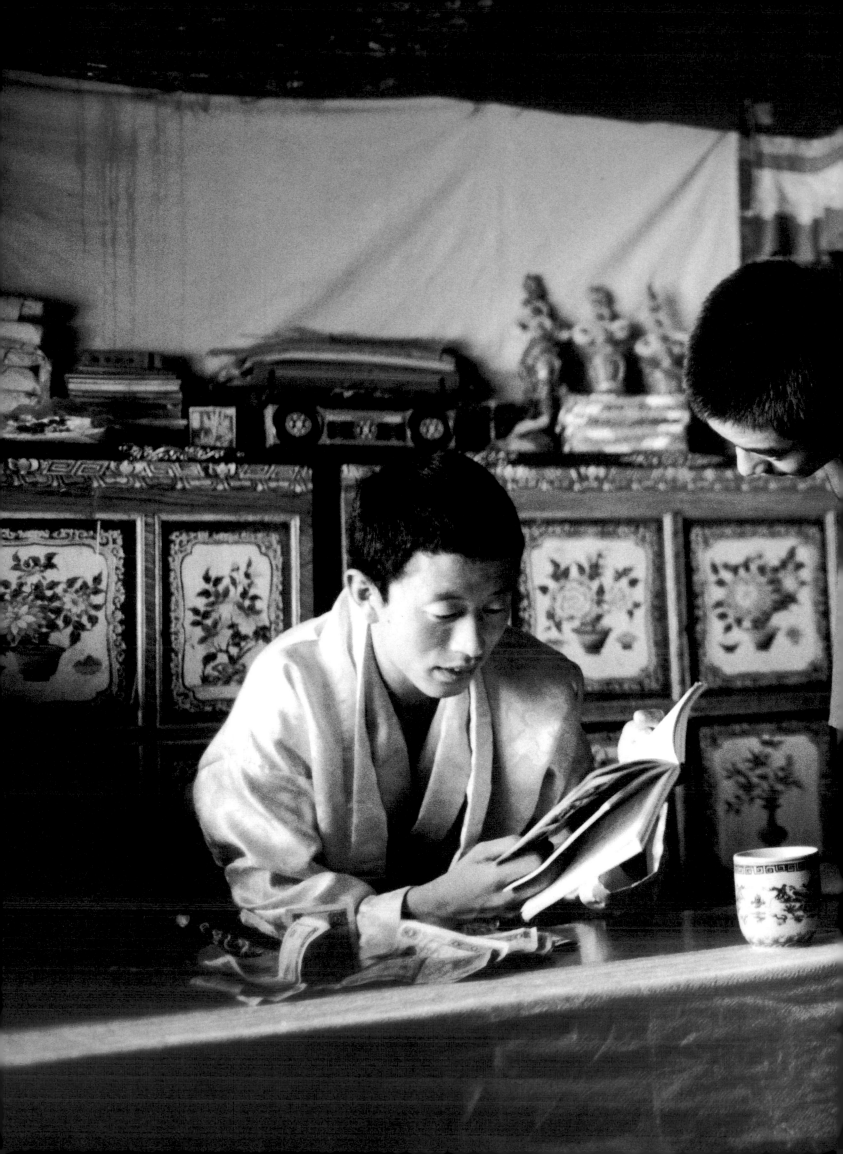

street market, the silk tasseled Khampa butchers, and the strange electric excitement and tradition of the Barkhor.

The Chinese section of Lhasa looks cheap, crass, and utterly tasteless: gaudy posters, plastic flowers, cheap sex, cheap architecture, cheap ethics. There is no fun and no faith in this part of town, only dying animals, fish, and birds, and people whose lives seem not much better.

I REMEMBER RETURNING to my room in the old part of town after walking through the brothels and markets of Lhasa's Chinatown. Just as I arrived in the hotel courtyard, a hailstorm opened up and dumped a blanket of icy snow over the ground. Within seconds the laughing Tibetan staff of the hotel tumbled into the courtyard for a snowball fight in their heavy woolen and fur coats. They took handfuls of the snow and shoved it down each other's shirts as they shrieked and chased each other around like kids. Their enthusiasm and laughter were as explosive as the storm itself. I thought of the unsmiling Chinese merchant in the silk dress and gold rings who fished out the eels. I thought about the whores in the white makeup on the sofas with their silly pimps. As I watched the Tibetan snow frolics, these contrasting images said so much about the two cultures that now lived side by side, but worlds apart, in Lhasa.

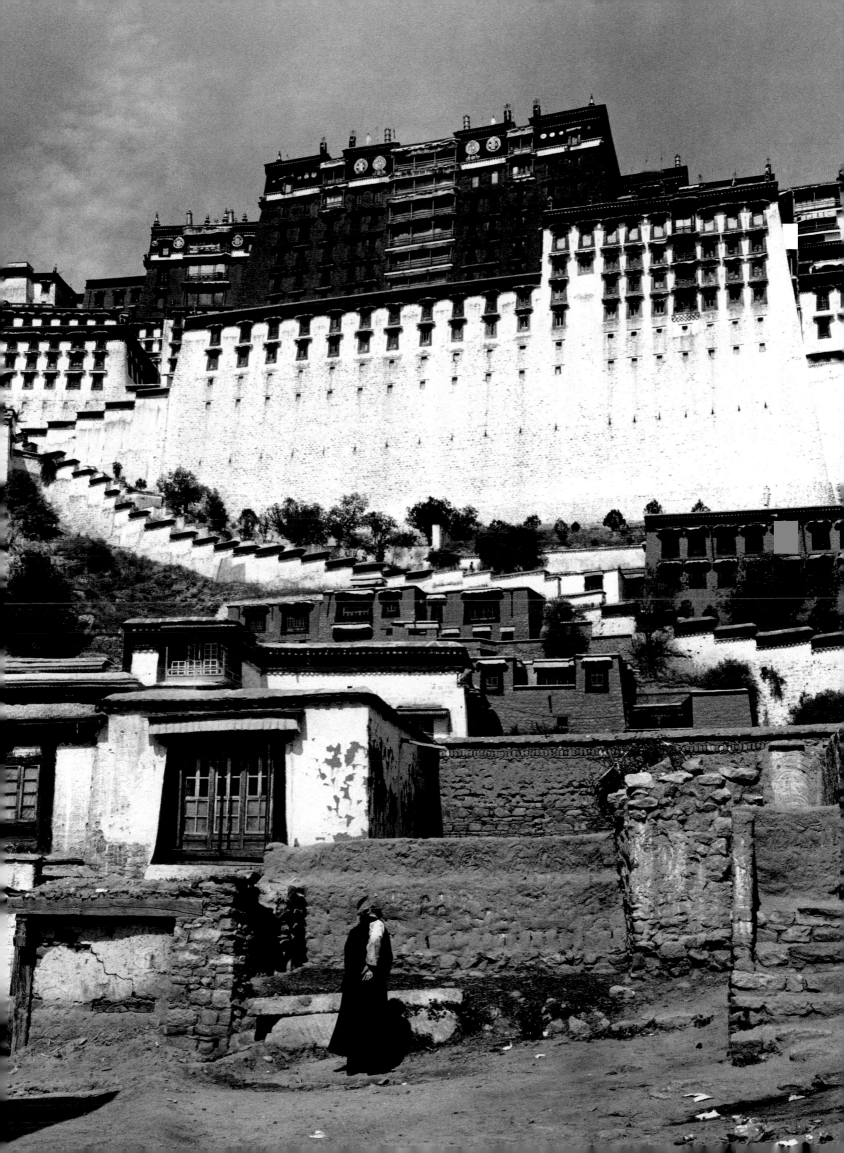

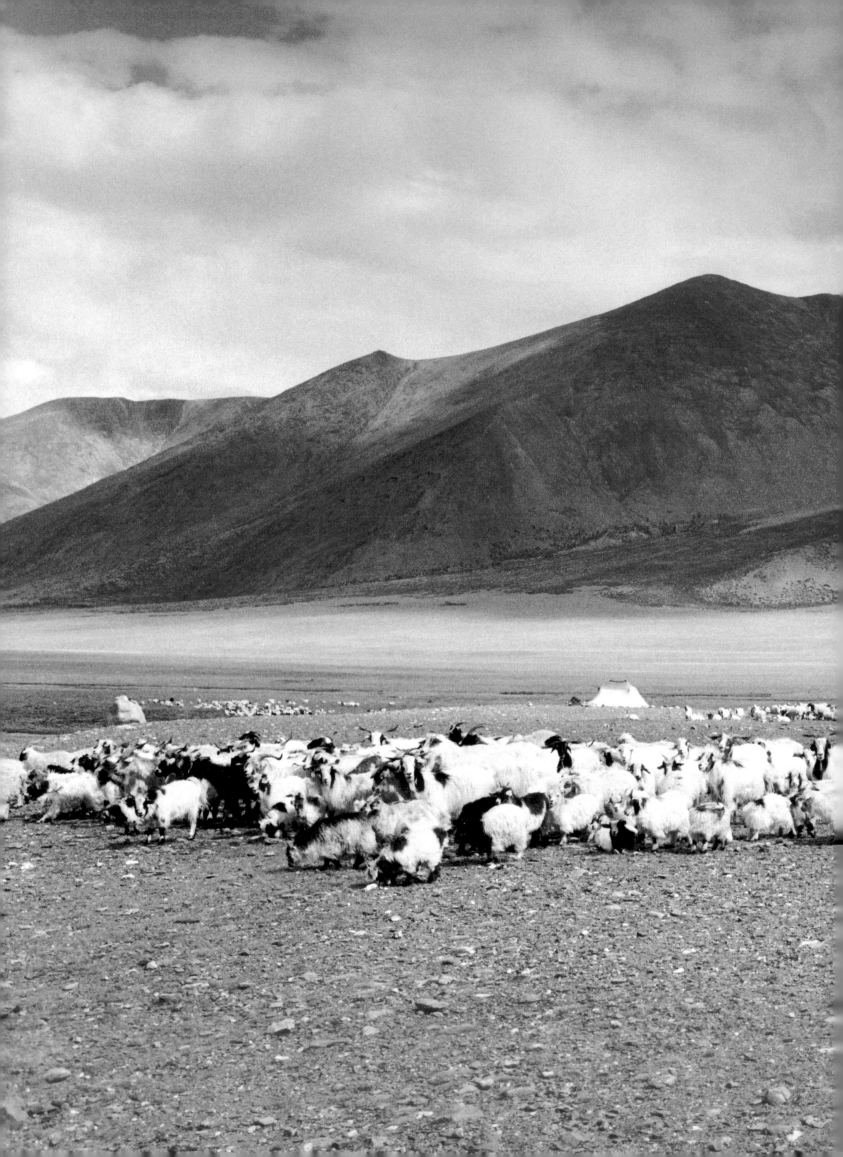

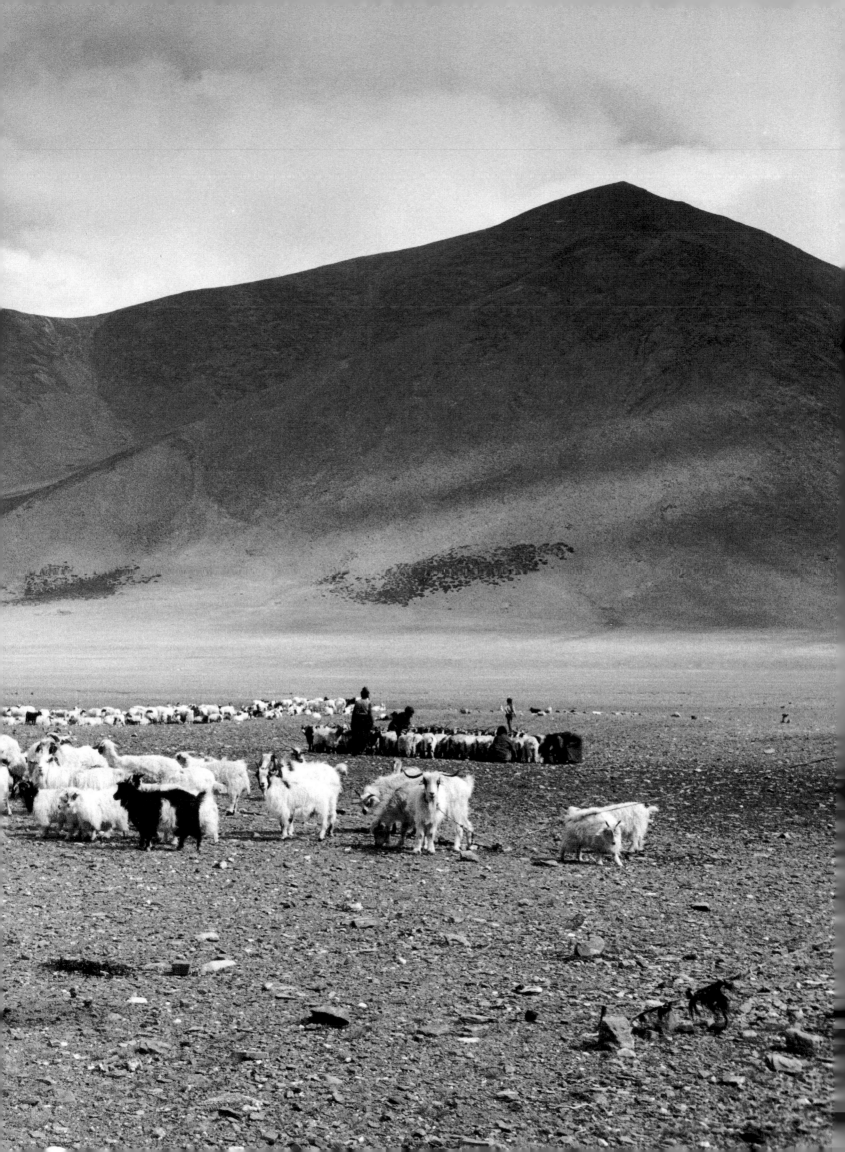

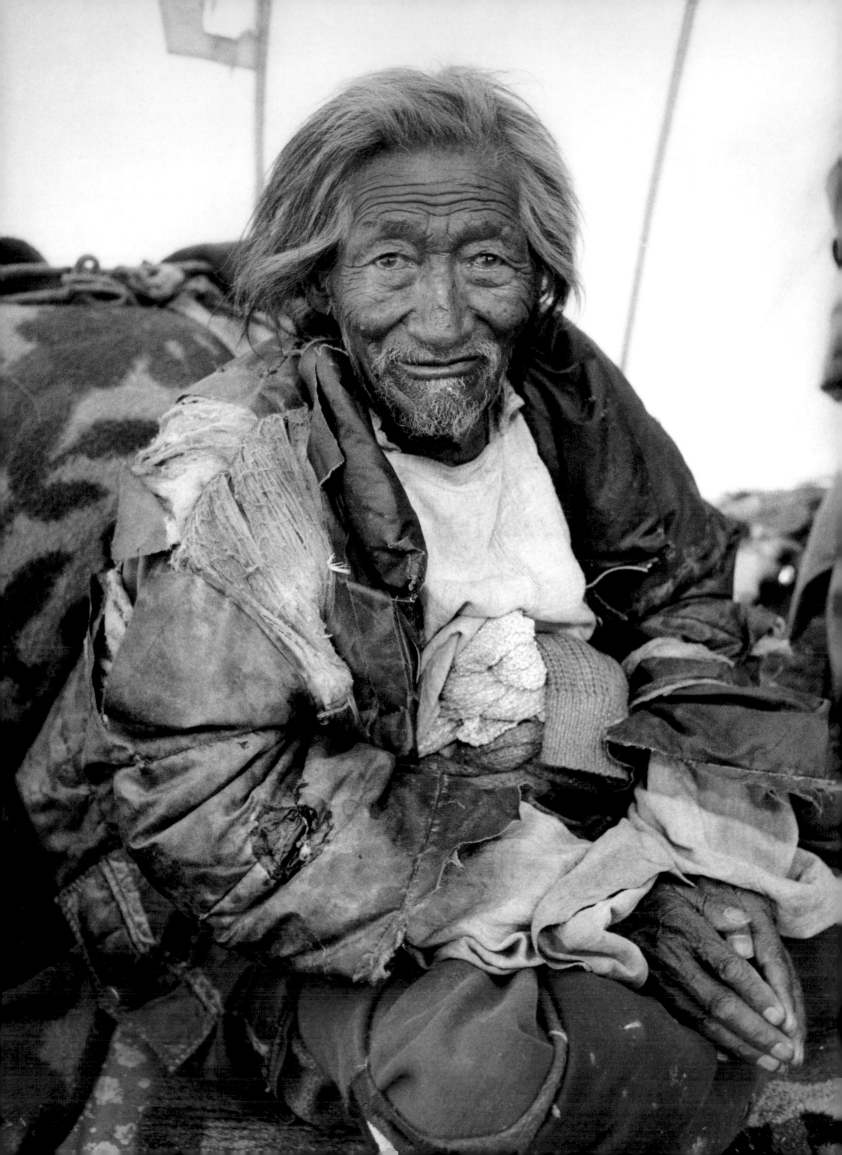

i had

a terrible headache. The nomads in whose tent I was sleeping thought my headache was caused by the altitude. On the Chang Tang Plateau it is common for the Himalayan height to push Western visitors to dangerous states of pulmonary and cerebral edema. The human heart gets lazy when the air gets thin; the heart does not have to pump as hard, so it doesn't. As a result, blood and other bodily fluids collect and pool up in hidden carnal eddies: in your brain, in your lungs. Monster headaches and difficulty breathing are common. So is death.

My Chang Tang headache was one of those helmets of pain that reduced me to a primordial position, an embryonic curl, with my hands over my eyes and my stomach climbing, burning, into my throat. The sound of a herdsman's boots on the fresh snow outside the tent or the light from a butter lamp glinting off the battered kettle atop the fire was enough to cause my brain to spasm in an agonizing tremor.

The nomads did not know that even at sea level I got serious migraine headaches. I tried the best medicine I had with me, a pill called Imitrex, which goes into the brain's chemistry and narrows swollen blood vessels. Back home, Imitrex is called a wonder drug. But here on the snow-covered plains of this mountainous desert, it had no effect. My brain was about to burst, and I could see myself as a future figure of nomadic folklore—the Westerner whose head exploded. Children

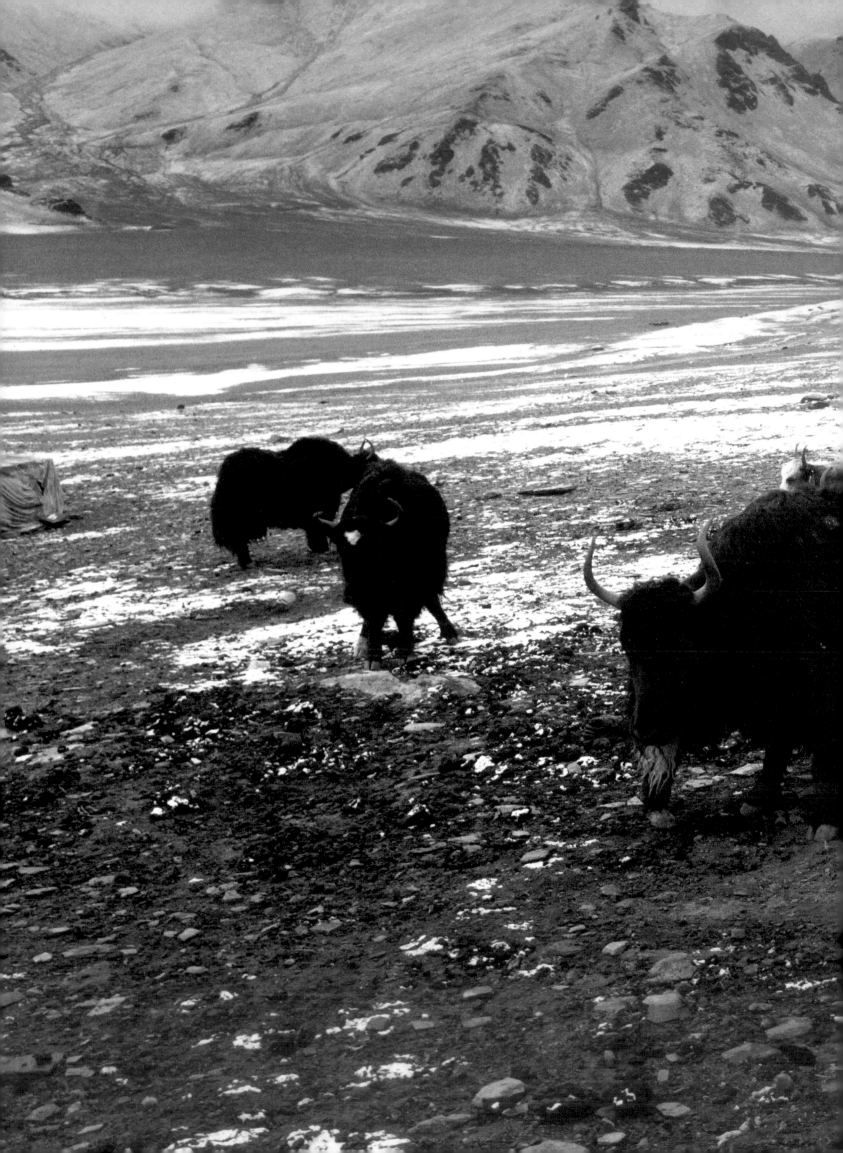

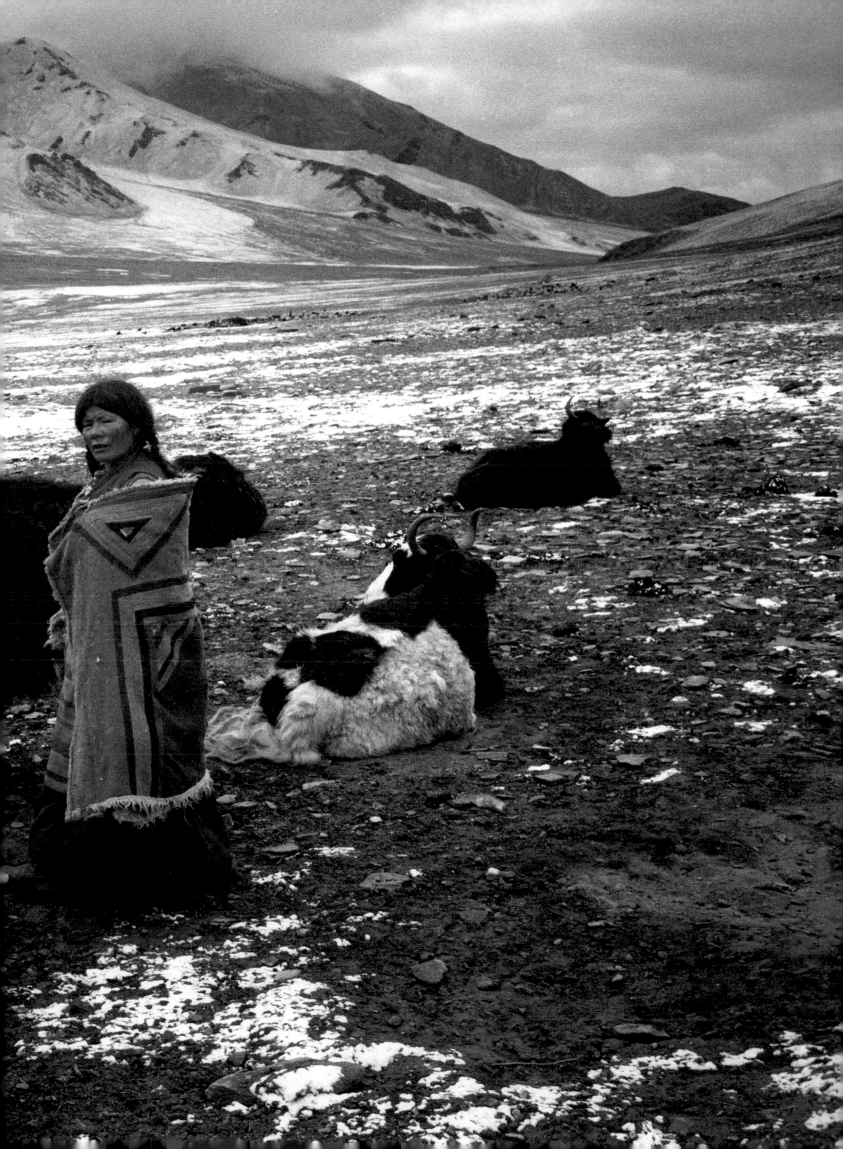

from Amdo to Ngari would hear tales of how a wrathful deity crept into my tent, hidden under the fur of a goat (there were many roaming around in my tent), and then climbed into my brain, where it set off a Chinese bomb.

The real problem was that the day before had been beautiful. But today the brilliant sunshine had been dramatically and quickly replaced by a sudden snowstorm. The air pressure took a nosedive, and a massive migraine settled behind my eyes. As I lay motionless, the nomads became increasingly concerned. Yet, first, before tending to me, they had to collect the snow. Because there is so little drinkable water on the Chang Tang—after all, it is a desert filled with brackish lakes—a snowfall like this one was manna from heaven. The nomads ran from their tents with tea urns, pots, and old oil drums abandoned by the Chinese army and filled them to overflowing with the soft, loose snow.

In the end it was a ginger, garlic, and melted-snow broth, swimming with swollen flakes of dried yak meat, that eased my headache—that and the prayers sent spinning skyward on my behalf. In another black tent there might also have been a shaman, similar to the old one I was about to meet, who had made a *tsampa* effigy of me to absorb my pain.

A few days later I entered another nomadic encampment in the same area. The last remnants of the snowfall still lingered in the long shadows behind the piled rocks that surrounded a shallow pit dug to keep the baby lambs warm at night. The bleating lambs poked their tiny

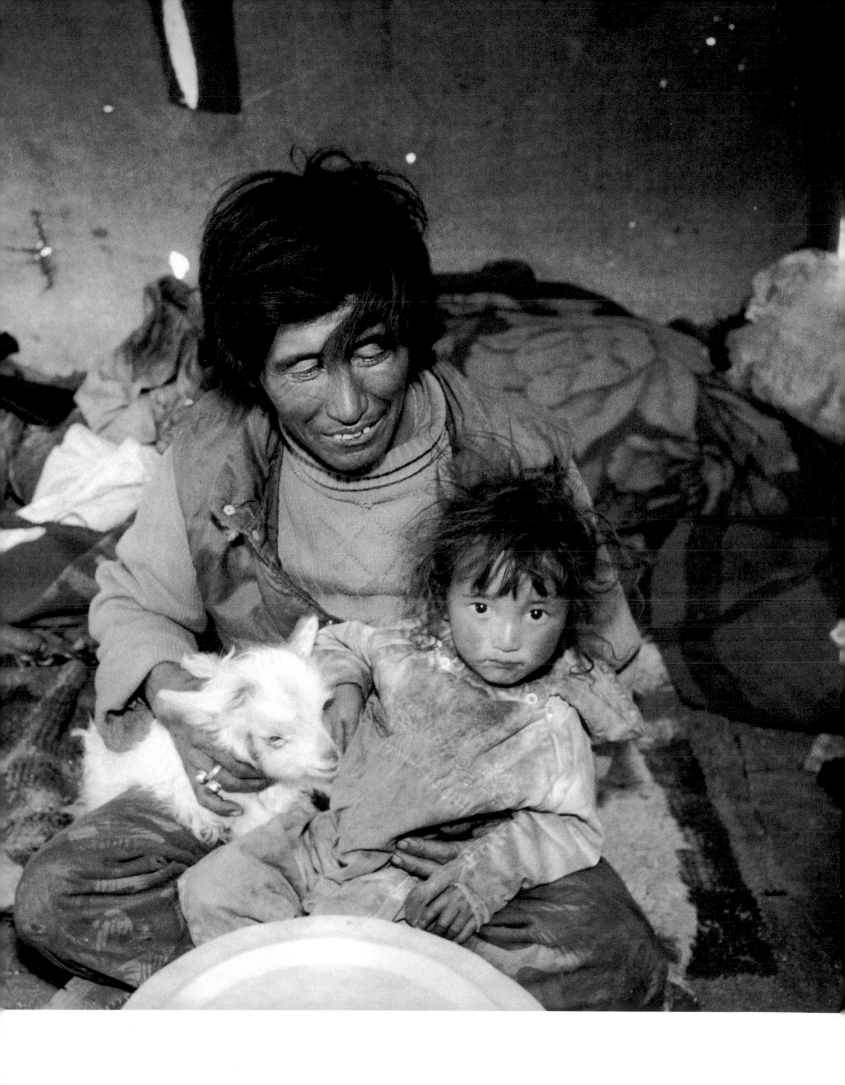

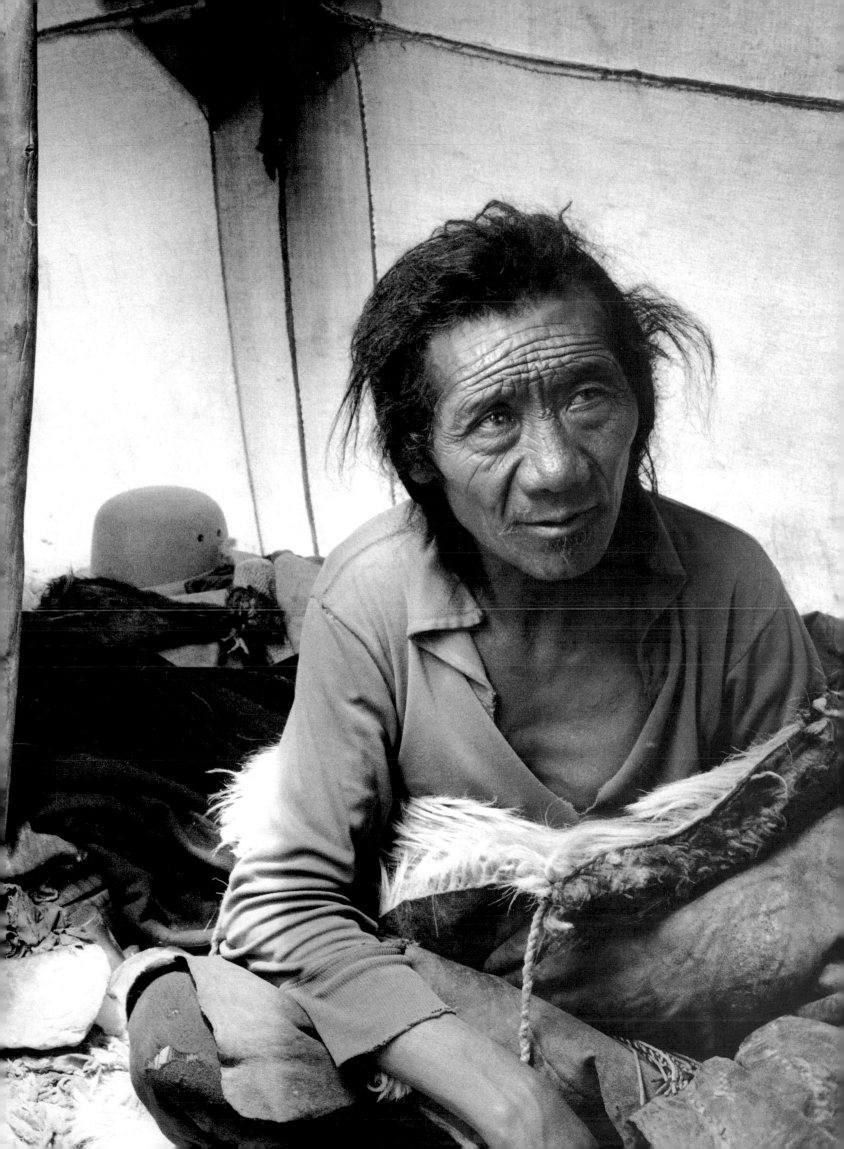

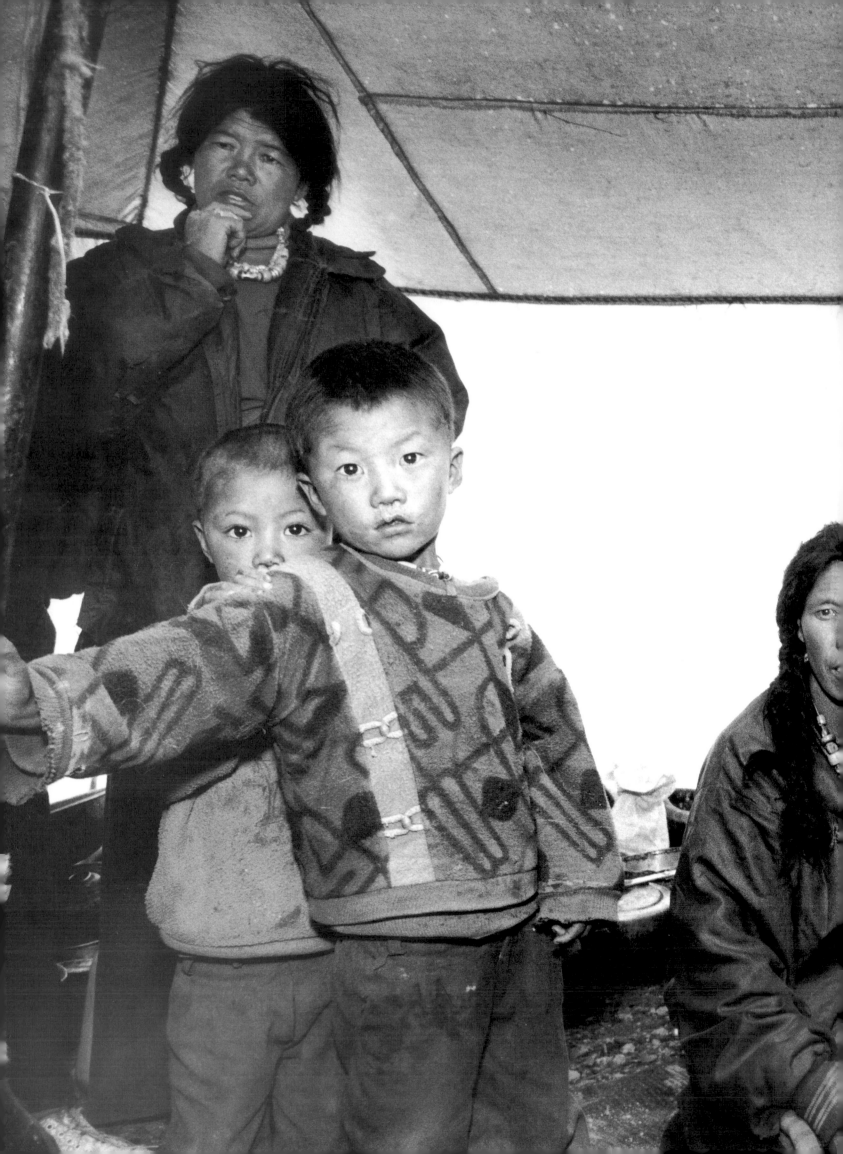

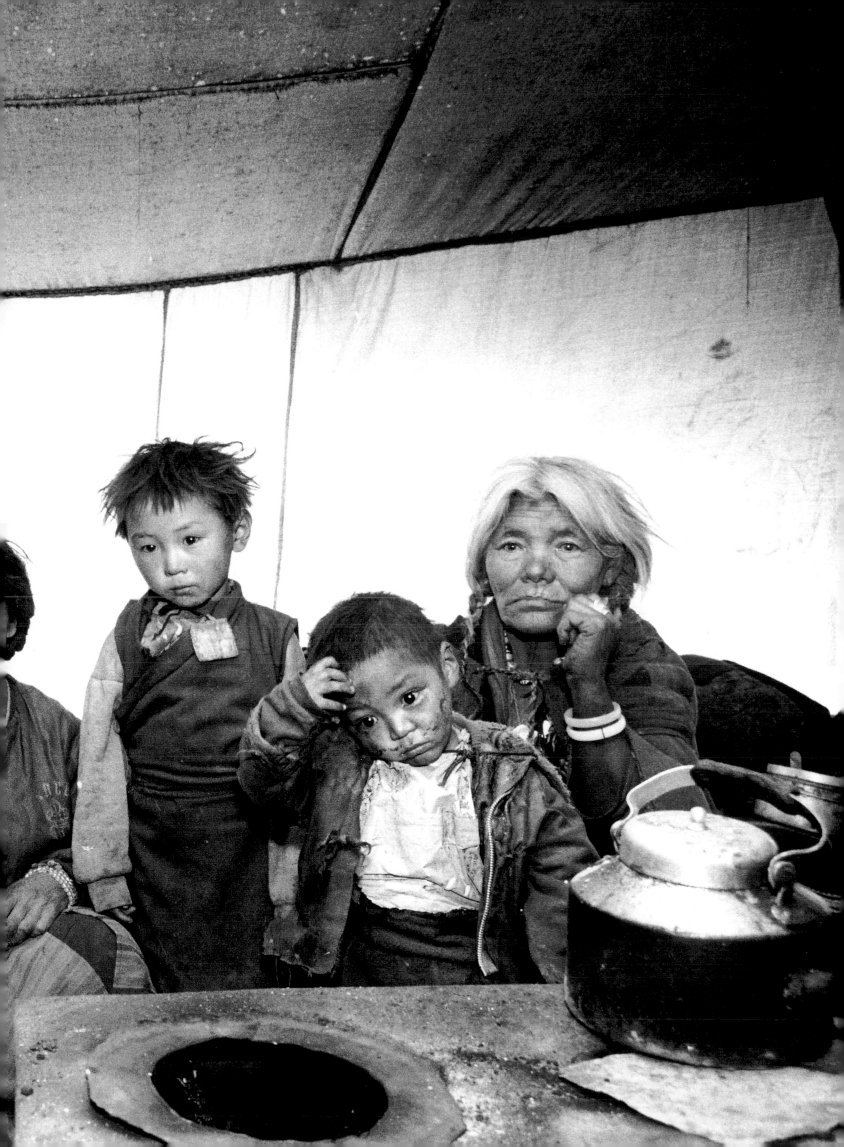

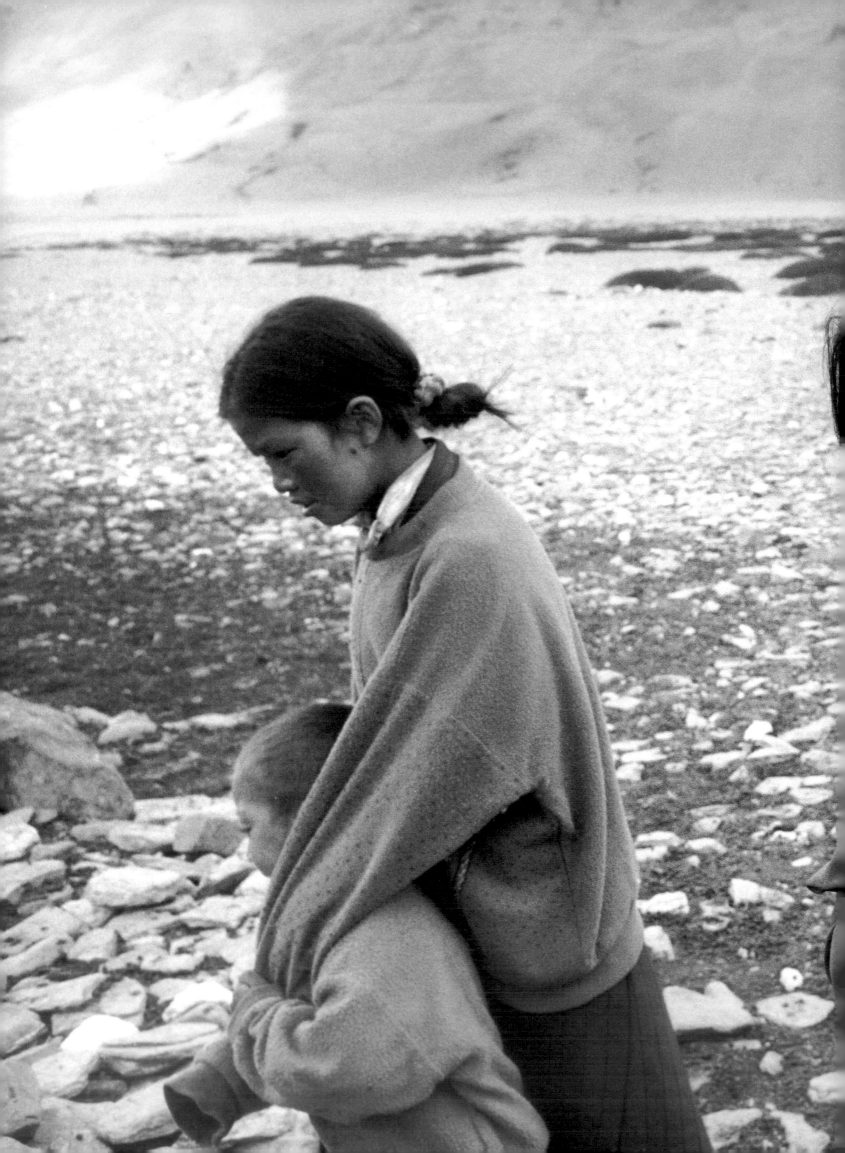

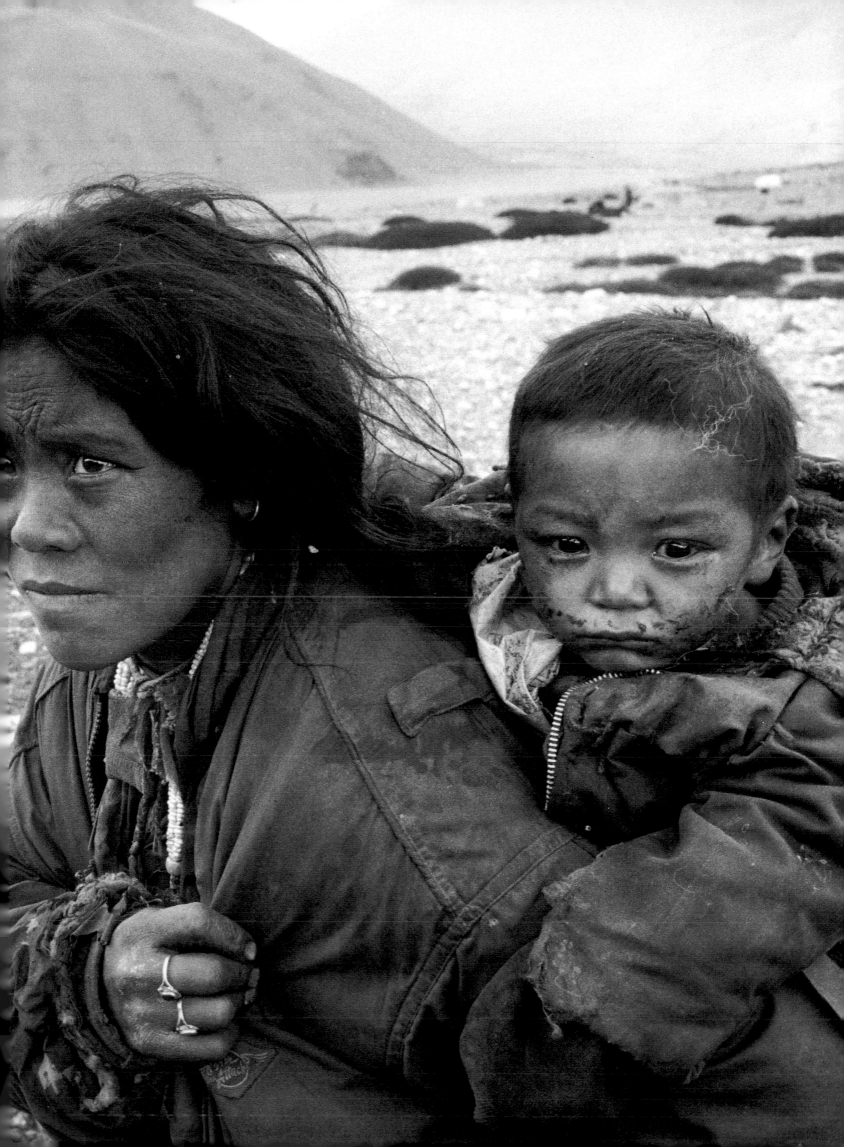

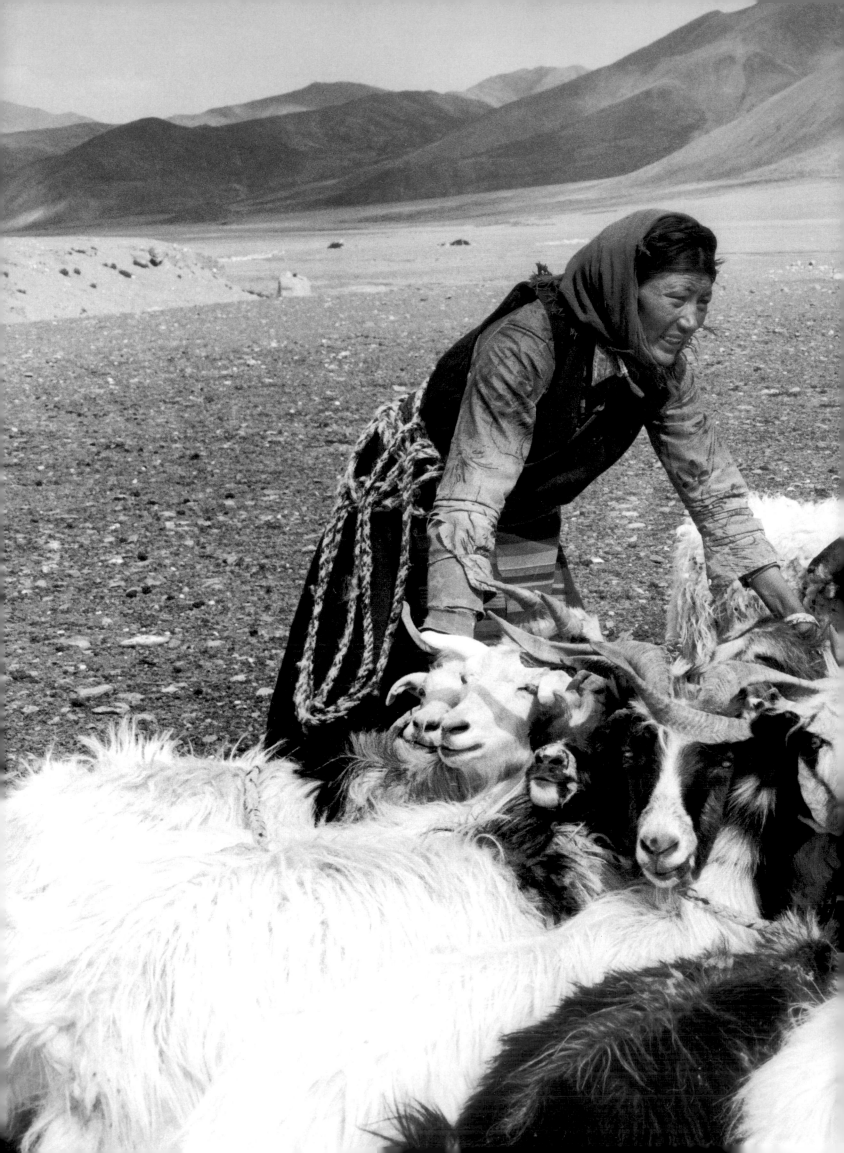

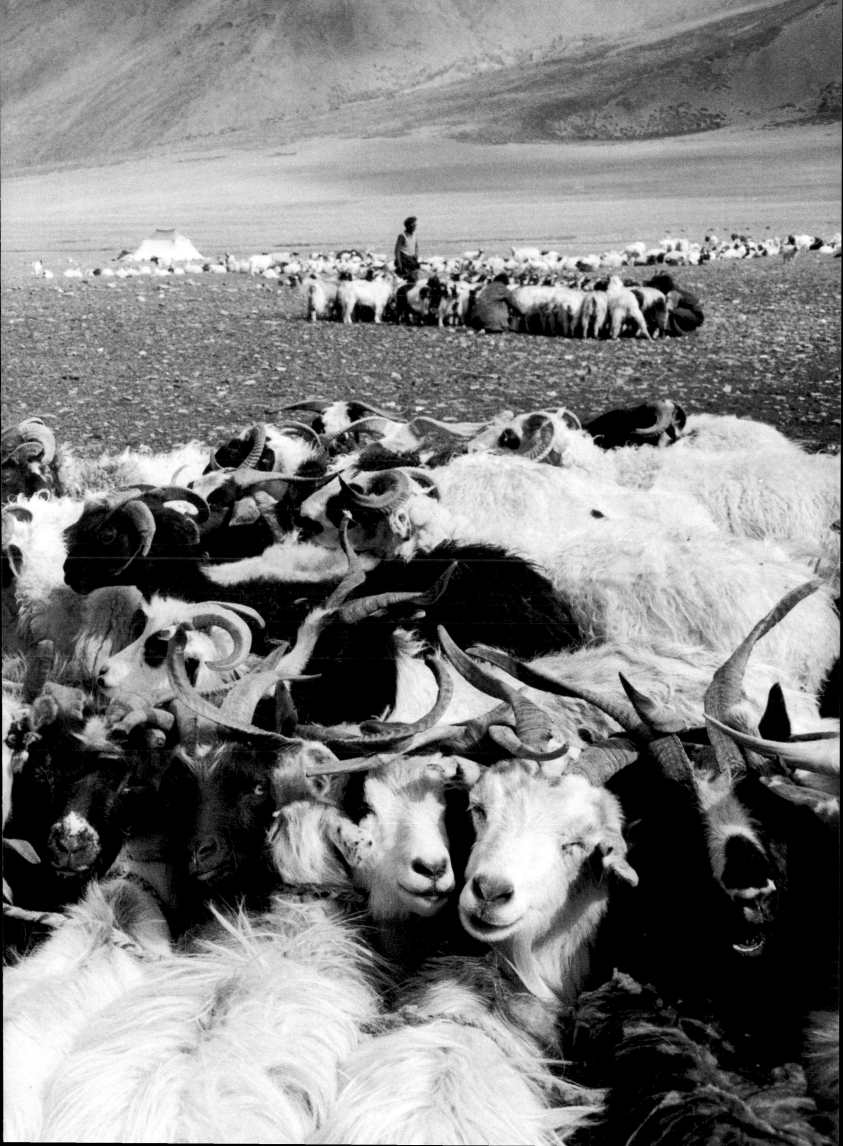

wet noses out from under their cover into the crisp morning air. A young girl with bits of dried grass and black goat hairs caught in the rough weave of her cloak ushered me into a tent where an elderly man with shoulder-length white hair and a large turquoise earring was making two *tsampa* effigies out of moistened barley flour. They were crude stick figures, which he quickly hid from view by turning his back to me. As I drank butter tea with his family, the old man kept working on the figures, adding bits of paste to their arms and legs. Then he dressed the small effigies in doll-sized orange clothing.

DURING MY TRAVELS in Himalayan Buddhist countries I have had many different lamas, shamans, and the odd *amchi* or *onpo* try to solve the mystery of my headaches. An *amchi* is a Ladakhi healer who uses ancient Buddhist texts dealing with anatomy and the preparation of Tibetan medicines. The key to an *amchi*'s healing is the taking of one's pulse to read the energies of one's blood. He uses the Tibetan forms of medicine and puts much credence in the color and texture of his patient's tongue and eyes. An *onpo* is an astrologer. He reads the cosmic signs to make sure one's daily decisions do not become disasters: the site for a new home, the time for a funeral. Often rice or dice are thrown and patterns of the future are read.

My first experience with an *onpo* was when Dechen, a young Ladakhi woman from Changspa, a village just west of Leh, took me to her family *onpo*. She said this

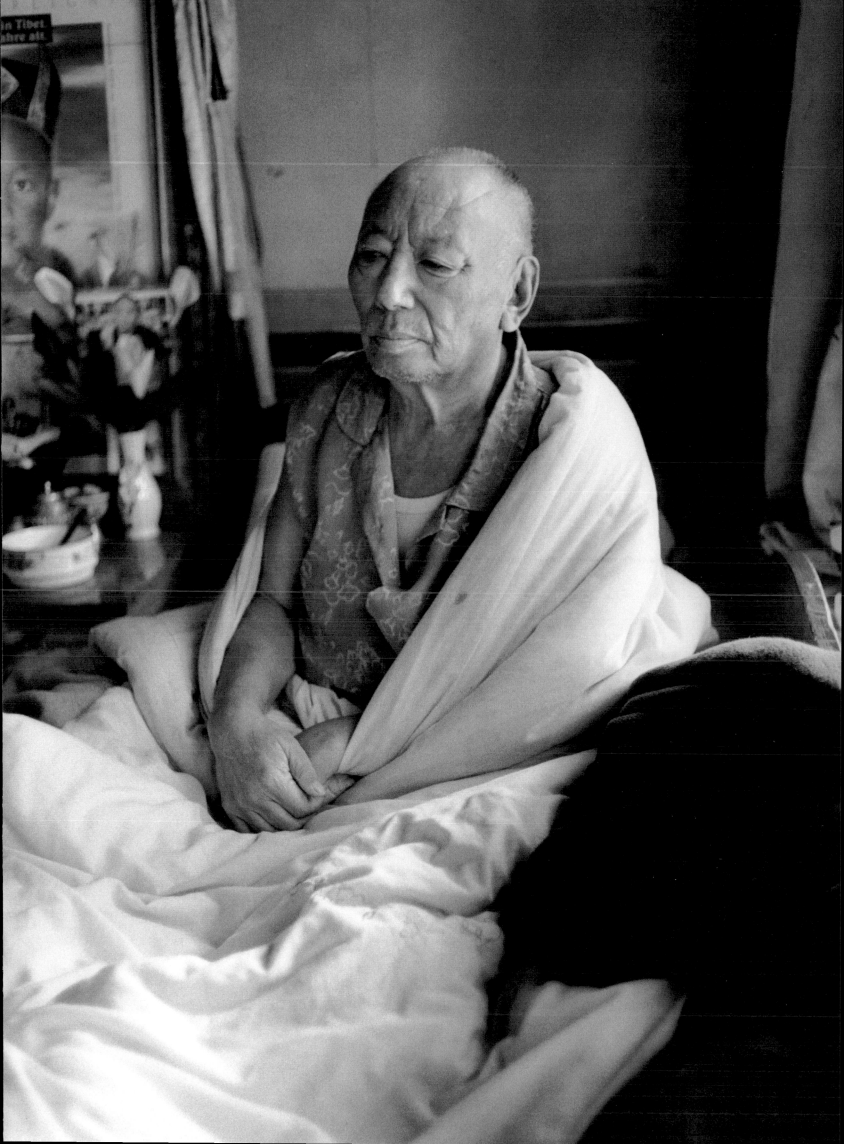

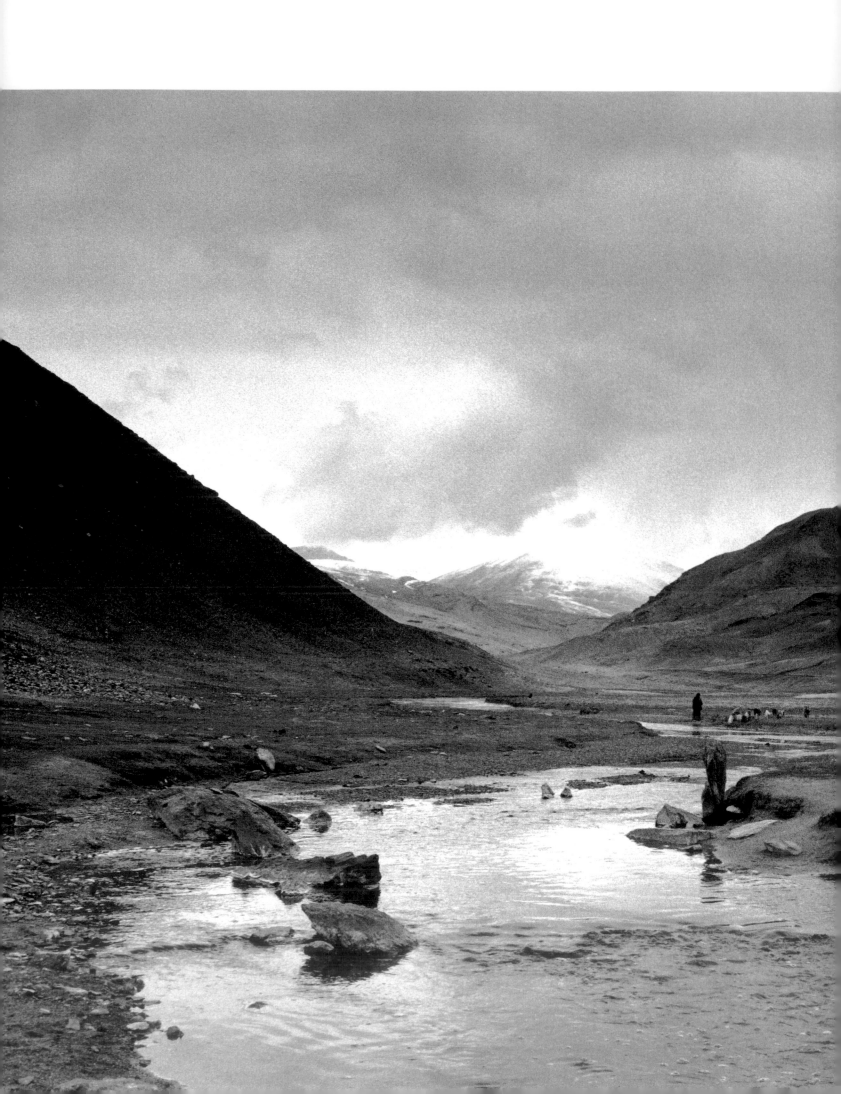

man was very special because he doubled as an *amchi* as well. He was famous throughout Leh as a great prophet and healer. Dechen guided me through a lovely poplar grove in the early morning light. We crossed a rough stone bridge over a stream and finally ended up at an old Ladakhi house. Climbing a flight of well-worn stone stairs, we entered a room filled with dark red and blue Tibetan carpets. Cushions were propped up against one wall, with a low table positioned in front of the opposite wall. The room was very dark, lit only by one small, dusty window. Dechen told me she had never talked to the *onpo;* she had always been afraid of him. This would be the first time she had spoken to him, even though she had visited him many times with her father since she was a child.

We waited. In a few minutes a strikingly handsome man about seventy years old entered the room. His long gray hair was pulled back into a ponytail, and he wore a heavy wool *chuba*, or coat, gathered at his waist by a green sash. He sat behind the low table.

The *onpo* could speak no English, so Dechen translated. She was noticeably intimidated by this powerful healer. In the beginning there was no speaking, only staring. He had Rasputin-like eyes—wide, wild circles that ate into your sense of balance and order. A woman, one of his two wives, came into the room carrying a large book covered on both sides with unhinged, elaborately carved wooden covers. The book was as long as the *onpo*'s arm but no wider than his open hand. Unwrapping the yellow cloth that bound

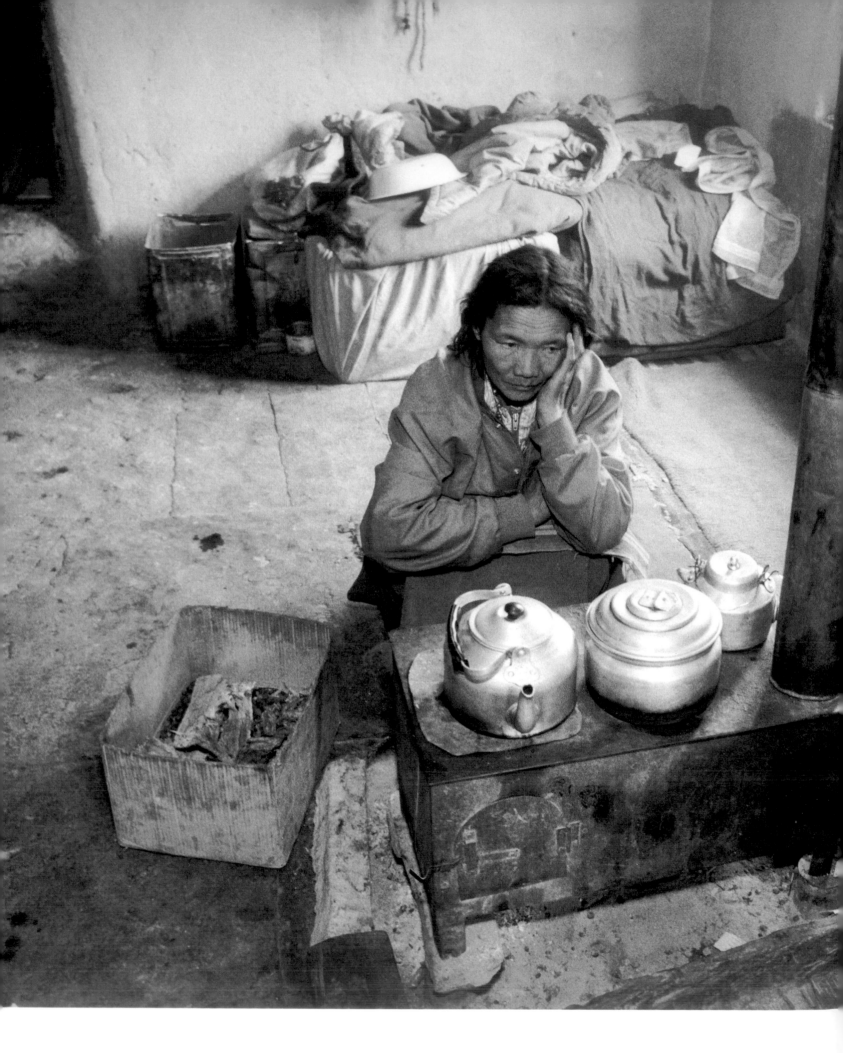

the book, the *onpo* began to flip through the loose, excessively decorated pages of wood-block prints. The black-inked images were of hands, stars, and detailed charts of the heavens.

The *onpo* finally spoke. "This book is five hundred years old," he told us. "Seven hundred pages, with text on both sides. One thousand, four hundred pages in all. At the time of marriage I take the boy's and the girl's birth dates and tell them when to wed. I can also tell you when to be cremated. Yes, the right time to do everything."

He went on to tell us about reading the North Star, about amulets he gave to people of ill temperament. He studied both the stars, or "the outside," as he called it, and the body, which he called "the inside." He asked my birth date and then checked my birth star. One's birth star points to different parts of the body and tells how one's health will be for the next while. If the star points to the mouth, one could die in a year. Lungs are luckier. They represent a long life.

The *onpo* was not happy with what he saw in my stars. Maybe I would get more headaches, maybe some other illness. The news was not the best.

In the end I paid the *onpo* in his usual currency: a bottle of rum. Dechen told me on the way home that the *onpo* did all his sessions in the morning. In the afternoons he was in no shape to see the future, let alone focus on the pages in front of him.

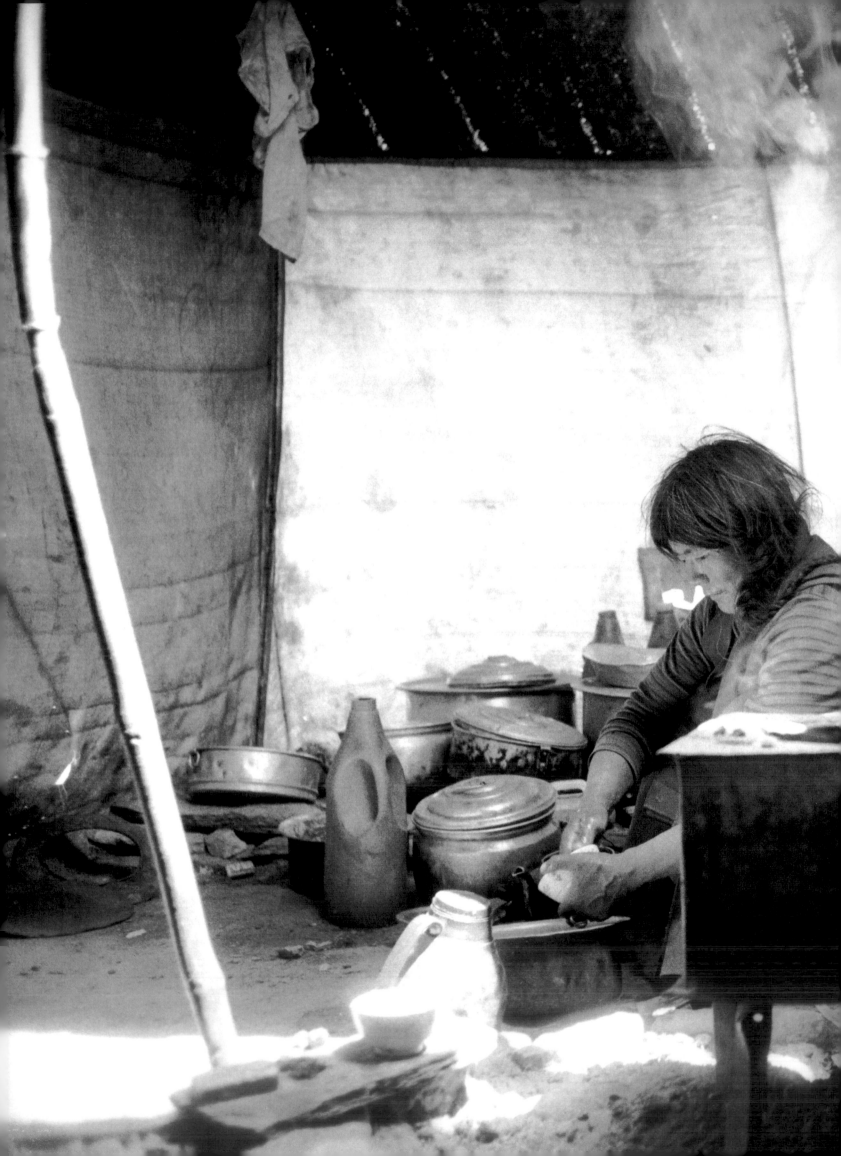

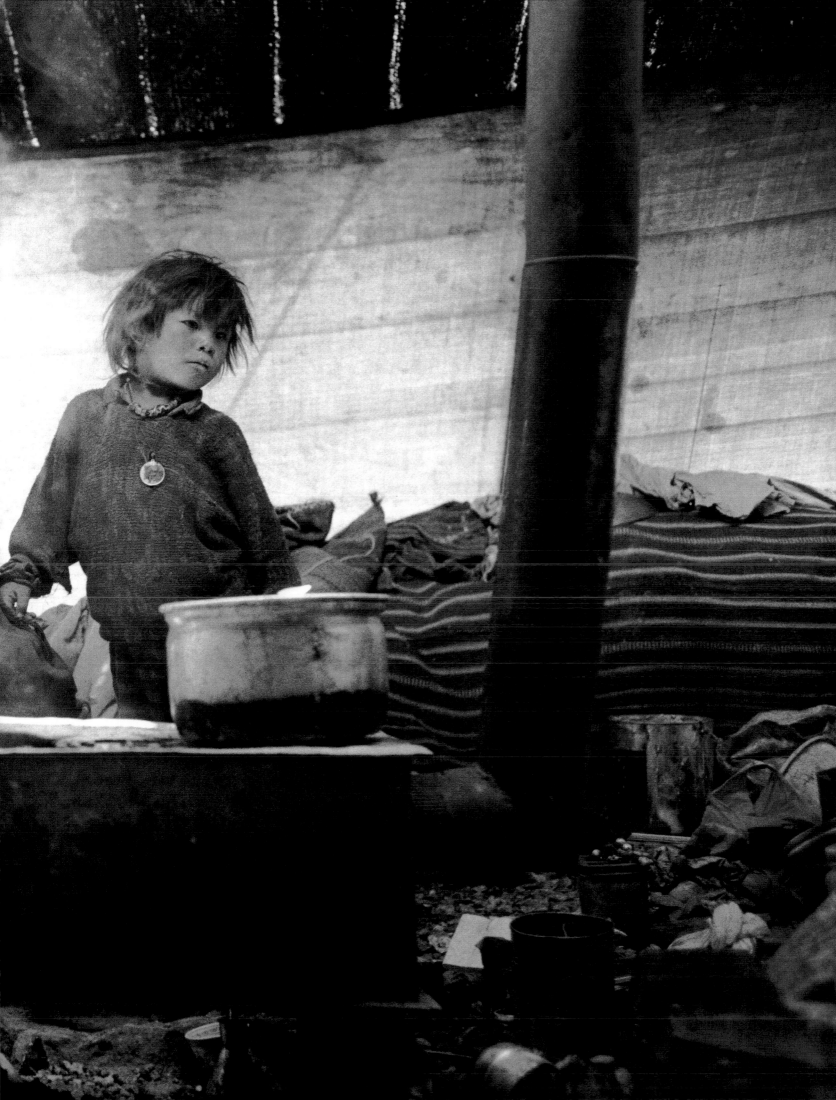

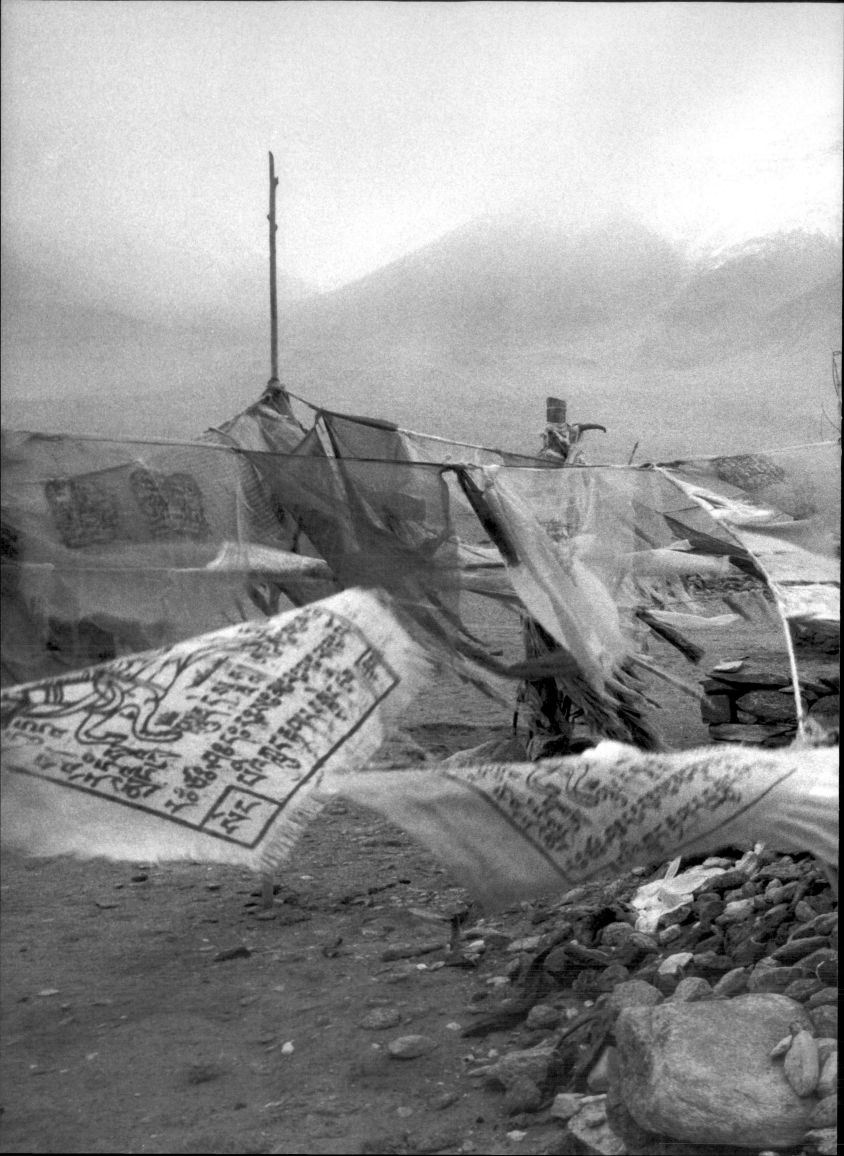

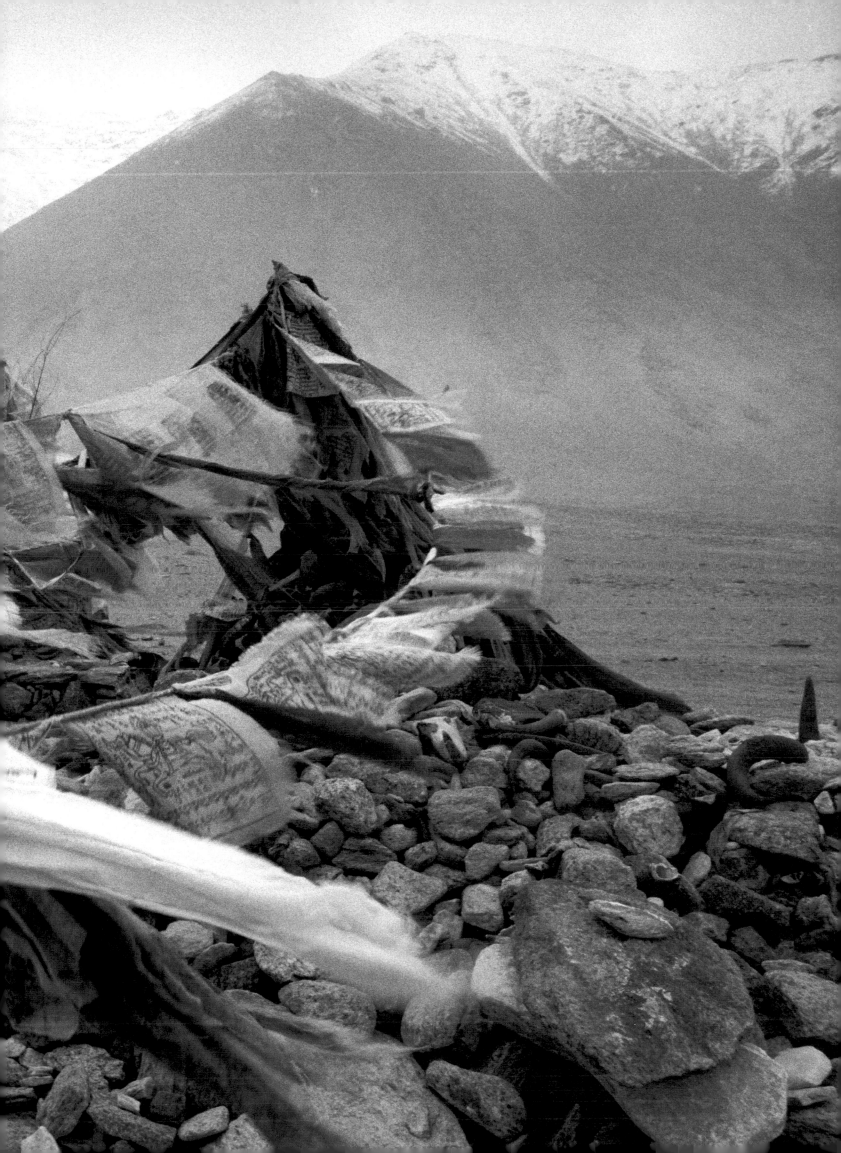

tibetan

spirituality, like Tibetan medicine, comes from long-held practices that were well in place centuries before the arrival of Buddhism in the middle of the seventh century. Buddhism actually reached Tibet more than a thousand years after its founder's death. By then it had developed into a northern school of Buddhism that merged the animism of tantrism with a sophisticated, monastic tradition based on the social ethic of universal love and compassion. From its beginning Tibetan Buddhism incorporated the profound techniques of tantric meditation as a means to transcend the realities of death and sexuality and to harness the powerful energies of the human psyche. As His Holiness the Dalai Lama explains, it is through sexual desire that you can melt the elements within your body and then experience a nonconceptual state that directs your attention toward, and focuses on, the mind of enlightenment.

Many Westerners see Tibetan Buddhism only as a nonphysical, meditative faith. But in truth, its roots and its modern practices address all aspects of the human experience. Much of this has to do with its deep, expressive history.

In pre-Buddhist Tibet, the Bon faith was the state religion of royal Tibet before Buddhism arrived. Over the centuries, Bon, which is believed to have Iranian roots, developed its own shamanistic practices. Even today, as I witnessed in the Ngari region, shamanism survives in the marginal areas of southern Tibet. The Bon faith, with its tradition of shamans,

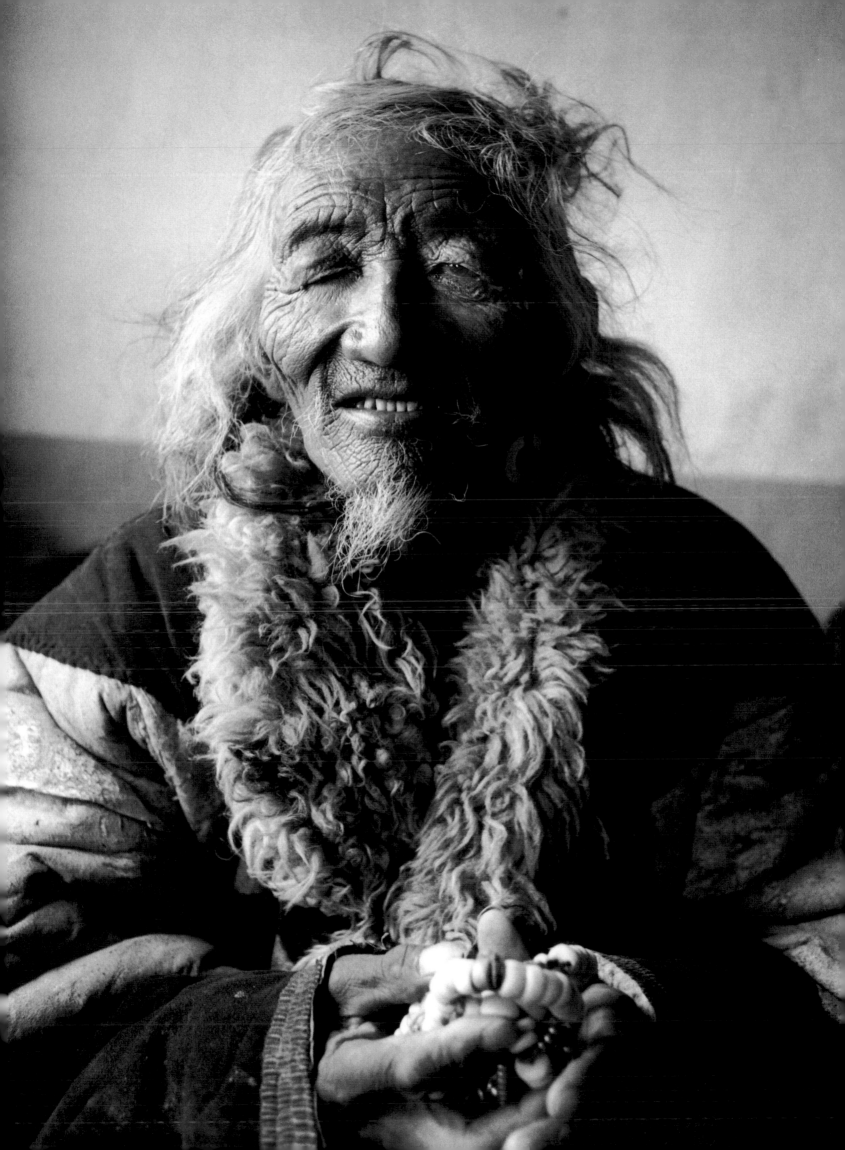

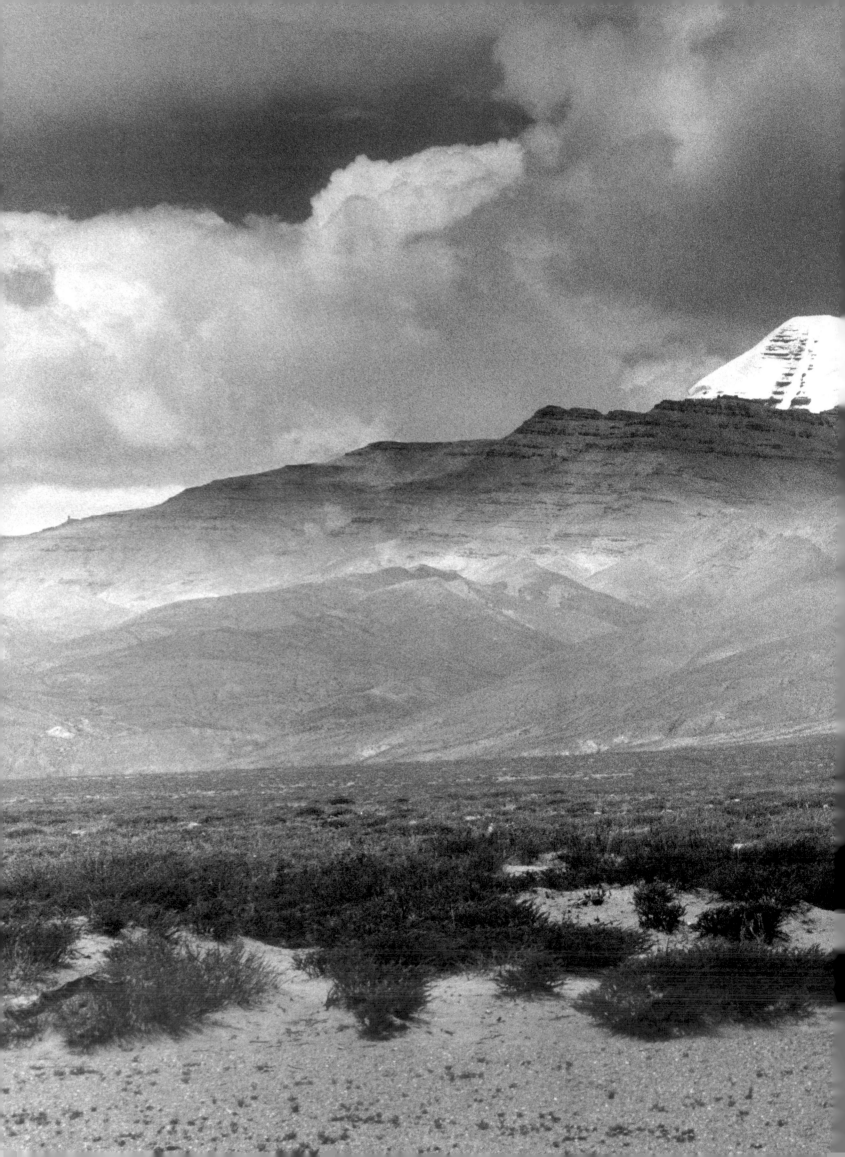

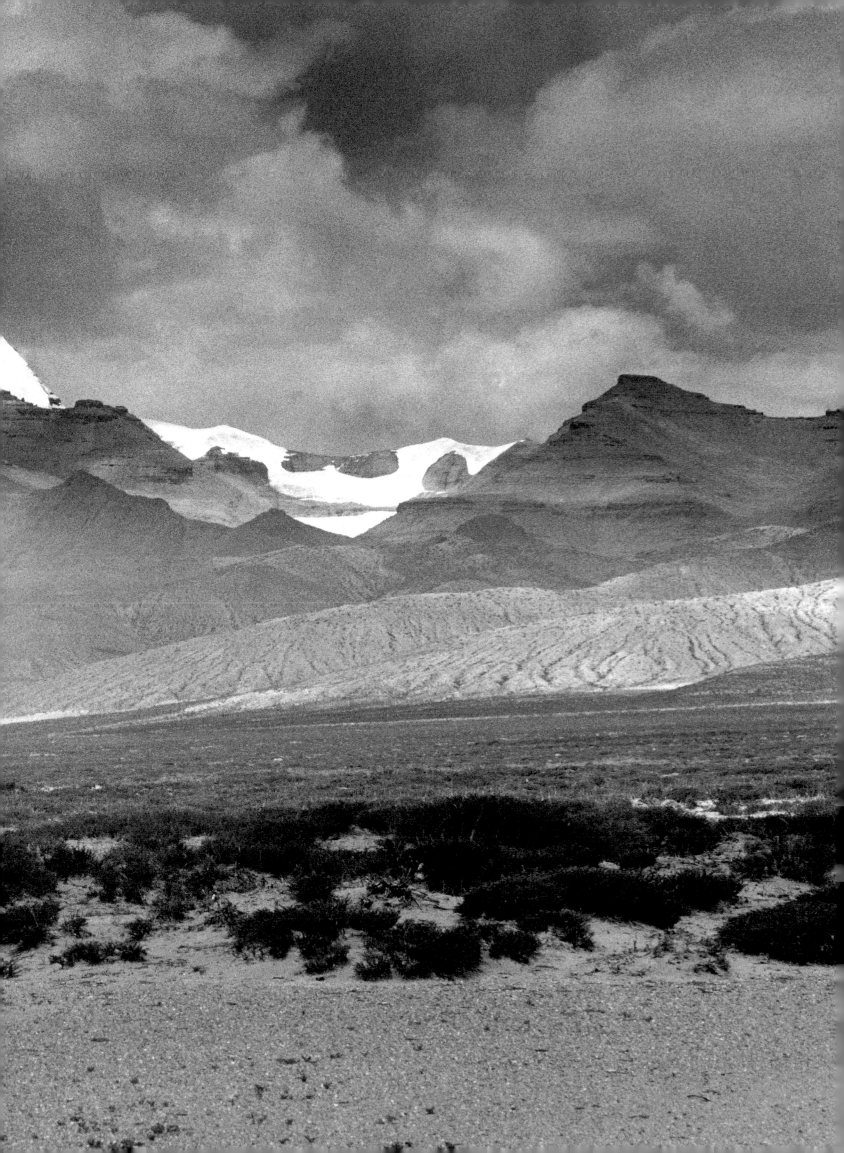

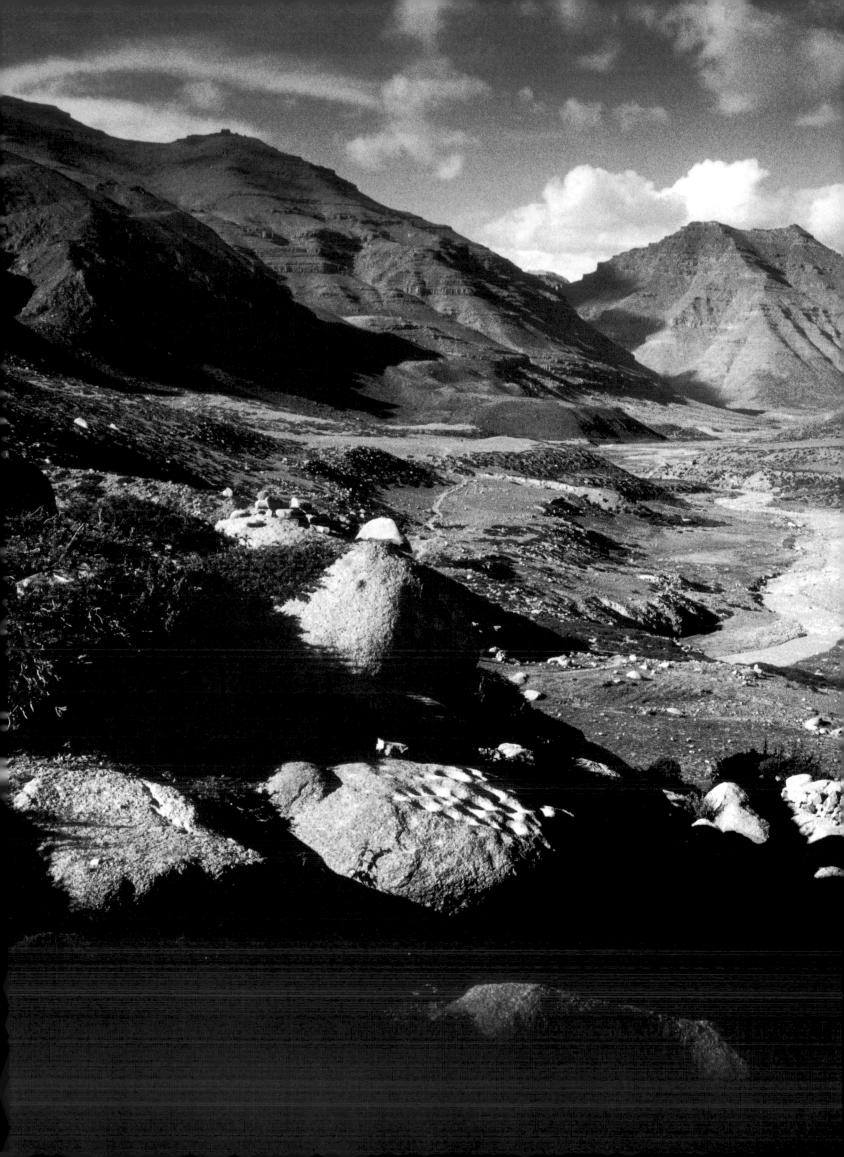

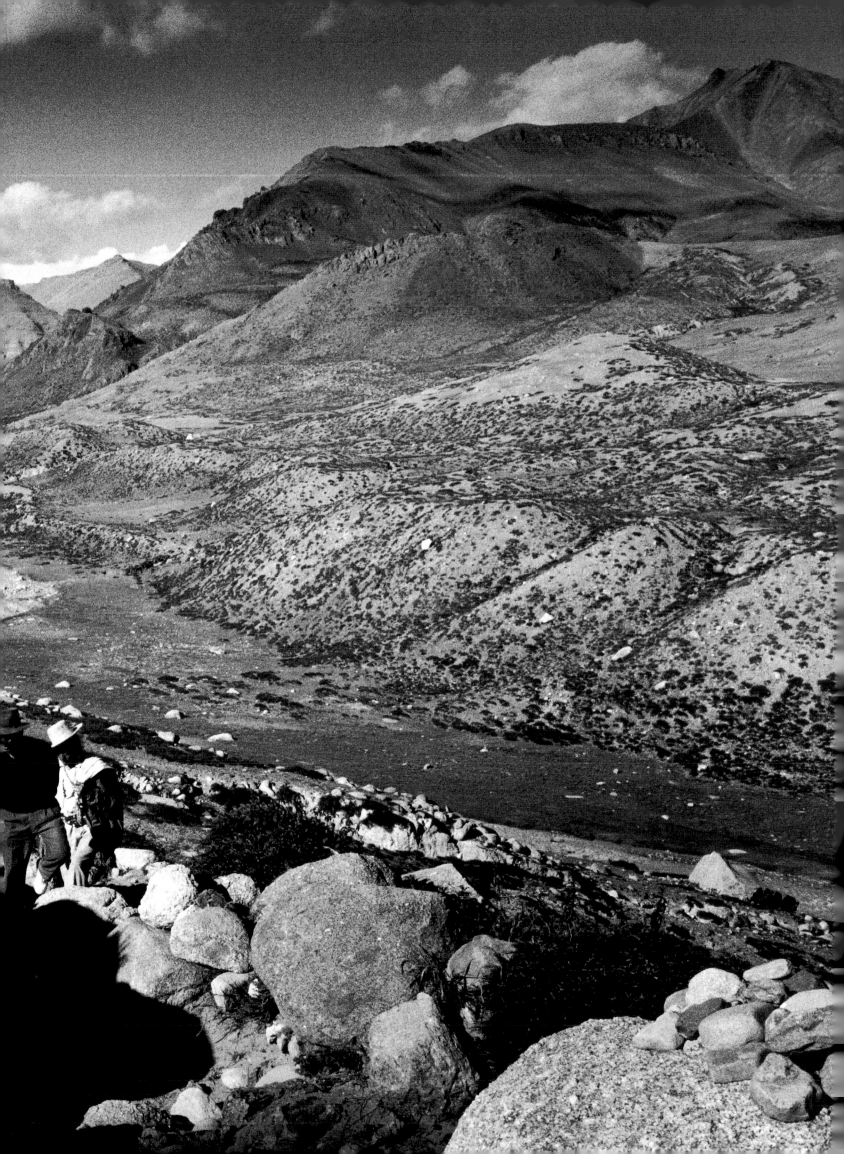

had little trouble accepting the magic and mystery of tantric Buddhism. Yet over the centuries, the more scholarly and monastic aspects of Tibetan Buddhism have separated from the primitive practices of Bon. It should be noted, though, that the nomads of Tibet, like the old man making the small *tsampa* effigies, have a lot of Bon left in their Buddhism.

Tibetan medicine can also appear to have a supernatural, mystical side. I remember one Tibetan *amchi* wanted to read my blood. He said he could only do it moments after the sun came up and before I had started my day. The body, like the mind, is believed to be freshest and most clearly readable upon waking. In fact, those who study Tibetan medicine are advised to memorize, in the hours just before sunrise, the 1,140 pages of the four medical teachings of Buddha. These teachings state that there are three elements that govern all sentient beings: wind, bile, and phlegm. When the *amchi* began pressing my arteries and veins to check my circulation, he obviously found something. He kept pressing one point around my left wrist over and over again. Within half an hour he made his prognosis.

"You have too much wind," he told me.

He then explained to me about the five winds that control circulation and respiration. What he was doing is called pulse diagnosis. At Mendzekhang, Lhasa's large Tibetan hospital, pulse diagnosis is a one-year course, but it takes a full decade to get a firm grip on it. Many Tibetan practices, both medical and spiritual, which we may find to be based on supernatural assumptions, are not so unbelievable. To

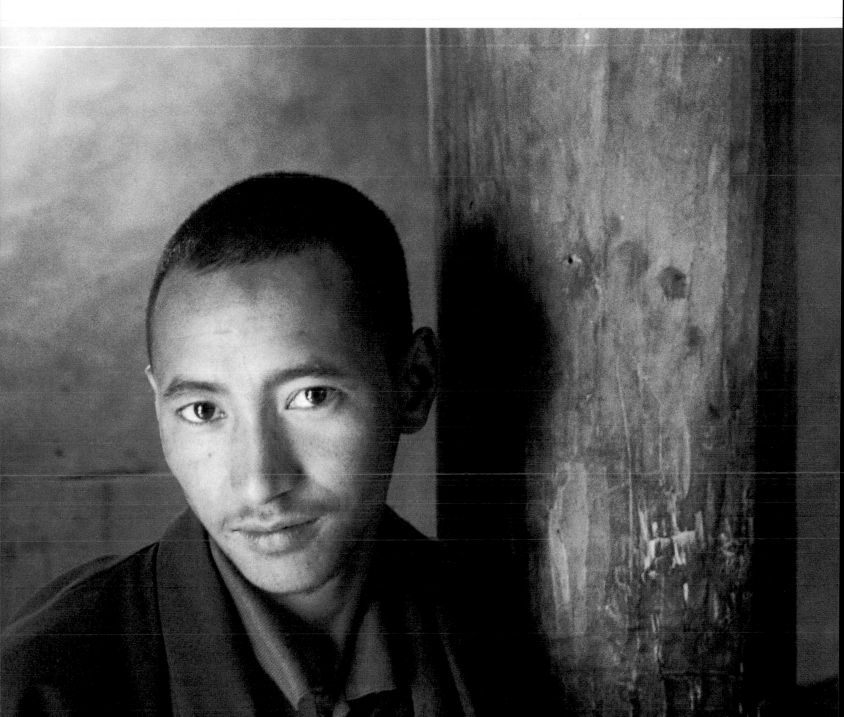

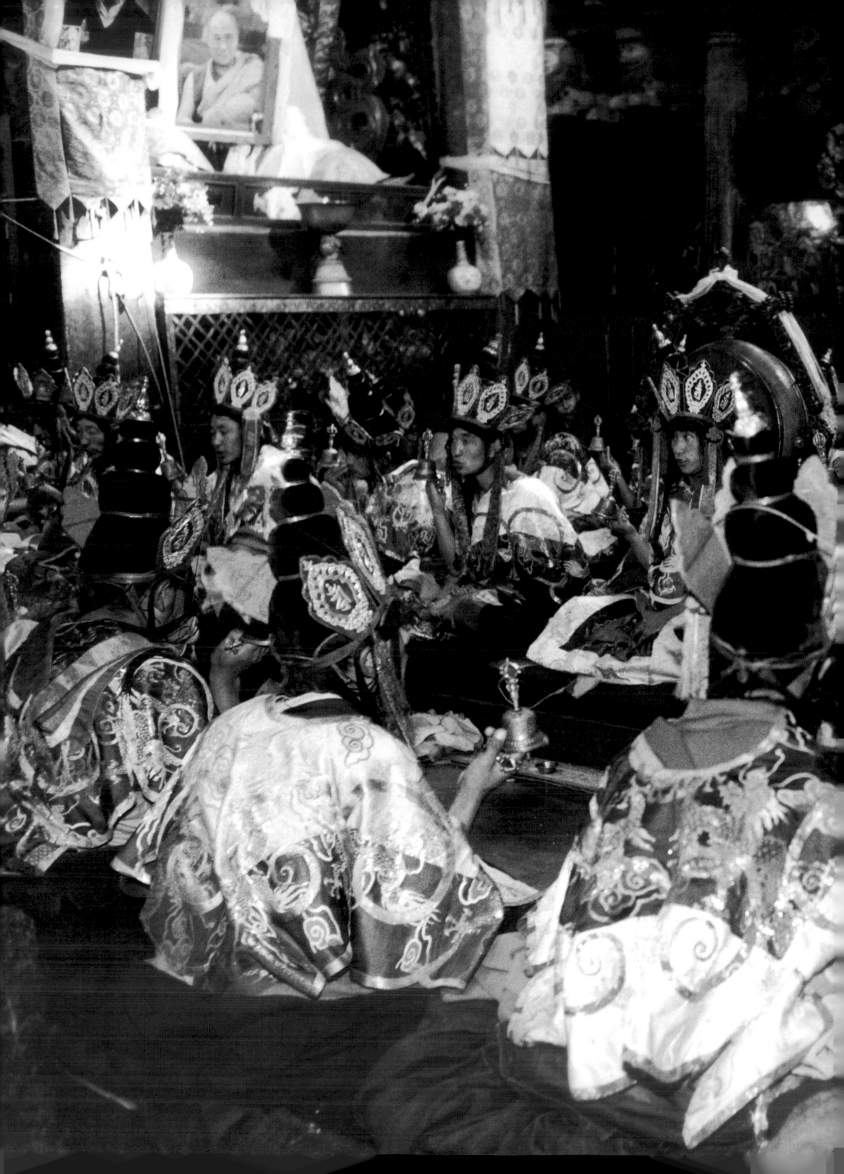

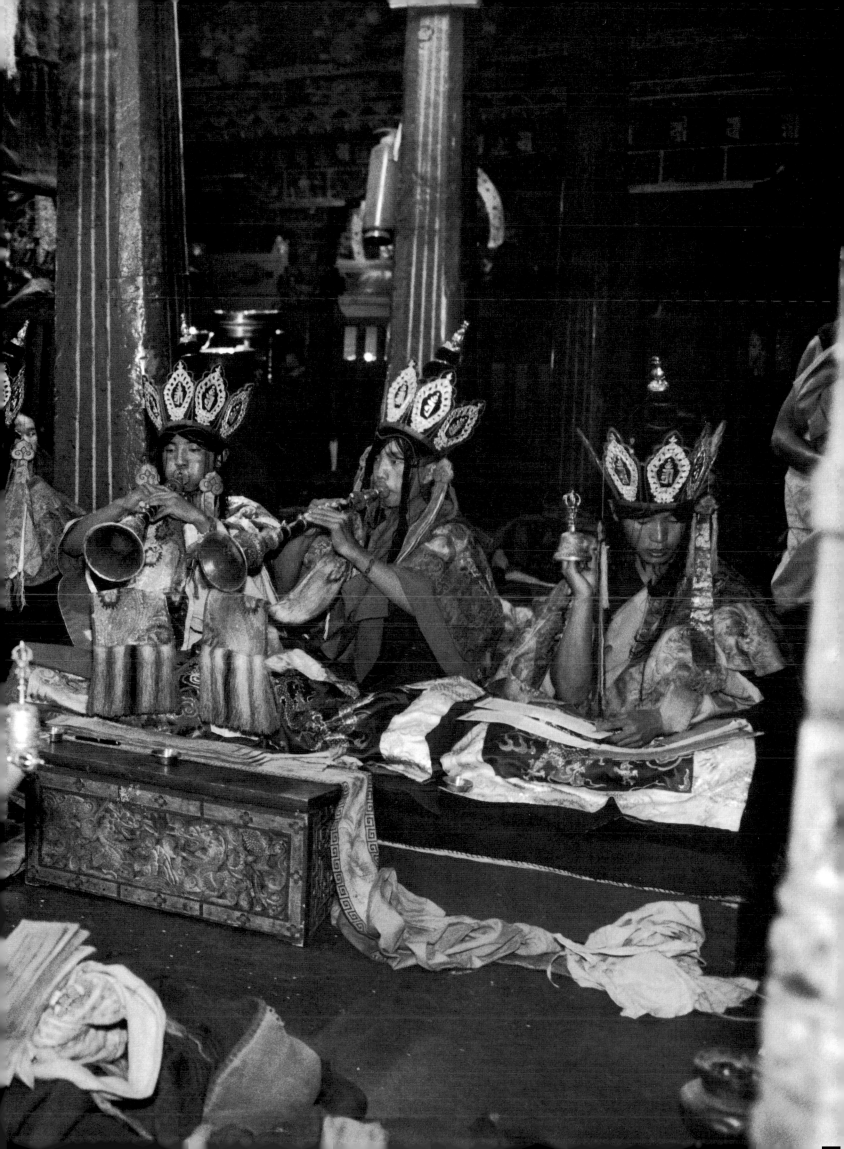

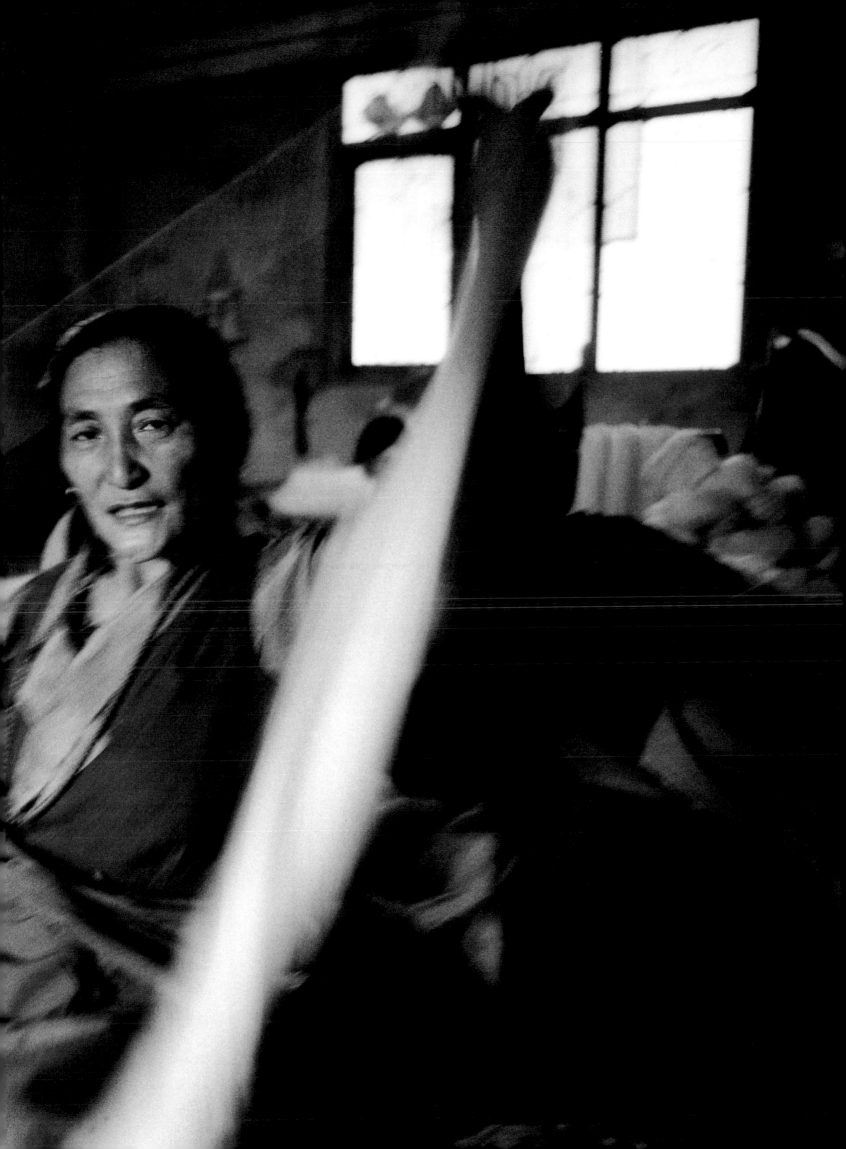

Tibetans, being ill is not an individual malady. Like everything else in their universe, nothing stands alone. It all has to do with a complete sense of harmony and balance within the body as a whole. So, a certain ache or pain is not viewed in isolation but as the result of the whole organism being out of balance.

THIS IDEA OF EXPANSIVE, all-inclusive thinking is really at the core of Tibetan Buddhism. Nothing in Tibet is unrelated to everything else. Whatever action, thought, or simple gesture a Tibetan may initiate, the result must be for a larger cosmic good. The smallest act of selfishness or evil can start a karmic ripple that will swell into a tidal wave of suffering and tragedy beyond itself. For this reason, Tibetans have long been ecologically and altruistically attuned to the well-being of all sentient beings on this planet. To kill an animal for sport is as unthinkable as killing one's grandmother. For a Tibetan Buddhist, disrupting the balance of nature is like disrupting the balance within one's own body or mind. Tibetan belief and practice have endured for centuries. And during those centuries, prayer has replaced power, compassion has replaced corruption, and Vajrayana[30] (Tantrism) has replaced violence.

The human spirit is the most treasured commodity—not wealth, position, or power. I met some nomads on the Chang Tang Plateau who owned nothing—only a tent full of faith—yet they were the richest people I have ever met. We could learn from Tibet. A bit more mystery and magic, and a healthy measure of wisdom

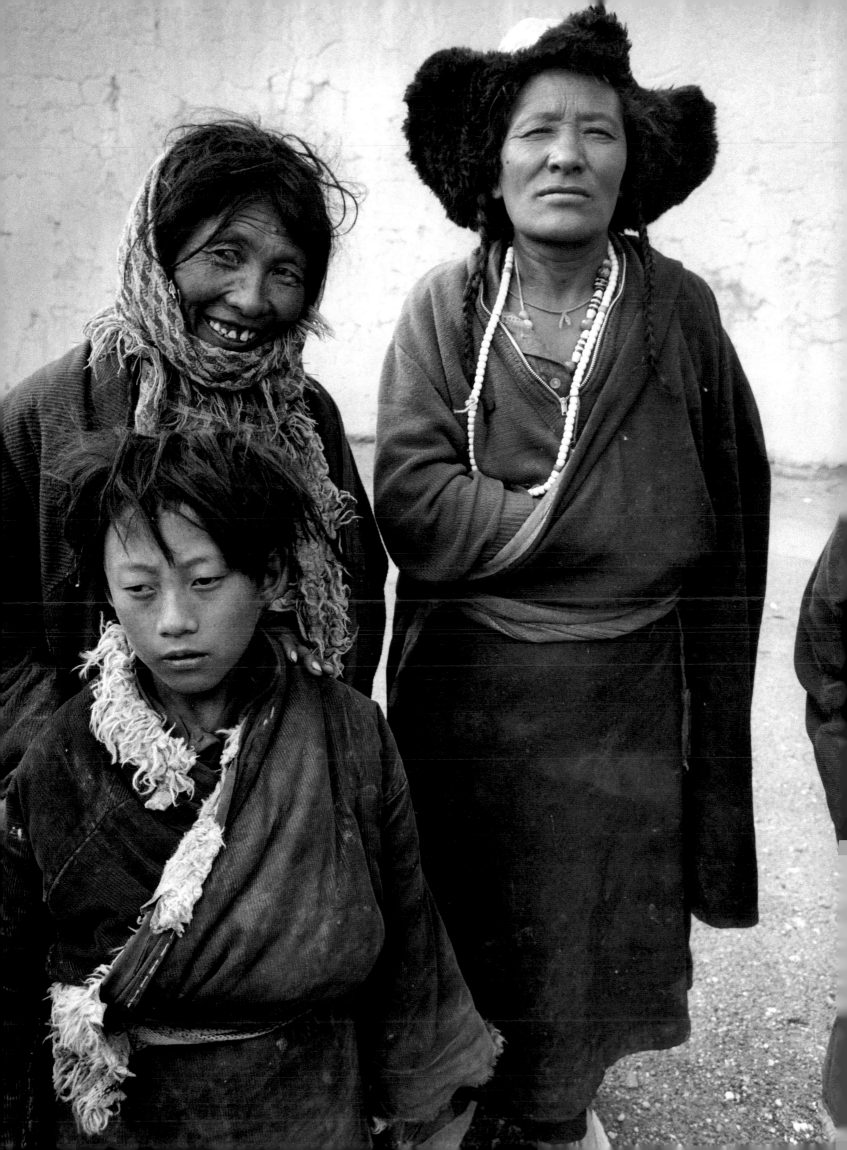

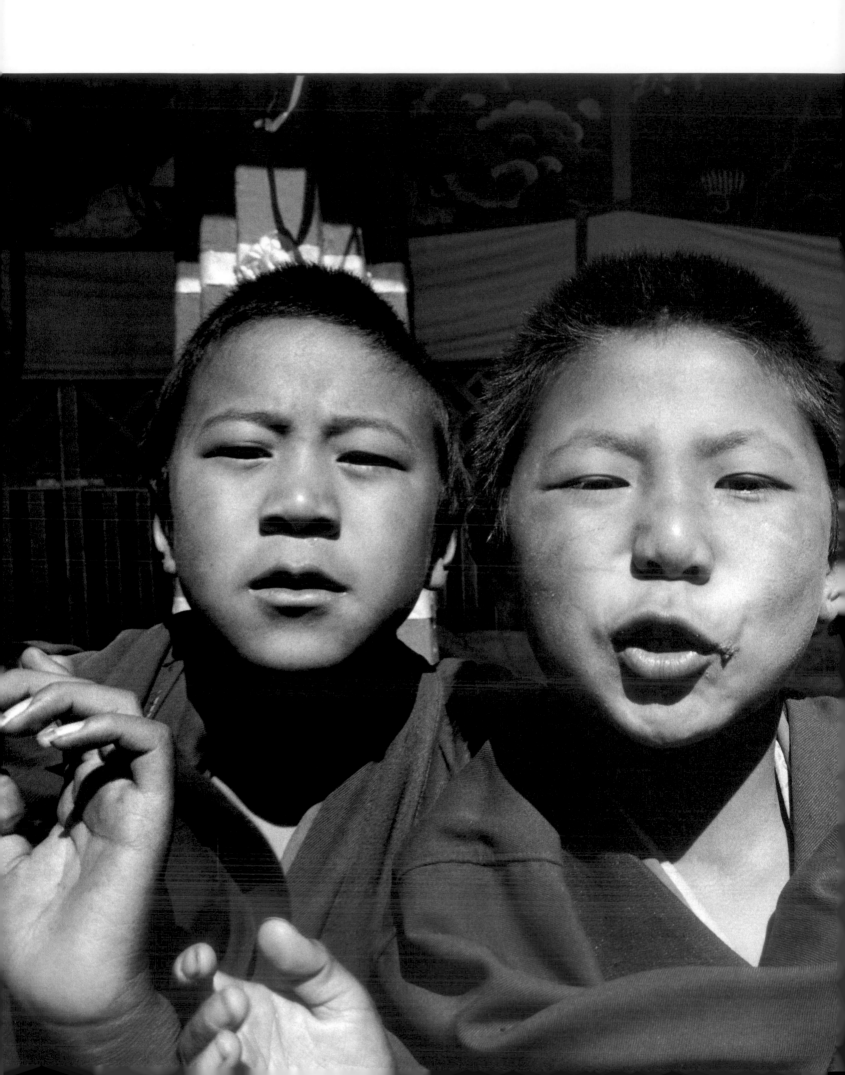

and compassion could help us along the way. I listened to many people during my travels among the Tibetans; some were brilliant scholars, some were uneducated herdspeople. I saw many things that opened my eyes and heart to the Tibetan people in a way that has changed me forever, and for the better.

The willful destruction of Tibetan Buddhist culture is one of the great tragedies of the twentieth century. Joy and faith have been slaughtered without accountability. Bombs have been dropped, murders have been committed, and innocence has been lost. But Tibet and its Buddhist culture, with all its Shangri-la otherworldliness, will live on in myth, if not in actuality. As you look at the Tibetans in this book, do not forget their story of faith in the face of unimaginable inhumanity.

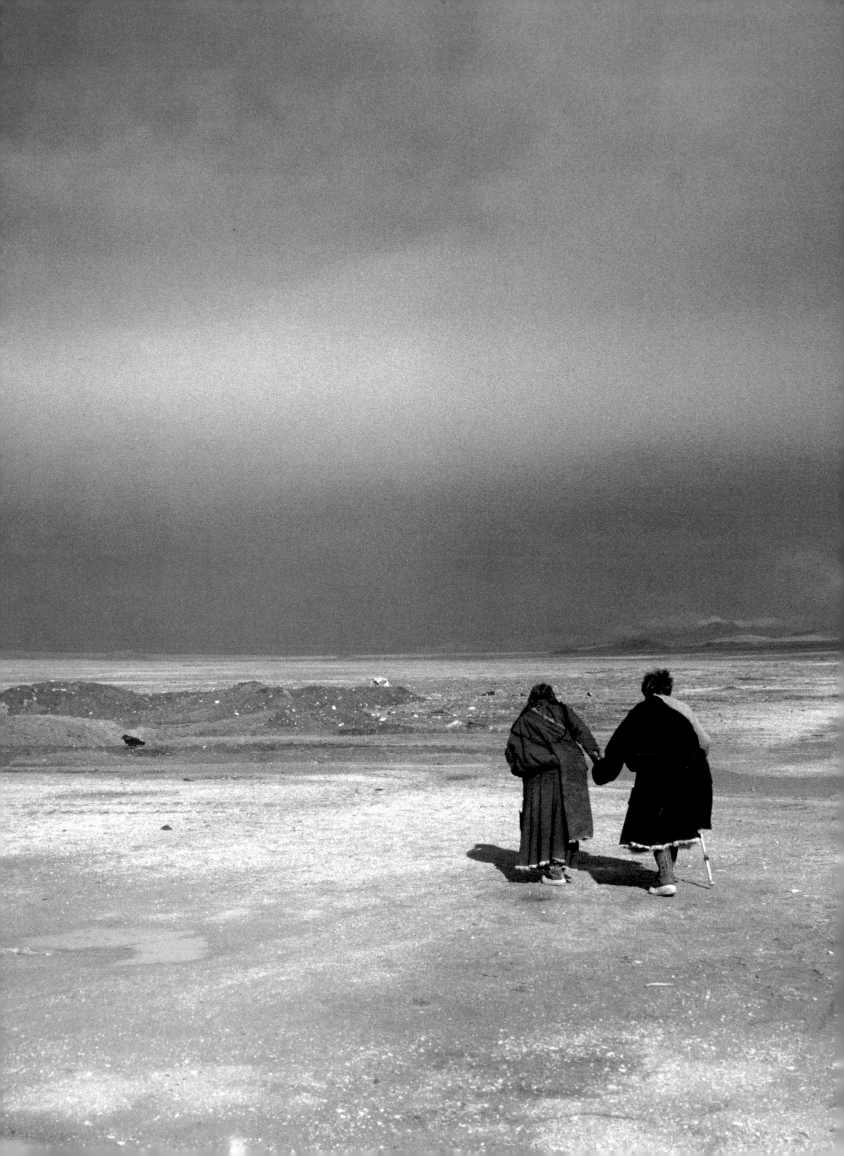

Prayer of World Truth
by His Holiness the Fourteenth Dalai Lama

O all-time Buddhas with your children and disciples . . .
May you rescue wretched beings, ceaselessly tormented
By the fierce push of unbearably vicious evolutionary acts,
Prevent the horrors of their dreaded diseases, wars and famines,
And restore their spirits in your ocean of bliss and happiness!

Please look upon the religious people of the Land of Snows,
Ruthlessly conquered with harsh tactics by malevolent invaders;
May your compassion exert itself with miraculous speed
To stop the torrent of blood and tears!

Ah! Those cruel people defeat themselves as well as others,
Driven to insane behavior by the devil of addictive passions;
Have mercy and restore their decent insight of right and wrong,
Use love and kindness to reunite them in the glory of human friendship![31]

Notes

1. His Holiness the Dalai Lama, *The Way to Freedom: Core Teachings of Tibetan Buddhism,* New York: HarperCollins, 1994, pp. 93–94.

2. Quoted in Mary Craig, *Tears of Blood: A Cry for Tibet,* New York: HarperCollins, 1992, p. 48.

3. Robert A. F. Thurman, *Essential Tibetan Buddhism,* San Francisco: HarperCollins, 1995, p. 154. Shantideva was a great eighth-century Indian master whose writings were translated into Sanskrit and universally became used in the practice of Tibetan Buddhism.

4. From a speech given by Alexander Solzhenitsyn in Tokyo, 1982.

5. His Holiness the Dalai Lama, *The World of Tibetan Buddhism: An Overview of Its Philosophy and Practice,* Boston: Wisdom Publications, 1995, p. 63.

6. His Holiness the Dalai Lama, *Beyond Dogma: Dialogues and Discourses,* Berkeley, Calif.: North Atlantic Books, 1996, p. 104.

7. See *Resistance and Reform in Tibet,* edited by Robert Barnett and Shirin Akiner. London: C. Hurst & Co., 1994.

8. Heinrich Harrer, *Seven Years in Tibet,* New York: E. P. Dutton, 1954.

9. Richard Berstein, *The New York Times,* Wednesday, March 19, 1997, p. B2.

10. Orville Schell, "Dreams of Tibet: A Troubled Country and Its Enduring Fascination," *WGBH Frontline,* December 1997.

11. Ama Tapontsang, *Ama Adhe: The Voice That Remembers,* Boston: Wisdom Publications, 1997, p. 91.

12. His Holiness the Dalai Lama, *My Land and My People: Memoirs of the Dalai Lama in Tibet,* New York: McGraw Hill, 1962; *Facts About Tibet 1961–1965,* New Delhi: Bureau of His Holiness the Dalai Lama, 1966; *Freedom in Exile: The Autobiography of the Dalai Lama,* New York: HarperCollins, 1990.

13. John F. Avedon, *In Exile from the Land of Snows,* New York: Vintage Books, 1986.

14. Craig, *Tears of Blood; Kundun: A Biography of the Family of the Dalai Lama,* New York: HarperCollins, 1997.

15. Warren W. Smith, Jr., *Tibetan Nation: A History of Tibetan Nationalism and Sino Tibetan Relations,* New Delhi:HarperCollins, 1997.

16. Dawa Norbu, *Red Star over Tibet,* New York: Envoy Press, 1987; *Tibet: The Road Ahead,* New Delhi: HarperCollins, 1997.

17. Palden Gyatso, *Fire Under the Snow: The Autobiography of a Tibetan Monk,* New York: Grove Press, 1997.

18. Tapontsang, *Ama Adhe.*

19. The International Committee of Lawyers for Tibet (ICLT) believes that "through human legal action and education, ICLT advocates human rights, environmental protection, and peaceful resolution of the situation in Tibet. A nonprofit membership group, ICLT is supported by attorneys, other concerned individuals, and organizations."

20. ICLT, *Tibet Watch,* Fall 1997, p. 9.

21. Ibid., p. 7.

22. Craig, *Tears of Blood,* p. 69.

23. ICLT, op. cit., p. 2.

24. Howard Chapnick, *Truth Needs No Ally,* Columbia, Mo.: University of Missouri Press, 1994, pp. 7–8.

25. Avedon, *In Exile from the Land of Snows,* pp. 348–349.

26. Michael Harris Goodman, *The Last Dalai Lama,* Boston and London: Shambhala, 1984, p. 218.

27. Ibid., p. 263.

28. Dalai Lama, *My Land and My People,* p. 129.

29. Jamyang Norbu, *Horseman in the Snow: The Story of Aten, an Old Khampa Warrior,* Dharamsala, India: Information Office of His Holiness the Dalai Lama, 1979, p. 70.

30. Vajrayana, as explained by the Dalai Lama, is the Sanskrit word for Tantrism; see *The World of Tibetan Buddhism,* p. 93.

31. Thurman, *Essential Tibetan Buddhism,* p. 280.

Captions

1. PAGES ii-iii
Young monks,
Drepung
Monastery, Lhasa.

2. PAGES iv-v
Mani stone and
chortens, Shey
Monastery,
Ladakh, India.
Chorten is Tibetan
for *stupa,* or domed
shrine. Often these
are reliquaries for
the cremated
remains of impor-
tant lamas. This
mani stone has the
mantra "Om Mani
Padme Hum," the
most common
Tibetan prayer.

3. PAGE viii
Karma Chowang, a
nomad of the
Chang Tang
Plateau, Gertse.

4. PAGE xiii
Nomad in a fur-
lined garment,
Chang Tang
Plateau. This
young man lives on
the high desert of
Tibet where he col-
lects salt from
dried lake beds.
Much of the
nomadic salt trade
has been under-
mined by the avail-
ability of cheaper
sea salt, though
most Tibetans pre-
fer the taste of
lake salt.

5. PAGES xviii-ix
Monks preparing
yak butter tea,
Drepung
Monastery, Lhasa.

6. PAGE xxi
Monk, Sera
Monastery, Lhasa.

7. PAGES 2-3
Ganden Monastery
and an approach-
ing snowstorm. At
one time Ganden
was a city of learn-
ing set high in the
sky. Before China's
Cultural
Revolution there
were more than
three thousand
monks at Ganden.
Since the bombing
of Ganden in 1966,
it houses only a
few hundred
monks.

8. PAGE 4
Monk in his room,
Ganden Monastery.

9. PAGE 7
Praying monks,
Jokhang Temple,
Lhasa. The
Jokhang is the
most sacred place
in Tibet. Often
Tibetans will cover
their windows with
colored cloth, usu-
ally red or yellow,
to create a warm
inner light.

10. PAGES 8-9
Chortens near
Shey Monastery,
Ladakh, India.

11. PAGES 10-11
Monk and khatas,
Drepung
Monastery, Lhasa.
Khatas are ceremo-
nial scarves, usu-
ally draped around
the neck of a
statue or lama.
Khatas are also
placed on guests as
a welcoming and
parting gesture
throughout Tibet.

12. PAGES 12-13
Monks, Serze
Monastery, near
Gertse.

13. PAGE 15
Chookey Dolma, a
nomad of the
Chang Tang
Plateau, Gertse.

14. PAGES 16-17
Monk and pil-
grims, Sera
Monastery, Lhasa.
This is Tamdrin
Lhakhang, Sera's
most sacred shrine.
It contains a statue
that once spoke,
warning of immi-
nent danger. The
walls are hung
with chain-mail
armor and swords
cast off by return-
ing Tibetan sol-
diers.

15. PAGE 19
Palmo Kunga,
Sumdho, Chang
Tang Plateau,
Ladakh, India.
16. PAGE 20
Palden Gyatso.
Palden Gyatso is a
monk and a sur-
vivor of Chinese
torture in Tibet.
This frail man
endured thirty-
three years of
imprisonment. He
stands as a living
testament to the
inhuman events
that are reshaping
Tibet.
17. PAGE 22
Young monk,
Spitok Monastery,
near Leh, Ladakh,
India.

18. PAGES 24-25
Nomad and yaks,
Samed, Ladakh,
India.
19. PAGES 26-27
Yak-skin boat fer-
rying passengers
across the Kyi Chu
River, near Lhasa.
20. PAGES 28-29
Three monks on a
pilgrimage,
Changspa, near
Leh, Ladakh,
India.

21. PAGE 31
Nomad in home-
made goggles,
Chang Tang
Plateau,Gertse.
This man has used
the bottom of glass
bottles to construct
an ingenious pair
of goggles to shield
his eyes from the
destructive ultravi-
olet light on the
high altitude
desert. Many
nomads wear wide-
brimmed hats to

shade and protect
their eyes.
22. PAGES 32-33
Nomad and dogs,
Chang Tang
Plateau, between
Raga and Tsochen.
This man has cov-
ered his lips with
yak butter to pro-
tect his mouth
from the wind and
sun.
23. PAGES 34-35
Nomads and herd,
between Ali and
Toling, Ngari
region. The Ngari
region is in far

western Tibet.
There is something
reminiscent of the
Wild West as this
lawless land has a
history of robbed
caravans and of
lost pilgrims who
never made it to
Mount Kailash.
24. PAGES 36-37
Nomad with
straining calf,
Sumdho, Chang
Tang Plateau,
Ladakh, India. Few
nomads kill their
own animals
because killing
brings bad karma.
There are poorer
nomads who do the

unclean jobs such
as killing and cas-
trating animals.
25. PAGES 38-39
Nomad boy with
goat herd, near
Gar-Gunsa, Ngari
region. On the
plains of Ngari
there are wild
asses (kyangs) and
gazelles (gowa) and
the beautiful
Hodgson's antelope
(tso) with its long
horns.
26. PAGES 40-41
Young monks,
Swayambhunath
Monastery,
Kathmandu,
Nepal.
27. PAGE 42
Monk with prayer
wheel, Tsurphu
Monastery, 70 km
northwest of
Lhasa. Tsurphu is
the seat of the
Karmapa, the spir-
itual head of the
Kagypa order of
Tibetan Buddhism.

31

30

32

29

33

37

38

34

36

39 **40**

35

28

28. PAGE 45
The Potala, Lhasa.
The Potala was the
winter residence of
His Holiness the
Dalai Lama before
his exile to India.
29. PAGES 46-47
Young boy and
family, Drepung
Monastery, Lhasa.
30. PAGES 48-49
Monks rebuilding
Ganden Monastery.
Chinese officials
are allowing the
major monasteries
near the capital
city of Lhasa to be
rebuilt, for pur-
poses of tourism,
not Buddhism.

31. PAGE 50
The seventeenth
Karmapa, Tsurphu
Monastery. The
first Karmapa
founded Tsurphu
Monastery in 1187.
He is credited with
initiating the tulku
tradition that pre-
dicted the circum-
stances of rebirth.
This young boy is
the seventeenth
Karmapa, who,
along with the
fourteenth Dalai
Lama, is one of the
most spiritually
important figures
for today's
Tibetans.
32. PAGES 52-53
Monk, Tikse

Monastery,
Ladakh, India.
This monk had just
performed a prayer
at six o'clock in the
morning on the
rooftop of Tikse.
Blowing his conch
shell horn, the
monk sent his
prayer out over the
Indus River
toward the dis-
tant mountains.
Tikse is a 500-
year-old twelve-
story monastery
set high on a
craggy cliff.
33. PAGES 54-55
Monk, Spitok
Monastery, near
Leh, Ladakh,
India.
34. PAGES 56-57
Monk and wall

paintings, Spitok
Monastery, near
Leh, Ladakh,
India.
35. PAGE 59
Young monk with
drum,
Swayambhunath
Monastery,
Kathmandu,
Nepal. To reach
Swayambhunath
Monastery in
Kathmandu, pil-
grims cross the
Vishnumati River

and climb the four-
hundred-foot
stairway past
clambering mon-
keys and
seated beggars.
At the top is the
stupa with its
white dome visible
throughout the
valley.
36. PAGES 60-61
Monk, Samye
Monastery.
37. PAGES 62-63

Woman collecting
mud, Kyi Chu
River, near Dagtse
Dzong.
38. PAGES 64-65
Monk, Ganden
Monastery. Tibet is
a cradle of land
more than twelve
thousand feet
above sea level.
39. PAGE 66
Monks, Spitok
Monastery, near
Leh, Ladakh,
India.
40. PAGES 68-69
Head lama of
Samye Monastery.
Samye was Tibet's
first monastery,
most probably con
structed between
775 and 779 amid
the dunes near the
Bramaputra River.

45

44

41 43

52

46

53

42

47

48

50

49

this young monk rests a wooden churn used for making butter tea. For most Tibetans butter tea is a daily drink that provides the fat and salt needed to survive in this cold climate.

41. PAGES 70-71 Monks, Swayambhunath Monastery, Kathmandu, Nepal.

42. PAGES 72-73 Monk sweeping, Spitok Monastery, near Leh, Ladakh, India.

43. PAGES 74-75 Young monk in his room, Ganden Monastery. On the floor to the left of

44. PAGES 76-77 Pilgrims walking the Barkhor, Lhasa.

45. PAGE 78 Nomad family in tent, Chang Tang Plateau, Gertse. This family lives near Gertse, a small one-street town in the middle of high desert country. A relentless wind rushes down the main street, a street that begins at one end of town and ends at the other. There

is no clear road leading into or out of Gertse.

46. PAGES 80-81 Nomads, Ali, Ngari region.

47. PAGES 82-83 Monks serving tea, Jokhang Temple, Lhasa.

48. PAGES 84-85 Monks in kitchen, Drepung Monastery, Lhasa.

49. PAGE 86 Pilgrims, Jokhang Temple, Lhasa.

50. PAGES 88-89 Pilgrims, Jokhang Temple, Lhasa.

51. PAGES 90-91 Pilgrims burning juniper, Jokhang Temple, Lhasa. In August 1989, the Chinese government banned superstitious acts. This meant that the ceremonial

burning of juniper became a criminal act. This photograph was taken on July 6, 1997, the Dalai Lama's birthday. For some reason the police were allowing this public display. No one knew why.

52. PAGE 93 Pilgrim, Drepung Monastery, Lhasa.

53. PAGES 94-95 Friends meeting, Lhasa.

54. PAGES 96-97
Head lama and
monks, Samye
Monastery.

55. PAGE 99
The Potala, Lhasa.

56. PAGES 100-101
Nomads and herd,
Ngari region.

57. PAGE 102
Nomad in tent,
Sumdho, Chang
Tang Plateau,
Ladakh, India. The
Chang Tang
Plateau makes up
70 percent of Tibet
and much of south-
ern Ladakh. It is a
desolate place that
remains frozen for
eight months of the
year. As no crops
can grow there, the
nomads live by
raising herds of
goats, sheep, and
yaks.

58. PAGES 104-105
Khando with her
herd, Samed,
Chang Tang
Plateau, Ladakh,
India.

59. PAGES 106-107
Nomads, Sumdho,
Chang Tang
Plateau, Ladakh,
India.

60. PAGES 108-109
Nomad, Gertse,
Chang Tang
Plateau.

61. PAGES 110-111
Sumdho, Chang
Tang Plateau,
Ladakh, India.

62. PAGES 112-113
Nomad family,
Samed, Chang
Tang Plateau,
Ladakh, India.

63. PAGES 114-115
Nomads, Samed,
Chang Tang
Plateau, Ladakh,
India.

64. PAGES 116-117
Nomads and their
goat herd, near
Gar-Gunsa, Ngari
region.

65. PAGE 119
Drupon Dechen
Rinpoche, Tsurphu
Monastery. Drupon
Dechen Rinpoche,
a disciple of the
sixteenth
Karmapa, returned
from Ladakh,
India, to Tibet in
1984 to help
rebuild Tsurphu.
This great
monastery rests in
the upper
Drowolong Valley
where it once was
the most splendid
in central Tibet. In
the 1960s, Chinese
forces destroyed
much of the
monastery. Luckily,
the sixteenth
Karmapa escaped
to Sikkim, taking
many of Tsurphu's
treasures.

66. PAGES 120-121
Sumdho, Chang
Tang Plateau,
Ladakh, India.

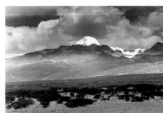

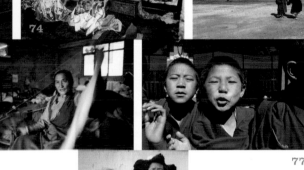

67. PAGES 122-123
Palmo Kunga making tea, Sumdho, Chang Tang Plateau, Ladakh, India.

68. PAGES 124-125
Khando and child, Samed, Chang Tang Plateau, Ladakh, India. In the summer months there are plenty of dairy products for the nomads. In the winter, they eat meat. Some sheep and goats are slaughtered in late August to celebrate the completion of sheep shearing, but most slaughtering is done with the onset of winter so that the meat can be frozen.

69. PAGES 126-127
Prayer flags on a mountain pass, Chang Tang Plateau, Ladakh, India.

70. PAGE 129
Nomad holding a malla, Ali, Ngari region. Tibetan Buddhists carry a rosary, or beaded malla, for counting their prayers.

71. PAGES 130-131
Mount Kailash, Ngari region. Throughout Asia there is a myth of a powerful mountain, the navel of the world. From

this mountain, Mount Kailash, flow four great rivers: the Ganges, Indus, Sutlej, and Brahmaputra. Four religious groups—Hindus, Buddhists, Jains of India, and the ancient Bons of Tibet—view Kailash as the most sacred pilgrimage site in Asia.

72. PAGES 132-133
Pilgrims on the khora of Mount Kailash, Ngari region. The pilgrimage to 22,028-foot Mount Kailash is considered the most difficult in the world. Once there, the 32-mile khora, or prayer circuit, around Kailash is a three-

to four-day walk. Yet some pilgrims, like the Khampa men in this photograph, do it in one day while other pilgrims do full-body prostrations that can take two weeks.

73. PAGES 134-135
Monk, Hemis Monastery, Ladakh, India.

74. PAGES 136-137
Monks at prayer, Jokhang Temple, Lhasa. In this photograph taken in 1995, the image of the Dalai Lama is proudly displayed over the altar. Today such a show of allegiance to His Holiness would be viewed as a criminal offense against the Chinese government.

75. PAGES 138-139
Tibetan refugee, Jawalakhel, Kathmandu, Nepal.

76. PAGE 141
Nomad family, Chang Tang Plateau, Gertse.

77. PAGES 142-143
Young monks, Drepung Monastery, Lhasa.

78. PAGE 144
Karma Chowang and Chookey Dolma, Chang Tang Plateau, Gertse.